Sailing the Inland Sea

Sailing the Inland Sea

ON WRITING, LITERATURE, AND LAND

Susan Neville

AN IMPRINT OF
INDIANA UNIVERSITY PRESS
BLOOMINGTON AND INDIANAPOLIS

This book is a publication of
Quarry Books
an imprint of
Indiana University Press
601 North Morton Street
Bloomington, IN 47404-3797 USA

http://iupress.indiana.edu

Telephone orders 800-842-6796
Fax orders 812-855-7931
Orders by e-mail iuporder@indiana.edu

© 2007 by Susan S. Neville

The paper used in this publication meets the minimum requirements of American National Standard for Information Sciences—Permanence of Paper for Printed Library Materials, ANSI Z39.48-1984.

MANUFACTURED IN THE UNITED STATES OF AMERICA

Library of Congress Cataloging-in-Publication Data
Neville, Susan, date
Sailing the inland sea : on writing, literature, and land / Susan Neville.
p. cm.
Includes bibliographical references.
ISBN-13: 978-0-253-34867-8 (cloth : alk. paper)
ISBN-10: 0-253-34867-6 (cloth : alk. paper)
ISBN-13: 978-0-253-21902-2 (pbk. : alk. paper)
ISBN-10: 0-253-21902-7 (pbk. : alk. paper) 1. American literature—Indiana—History and criticism. 2. Authors, American—Homes and haunts—Indiana. 3. Authors, American—20th century—Interviews. 4. Indiana—In literature. 5. Middle West—In literature. 6. Landscape in literature. 7. Place (Philosophy) in literature. 8. Setting (Literature) 9. Authorship. I. Title.
PS283.I6N48 2007
810.9'9772—dc22
2006026925
1 2 3 4 5 12 11 10 09 08 07

For Steven, Laura, and Ken—
my shipmates on the inland sea

CONTENTS

CONTENTS

PREFACE

Handful of dust, you stagger me—
I did not dream the world was so full of the dead,
And the air I breathe so rich with the bewildering past.
 —from "A Handful of Dust," James Oppenheim

No single thing abides, but all things flow.
Fragment to fragment clings; the things thus grow
Until we know and name them. By degrees
They melt, and are no more the things we know.

Globed from the atoms, falling slow or swift
I see the suns, I see the systems lift
Their forms, and even the systems and their suns
Shall go back slowly to the eternal drift.
 —from "On the Nature of Things," Lucretius—about 60 BC

The hurricanes of 2005 blew enough of the white sand from the beaches of Florida's emerald coast to reveal the remains of a petrified forest, so if you walked along the beach in the spring, 2006, you saw bulldozers dredging the ocean and moving piles of snow-colored sand to cover up the crushed black peat.

So many layers of history lie beneath any landscape. A forest beneath an ocean. A sea that once covered the midlands. Everything constantly in flux.

Despite the fact that Indiana is a landlocked state, and I consider myself a Hoosier writer, when I think about Indiana, the image I seem to be most fascinated by is the image of the Midwest's vanished inland sea.

When I began writing essays and lectures about Indiana literary history and about the process of writing, I found myself returning to this idea in almost every piece in one way or another: to the inland sea as a specific

place reflected in the imagery of rivers and swampland and lakes, but also the inland sea as a metaphor for the landlocked imagination. A writer traverses this sea, still, by sailing: tacking and coming about while heading toward the undiscovered material she hopes to find while in the act of writing.

The essays on writers, writing, and the land collected in *Sailing the Inland Sea* range from interviews with Indiana writers Kurt Vonnegut, Scott Russell Sanders, Dan Wakefield, Marguerite Young, and Etheridge Knight, to discussions on techniques of writing, grounded in a Midwestern sensibility and illustrated by writers from Shakespeare to Flannery O'Connor and by anecdotes I've collected in my years co-directing the Butler University's Delbrook Visiting Writers Series. As the inland sea that is my Midwest is covered by more layers of history, it's my hope that one copy of this book might remain in some library and be found, years down the road, by someone who might say here's a tree rung, a bit of exposed ocean, a ghost ship, the record of what some writers said while sailing through this land, trying to make sense of it.

ACKNOWLEDGMENTS

"On the Banks of Lost River" and "River of Spirit" first appeared in *The Indianapolis Monthly*.

"Sacred Space in Ordinary Time" was published, in a slightly altered form, in *Falling Toward Grace: Images of Religion and Culture From the Heartland*.

"Quaker Zen" was published in *Nuvo Newsweekly*.

"Vonnegut," "Free Singers/Be," "On Wildness and Domesticity," and "The Gift of Fire" first appeared, in different form, in *Arts Indiana*.

"On Being Fierce" was delivered as a lecture at Butler University and Purdue University–Calumet.

"Sailing the Sea in New Harmony, Indiana" and "Monopoly Houses" were delivered as lectures at the Ropewalk Writers Conference in New Harmony, Indiana.

"Where's Iago?" "Saturation," "Time Capsules," and "The Apprenticeship of Flannery O'Connor" were first delivered as lectures at the Warren Wilson MFA Program for Writers; "Where's Iago?" later appeared in the book *Bringing the Devil to His Knees*.

"On Common Ground " was delivered as a lecture at the Indiana State Library and later appeared in *The Hopewell Review*.

I would like to thank all my students and colleagues for allowing me to test many of these ideas in conversation. I owe a particular debt to Aron Aji, Jim Watt, Marianne Boruch, Michael Martone, and Joe Trimmer.

Sailing the Inland Sea

ON THE BANKS OF LOST RIVER

It's a straight shot from Indianapolis to Lost River. Drive out of town, down Highway 37, past Bloomington, until you start to see the moonscape of limestone. First there's the Oliver Winery with its mini-Stonehenge, then the square stacked boulders of Bedford. You drive away from the swampy shoreline, remnants of an inland sea, veneered now with glacial drift. It seems important to try and imagine this as often as possible, to remember that our cars are always sailing on what used to be an ocean.

When I reach the town of Orleans at half past seven in the morning, people are milling around exactly where the Lost River website said to gather, on the southwest corner of the square. Tours of Lost River leave this corner three, and only three, times a year. You need the tour because you really couldn't find the river on your own. I'm surprised by the number of us. I wonder about our motivations for being here on this beautiful day, knowing it has nothing to do with gambling or with sin.

The tour will be a caravan of twenty cars, and we'll stay together all day, we're told, stopping every mile or so to get out and follow our guides. The woman in charge is wearing jeans and a sunflower shirt and a hat with a sunflower, and she's passing out folders and putting up maps on an easel.

She has a box of walkie-talkies, one for each car; we'll be like a moving drive-in movie. She seems fondly annoyed when a man walks into the middle of the crowd: in his early seventies, wearing a plaid shirt, suspenders, and fishing hat, he has an incredible fall-in-love-with-him-immediately smile. Carrying a baggie with a large moth inside, he takes individual tour-goers aside and talks right over the efficient woman with the sunflowers, telling each of us about the moth. He's like the clown who enters an audience in the middle of the straight man's talk. I decide he must be the efficient woman's dotty uncle.

Instead, it turns out they're a team and that he's anything but dotty. She's the organizer; he's the poet laureate and head explorer of the river. He's Bob Armstrong. She's Dee Slater. They're in-laws. He's a retired engineer from Naval Avionics, in love with this river since his days at Rose Poly in the '50s. She's an amateur geologist and a nurse who works full time at Pendleton Prison. I hope, she says, to never see you there.

Back and forth their conversation goes—Dee enthusiastic and earnest, Bob whimsical and smart—as more of us gather. A number of teachers, some young families, some young couples, a group of architecture students from Ball State, some women who grew up in the county and had left, a photographer, and a spelunking father-and-son team from Kentucky— wiry, hyper-alert and serious, they must be ex-Marines. Not the bulky type, but the sniper type, small enough to slither through tight caves.

We find out that we're not here just to see a disappearing river but a whole group of geological features that make up what's called a karst region. There are, it seems, several of these areas in the world, and we're relieved when we hear that this particular one is an important one. After all, we've driven all this way, it's early in the morning, and we're planning to devote an entire day of our lives to seeing it. It's a young karst region, still developing, and it has the greatest variety of features in the smallest area, we're told—a Disney World of karst. Geologists from all over the world come to study it, and Bob and Dee and other geologists, both professional and amateur, have devoted many days of their lives to its preservation.

What's a karst? a woman next to me asks, and I'm glad she does because I have no idea myself. It is, among other things, Bob and Dee explain, a place where water shapes the topography of the land from underneath the surface. Basically what we're going to be driving over, Dee says, is something like a limestone sponge where most of the drama is going on beneath the ground. Dangerous roaring rivers, unmapped pirated streams, caverns filled with water, endangered blind albino cavefish.

As I go through the day sometimes it will feel to me, a city person, like

I'm walking through mud to see mud, and I will have to call up this sense of mystery from the imagination.

Orange County, Indiana, has always been somewhat lost, and that has been its virtue. Although easy to find, it was, and is, almost impossible to drive to unintentionally. This lostness was a plus in the late 1890s and early 1900s when the dome in West Baden and its sister hotel in French Lick were built. It was a good place to hide Chicago's late-Victorian secrets—gambling, whiskey, weekend getaways, it was said, for Al Capone. Anything could happen under the guise of a trip to the legendary healing springs. In the 1890s, the twentieth century was already inside of everyone, an emerging double self, secret and shameful, and it needed a place to both express itself and hide. Orange County was the place. Las Vegas before Las Vegas. Whatever happened there stayed there, as the advertisements go.

It was in fact when Nevada legalized gambling in 1949 that Orange County began to flounder: becoming home to a hair museum, trying to sell its sulfurous water in bottles, and finding out that the thing that drew the crowds and the money wasn't the water after all. It never *had* been the water. It was the sin.

In the dome in West Baden, in particular, secrets were hidden in a building that should have stunned the shame right out of you—a building that, with its light, its tinted glass, its marble statues, and its gardens, could have been a church. The dome, two hundred feet tall, clear-span, was the largest in the world until the Astrodome was built and domes started popping up like they were nothing.

At one time there were 708 hotel rooms there, an indoor bicycle track, gangsters walking with their mistresses on the promenades. It was a spa, it was Oz, it was a grand casino. Much of what passed there was illegal. It was, in its day, the eighth man-made wonder of creation.

For years the building has been on the state's list of most-endangered buildings. Historic Landmarks of Indiana began a restoration, but the dome needed a new purpose. Orange County has the worst unemployment rate in Indiana, two of the most beautiful buildings, and arguably the most interesting topography. For a while arts groups tried holding concerts in the dome, but that wasn't enough to save it. It had, in its initial decline, housed both a circus and a school. Nothing holy would work. What was needed was more sin. What was needed, it was decided, was a return to gambling.

But in Indiana, gambling is allowed only on water—it must be confined inside a boat so it doesn't spread, Las Vegas-style, and contaminate the virtuous.

[3]

This is a kind of state-legislature-endorsed weirdness second only to the weirdness of the legislature's nineteenth-century attempt to redefine pi, rounding it upward so Indiana schoolchildren would find it easier to remember. In Indiana, circles would defy the laws of geometry in much the same way that the construction of the boat inside a swimming pool will defy the laws of common sense. Because in order to save French Lick and the Hotel at West Baden, the owners will have to build a moat to contain the gambling.

And this particular man-made lake will have to be totally sealed off from the ground. Because anyplace you'd build a pond in that landscape would be floating on land that itself floats on underground springs and streams and rivers. An unsealed lake would be an ecological disaster, sinking into a system of phreatic tubes and reappearing as something else, somewhere else, disappearing into a wormhole in space and time, like Lost River on whose invisible banks the new casino will be built.

In my drives through Indiana I'd seen signs for Lost River and had tried, unsuccessfully, to imagine it. The restoration of French Lick and the Hotel at West Baden reminded me of its existence. And so, out of curiosity, I decided to join other pilgrims in search of it: Indiana's Lost River.

The Marines drive a red pick-up and take up the rear, a position of protection they approach very seriously. Throughout the day the son will crouch near the edge of springs and strange swirling mud pits, keeping his eye on us all. When one of the university students drops his notebook in the river, the father will leap down the bank and retrieve it while the rest of us just watch it float.

As we begin to drive, the walkie-talkies so carefully numbered and distributed sputter and crackle; we're supposed to call out our car number if we can hear at all, and most of us can't, so the river-of-cars-as-drive-in-movie-theatre idea is abandoned. We'll just drive and stop and drive and stop and learn what we've seen or are seeing or would see if we had X-ray vision.

We drive past Amish windmills, down dirt roads where the dust rises so thick that it obscures our sight. They say that human beings are blind to the evils of their own time. On the "modern" farms, the hay is rolled, and the soon-to-be-discarded crust (where the hay has hardened on the outside of the roll), a bit of waste you'd never see on an Amish farm or a nineteenth-century one, already shines a blinding silver in the sun. Like disposable ballpoint pens, that crust, that lack of economy, somehow reminds me again of sin.

Our first stop is the Lost River Bridge by the Lost River Baptist church. Someone's written *Life Is Lost like the River* on the riveted green structure.

Lost River starts as ooze in a meadow, we're told, and ends up as a tribu-
tary of the White River. How does it start? It *just starts*, Dee says, beginning
as a trickle of acidic rain in a low region where it eats its way into cracks in
the limestone and then builds to a stream.

This is our first glimpse of the river, and it will be the only time it
looks like something you've seen before. At this point, it's perfectly clear
water, amber on the sunny side and chartreuse in the shade, like any
normal leafy stream. We're near the beginning of the river, downstream
from the cosmic ooze. It's pleasant to be out in the country on a summer
day. I could stand on this bridge for hours and dream. But we get in our
cars and drive again. Past limestone pillars on a wood frame house. Odd,
sweet-faced goats. A basketball goal facing the street. Wherever we go,
women come out on their porches to watch us. They know where they are.
They've always been here. This isn't a place meant for a river of cars, and
it's easier to imagine an underground river than a soon-to-be casino
owned by some multimillionaire like Donald Trump.

We drive past a farmhouse and turn right into a fallow field. We get
out and walk through weeds, following Bob, who, at seventy is in better
shape than any of us. We're looking for a swallow hole, a place in the
ground that gulps the river, where the river disappears. There are swallow
holes in Indiana, and I never knew there was such a thing in the world.

We find one, finally, and then another. It's like something from a bad
dream, a swirling pit of mud and debris where the thirsty limestone gulps
in the river and the river loses itself. It's gone. Underground. The door is
locked, will remain locked for miles, and you won't be able to see in.

Right before it goes under, there are timber rafts, what looks like a
solid raft of logs and sticks that you could walk across but which in fact is
an illusion covering a section of the river. Step on it, and you yourself will
disappear. This is where the spelunking marines are particularly cautious.
They watch the children. At the edge of the rafts the water swirls and drops
like water down a toilet.

Our next stop is by a wheat field, the wheat waist high. When you look
across a field of wheat up close, because of the spidery tips, you feel as
though your eyes are unfocused. Yellow pollen comes off on your fingers if
you touch it. We walk along the wheat to see the dry riverbed, to be
convinced and reminded that the holes have quite thoroughly drunk the
water in. I believe. For twenty miles, Bob says, the river's lost. Or rather, he
says, we won't be able to find it. Twenty miles. But still, he says, it's
underneath the surface, raging and dangerous. Even scuba divers can't go
into it. You can't hear it. You can't see it. You just know it's there.

When we leave the wheat field, he points out sinkholes in the land-scape, and I begin to see them everywhere. They're lunar craters the size of baseball diamonds that look like places where asteroids have hit in the middle of fields of corn. Perfectly round, like a gigantic mold of human breasts. In the center of the crater there's a small fissure in the limestone underneath, and the river uses it to drink in rainwater. Sometimes the fissure becomes plugged with debris and a round pond is formed, temporarily.

In this karst valley there's an acre of land that has over 1,000 sinkholes, Bob says. Now and then you read or hear about a tractor falling into one as the roof of a subterranean cavern collapses. One of the Ball State students has talked to a local woman who says the sinkholes appear and disappear, that once her family lost a cow who showed up, a week later, all covered with mud, leaving the family convinced she'd been swallowed by the earth and found a spot to breathe until the sinkhole coughed her up. Catastrophic collapses are rare in a karst region this young, so such stories may be the stuff of rural legend, but still: *How can you live in a place like this?* I ask someone, and he answers by saying he was baptized in Lost River.

You walk on faith here, Dee says.

We stop at an Amish farm for a break. The porch is filled with hand-woven baskets, hearth-baked bread. The mothers and aunts sell the goods. The fathers and uncles ride horse-drawn plows. The boys work in the fields wearing black brimmed hats. A beautiful, idyllic place. A quiet I'm not used to, living as I do in one of the country's largest cities.

We stay a while, and some of us shop, and when we leave the teenage girls come out to bring in the baskets. I wonder if they've had their rumspringa yet, if they're returnees or just getting ready to fly headlong into that year when they'll wear tank tops and talk on the phone, wild and free as any American teenager. Only a small percentage of them are lost to the faith when they do this, I'm told. Most return. I wonder what it is they see so clearly about the world the rest of us live in, what it is that drives them back.

At the corner of the farm I see an electrical generating plant, an eyesore. No wires connect it to the Amish buildings, but catty-corner to the farm is another home, from which comes a familiar noise. A man is cutting his small patch of grass with a riding mower while the Amish men quietly zigzag through their fields. There are wires attached to every corner of the lawnmower owner's house.

We stop at a graveyard. There are gravestones made of limestone, Bob points out, those blackened pitted-teeth gravestones that you see so often in

country cemeteries, where the names and dates begin to wear off and fade because limestone is, as he reminds us, so easily sculpted by any acid in the rain. Then he points to a headstone as old as the rest, or older, that is smooth as soap, the letters amazingly clear. Made of Orange County silt-stone, he says, a stone called Hindostan. All of the outcroppings of this particularly strong and beautiful stone, made from the extremely fine dust of quartz, are in Lost River valley. All of the outcroppings in the world. Whatever happened to make Hindostan happened in less than a decade, he says, and after that decade, it never appeared again. Geologically it was a small happening, both in time and in space. The stone is formed of thumbnail-sized striations, each one representing one lunar day.

Eventually the market, but not the stone, dried up. Of fourteen known quarries, the last one closed fifty years ago, Bob says. It was Indiana's first mineral export and now no one needs it because the stone can be duplicated synthetically.

We drive. We stop. We see a field of sinkholes. We imagine the raging river. We drive. We stop. We look out over the valley—about the size of the Grand Canyon, only more subtle, in the same way that the ponds and pools are mud-colored versions of the morning glory blues and emerald greens of Yellowstone.

When the river's lost, when the canyon's subtle, when the pools are the color of the earth, what you're left with is the imagination. You carry it with you, it disappears underneath your skin, and sometimes it erupts and frightens you.

We walk down a winding Dantean path to a bubbling mud-colored lake. The air by the lake is cold and clammy as the flu. It's cold because it's a gulf, a place where long ago the roof of a cavern collapsed. So not all the stories are apocryphal. While standing with the sky over our heads, we're actually standing in the chill of a cave. The swirls in the water are more swallow holes.

Without the timber rafts to cover them, they're creepy and particularly vicious-looking here. What we're seeing is a brief glimpse of the river that has been there all along, the mouth of a cave and the force that wants to pull it all back under. The cave on one end spews out water. The other end drinks it in. This is the weirdest place I've ever been. How long ago did the roof collapse? No one knows. Hundreds of years ago. People who lived here used to come down this winding path for picnics and shivarees. The same time mobsters were walking on the promenade at West Baden. In the clammy cold you feel like you can see all their ghosts. Their brief passion-filled lives, their eventual rest in the graveyard where most of the gravestones are made of limestone and their names have been erased.

Indiana caves, Dee says, are small and cold and wet and nasty. They open up to a big room every once in a while, something real pretty, but then they're back to being wet and cold. That's all there is.

I think again about the irrationality of building a false lake to hold a casino. I hear echoes of Jess, the character in Jessamyn West's Indiana novel *Friendly Persuasion* who describes life on the Muscatatuck River as "Swamps, ague, broken axles, meal turned bad, fords washed out, unmarked crossings, torrential downpours. And the forest so thick them days it was all like traveling in a cave."

When something seems illogical on the surface, there has to be a buried logic somewhere, perhaps something located deep in the collective memory of a place, in this case the ooze and muck of what was at one time a heavily forested and watery landscape.

A few years ago I taught a course on Indiana literature and the land. In preparation for the course I read every book by a Hoosier author, living or dead, in print or out, that I could get my hands on. I started with the creation legend of the Delaware Indians, the *Walam Olum,* and read up to the present. And I started collecting quotations from my reading. By the end, I had more than seven hundred notecards with quotations from Indiana writers in reference to nature, and there was a definite pattern to those passages.

We experience nature now in patches of mud or snow, in the sight of rivers as we cross over them on bridges, but primarily in sunlight and wind, in rain or the lack of it, in temperature, in the closeness of the sky. Nature that's primarily air, ungrounded, nature that represents flight and not decay.

But it wasn't always this way. From the *Walam Olum* and the early pioneer journals to *The Girl of the Limberlost* and *The Bears of Blue River* to *Going All the Way.* From the novels of Meredith Nicholson and Booth Tarkington and Jessamyn West, clear up to the present, the references give the same message: that the forests and sluggish swamp-like rivers were associated with both fecundity and evil. When someone in an Indiana novel commits a sin—John Shaughnessy's sexual encounter with Susannah in *Raintree County*—it's on the banks of a river. And afterward he or she is, often as not, swallowed up by water. A swamp, a swallow hole, a step onto a timber raft, a river you can't see.

All this fluidity was bothersome to our ancestors. The rivers, lakes, and swamps filled with cholera, the wet decay of forests, nature's amorality. *Small and wet and nasty.* It's a fluidity that oozes through in literary works, associated both with sin and, in many cases, the freedom to commit it.

[8]

Theodore Dreiser's story "Encounter" takes place on a "love boat" on the Ohio River, away from the "dry, sweltering heat of the city," a "picture of life and love" that was "taboo in the city." Dreiser's narrator sees this as "gayety and freedom" and is saddened by the cold rational retreat of the male partner into his loveless marriage, into "safety and sanity." A river is a place where you can *safely* sin.

So of course our grand cathedral to illegal gambling was built in a county filled with bubbling sulfur springs and sinkholes and a strange mysterious river. As it is in dreams, even the collective psyche of our legislature speaks in metaphor and symbol, and so we place what we sense is necessary but somehow believe is evil in its natural fitting environment. On the banks of Lost River.

The last stop on the tour is the Orangeville Rise, another boiling mass of water where Lost River makes a violent appearance through the mouth of a cave. Divers have gone into this rise, and they know that Lost River, even when it's lost, is deep. Over two hundred feet they've gone, pushing their oxygen tanks ahead of them before the river's rising pressure pushes them back up.

It's a thrilling place, filled with the pulse of water, with cracks and seams, with rocks shifting and changing shape, nothing really solid underneath your feet.

It occurs to me that we're only miles away from the spot where the new casino will be built, where the springs, even deeper than this river, drew gangsters and society a century ago to gamble, to drink illegal whiskey, and to take the waters. Waters that bubbled up from some hidden place beneath the placid midwestern plain.

So much of life lies hidden beneath the surface. As I stand on the banks of the Rise with the other pilgrims, I try to see downriver in the early evening fog. But it's like trying to see the future. From this point on, we're told, the water will make its own way toward the west, leaving behind its underground bed. But the river itself will always be lost, like the submerged psyche of a state. And like its sin will appear and reappear: mysterious, tempting, and forbidden.

WHERE THE LANDSCAPE MOVED LIKE WAVES

An Interview with Marguerite Young

Some years ago, I hit one of those discouraging spells where it seemed my fountain pen was slogging through mud. Not only did I feel my novel was going poorly; I couldn't see any reason for writing it at all.

It was during this period that I started dipping into *Miss MacIntosh, My Darling*. Whatever page I turned to, it seemed, a glorious wealth of words swooped out at me. I always went back to my own book feeling more hopeful, more aware of possibilities.

No wonder, then, I gave my wandering hero *Miss MacIntosh, My Darling* for his traveling companion. And no wonder, when I watched the movie version of my novel a few years later, I was so pleased to see the prop director's triumphant find nestled in the hero's suitcase: a genuine hardback copy of *Miss MacIntosh*, dear and faded and familiar among all the Hollywood glitter.

—Anne Tyler, on writing *The Accidental Tourist*

What dream among dreams is reality? Man is the creator of those values by which he lives and perhaps dies. They are not handed down from heaven, usually.

—Marguerite Young, *Angel in the Forest*

One summer when we were graduate students, my husband had an internship at a Veterans' Hospital in Danville, Illinois. For that whole summer we lived in a place where we knew no one, in an apartment in a house owned by a woman who painted every wall a dark moss green, a woman whom life had made so soft and inexact she seemed like bread dough that had risen too long and was about ready to fall back in upon itself. She was a woman of hobbies. She worked plastic needlepoint canvas and cracked marbles in her oven and glued them together into clusters of grapes. I think her name was Mina. She was a sweet woman, but I was irrationally terrified of her. You become an adult midwestern woman, I thought, and your life stops dead in its tracks. A sweet woman, very dear, and when we left Danville she ran out to our car and handed us some cracked-cat's-eye-marble grapes. They grew dusty in my closet, and when enough years had passed that I'd forgotten her, I threw them away. Which is what will happen, inevitably, to all her cracked glass fruit and crocheted potholders.

I hated living there. Our bedroom window in that house was five feet away from the drive-through window at an all-night Dairy Something. The summer jobs were already taken by the time we arrived, so I signed up for Manpower, worked sporadically, and most of the days and many of the nights—after someone would yell "Blackberry Shake!" to the deaf night-time clerk at the drive-in twenty times until we would wake up and yell back "He said Blackberry Shake! Please give this boy a Blackberry Shake!" and I would be unable to get back to sleep—I read. That was the summer of Anaïs Nin.

Years later, someone would name a perfume after Anaïs Nin, and I would ask a department store clerk in Richmond, Indiana, how to pronounce her name. That summer I had no idea. But I read every one of her published diaries. Instead of living in Danville, Illinois, I was living in Paris, in Nin's house with pale turquoise walls, lending my typewriter to the deadbeat Henry Miller. Now and then in the diaries a name, Marguerite Young, would appear, and something about Young's novel *Miss MacIntosh, My Darling*. By the time I finished the diaries and went on to Nin's book *The Novel of the Future*, I was ready to believe anything she said. And *The Novel of the Future* is, more than anything, an homage to this Ms. Young and to her book, which Nin called the greatest modern novel. "A writer like Marguerite Young," she wrote, "is as valuable as an explorer of unknown planets."

I couldn't find *Miss MacIntosh* that summer in the Danville library, or in any of the bookstores, but if you'd asked me what the greatest modern novel was I would have said *Miss MacIntosh, My Darling*. Because I *was*

her, Anaïs Nin, in the same way that I would become, later that summer, Virginia Woolf, my lungs breathing in their language to a far greater extent than the polluted air of Danville. Can you tell how young I was? Twenty-two, filled with the angst of being twenty-two, directionless I thought, fairly confused, a young woman hobbyist myself, and those books pulled one way—perhaps up and out—and Mina another—comfortably, lugubriously, murkily, down.

So I had to believe Anaïs Nin because I believed that the road to my salvation was language. And so imagine how excited I was to discover, a year or so later, that Marguerite Young was from, of all places, Indianapolis. And that her novel takes place in the Midwest. And that she'd written stories about Indianapolis, a book about New Harmony, one of my own obsessions, and later, a book about Terre Haute's Eugene Debs. And then to discover, as I began teaching at Butler University, that she was a graduate of Butler. If that were true, anything was possible.

When *Miss MacIntosh* was released in 1965 it was the subject of one of those huge spreads they used to print in *Life* magazine, back when a major new book was major news. People lined up on the streets of New York to buy the book, and there was a parade on Fifth Avenue, complete with rented buses and angels passing out champagne and playing trumpets.

The *New York Times* review by William Goyen called the novel "a work of stunning magnitude and beauty. Its force is cumulative; its method is amassment, as in the great styles of Joyce or Hermann Broch or Melville or Faulkner. . . . It is a masterwork." National Book Award winner Jerzy Kosinski called *Miss MacIntosh* a "novel of massive achievement." Critic Mark Van Doren wrote that "Marguerite Young's eloquence has no parallel among the novelists of our time." Writer Anna Balakian calls Young "one of the most innovative novelists of our time . . . to this part of the century what Gertrude Stein may have been to the beginning, but so much more human, more poetic, visionary."

Kurt Vonnegut said that Young is "unquestionably a genius." Truman Capote said "she was the one who taught us all." Because she taught the student—Paul Griffith—who became the teacher of Flannery O'Connor, O'Connor referred to her as her "dearest grand mere."

Although she was one of the grand dames of American letters, was one of the first and most influential teachers in the Iowa School, and though she had a profound influence on writers such as William Gass and Paul West and Anne Tyler; although there was a whole section of papers about her work delivered at the Modern Language Association annual meeting; although Sinclair Lewis, running into her in the Algonquin Hotel in New

York, called her his "favorite writer," and although the great mad poet Theodore Roethke fell in love with her at first sight in the Claypool Hotel (now the "old part" of the Omni Severin) in Indianapolis—all these wonderful stories—and although she's from Indianapolis, if you ask people who the finest Indiana writers are, her name is seldom mentioned.

She deserves better. In the pages of her books she's seen Indiana as the dream it is—the wonderfully strange, phantasmagoric people and places—and raised them to the level of myth. A whale in a boxcar, a small town full of people with ear trumpets (all of them deaf from malaria), hollyhocks in Indianapolis that came originally from Shakespeare's garden—she saw them, called them back into being. She's one of those writers who made Indiana possible as a subject matter, and was, perhaps, the finest prose stylist ever to come from this state. Her language is, from paragraph to paragraph, knock-your-socks-off stunning.

So a decade or so ago I was sitting in my office at Butler, and I decided to track her down. I'd seen an interview with her in the *Wall Street Journal* and knew she was still alive. I found an old phone number in New York and tried it for weeks, but it just rang and rang, and I gave up on that. Eventually, my search led to her new publisher, Dalkey Archive Press in Illinois.

Dalkey Archive is a press committed to keeping modernist classics (and new experimental work) in print, and they had recently released a reprint of *Angel in the Forest*, of *Miss MacIntosh*, as well as a new collection of essays and stories titled *Inviting the Muses*, and a fetschrift of essays celebrating Young titled *Marguerite, Our Darling*. From her editor I discovered that Marguerite was less than a mile away from my office, in her niece's home, recovering from an illness.

So I called her niece and over the next few months I stopped by, occasionally, to talk. When I first met her, Marguerite Young was eighty-five years old and frail, lying in a pink bedroom surrounded by dolls and Victorian crochet and her niece's artwork, but with a mind that still ranged over the universe, "the distance between Indianapolis and heaven being," she'd written, "shorter than the distance between Indianapolis and Cincinnati."

"My doctor sent me here," she told me, "because she said that, if I remained in New York, I would die." So, after all these years, she returned home. I talked with her in the pink bedroom and then in the room her niece and the niece's partner painted the same color of maraschino cherry red that Marguerite's Greenwich Village apartment had been painted, this new room filled with carousel horses and more of the famous collection of dolls. I talked with her in her room, and later, at the nursing home, where

the staff was fond of her but thought all her talk of being a writer was part of an old woman's ravings.

Because, I suppose, you didn't talk with Marguerite so much as you listened to her talk. She was a storyteller, going in and out of dream, in the always fascinating and hallucinatory way she wrote.

Marguerite Young wrote her first book, a collection of poetry titled *Prismatic Ground,* while she was teaching at Shortridge High School and living in a house at 16th and Penn.

While she grew up with the idea that it was her destiny to be a writer, a woman who lived in that house (and who wore a spare wig to keep her head warm, like Miss MacIntosh), "knew I had the true gift, helped give me the courage to believe in myself. She encouraged me never to conform. When poets would appear at the Art Museum, you weren't invited to attend unless you were a society woman. Miss Alexander told me to get dressed up and just walk in. To act like I belonged. And it worked."

She explained that "the person who arrived late on all those occasions was Booth Tarkington's sister. She talked so much about Terre Haute that we called her Hautey. She thought she was the resurrection of Cleopatra; there were two resurrections of Cleopatra in Indianapolis at the time. No matter who came—Edna St. Vincent Millay, whoever—she made no sensation like Hautey did."

Young has displayed a remarkable fidelity to her subject matter—to this place—the setting for her stories and novels. She spent over forty years on her biography of native son Eugene Debs. (A condensed and heavily-edited Debs biography was published posthumously: edited first by the niece's friend who sat at her bedside as she made changes in her last years and second by the editor at Knopf. There are one or two original copies of the manuscript, as she intended it, in existence.)

"It's by the deepest regionalism," she wrote, "that one becomes most unregional (surregional?)." But, she said to me, "if I had stayed in Indiana I would have been destroyed. It was a Victorian world then. There were families that were important. Recognition? I didn't get any. Anyone who has ever written a history of Indianapolis has left me out." And those who did recognize her gift often wanted her to change—"to leave the unconscious material out," she said, or to shorten her sentences.

She spent several years working on a biography of James Whitcomb Riley, which she abandoned, part of which shows up in the biography of Debs. They were great friends. "I wasn't interested in Riley's poetry," she explained, "but in the man. Riley thought he was the resurrection of Poe. He could be a complete phony, an actor." Riley, Marguerite said, "owned whorehouses, collected rent from them. Louis Untermeyer said 'you

know, when we're young we make fun of Riley, but he was always on the side of the angels. He was a pacifist. His life interested me. As did Debs. His project was a dream, a revolution. That's what fascinated me—that it's all a dream."

In her essay on Riley in *Inviting the Muses* Young writes that "for a man of his temperament, it was a serious thing not to be married, to walk alone. It was a serious thing also to be married, for if he were married, then how go fishing by so many streams of memory, how turn toward home? Should not his wife be rivaled by that greatest love, the past, the hand that was no more?"

In her own writing, and in her life, she expressed a boundless love for children, for her nieces and nephew and grandnieces and grandnephews. I asked her whether she felt that she had to make a choice between marriage and her writing.

"If I had married," she says, "I would have married the worst man I could have. I had poor judgment. I liked brilliant men. And I sensed that I had a gigantic genius, that a man would always be jealous."

She laughed. "The genius of a stupid fool. I should have written poems all along. The poems tell with lightning swiftness what I'm trying to say."

"Personally, I'm rather conventional. I had lovers. There was a time when I couldn't walk down the street without receiving two proposals. And I had all these fabulous intellectual friends." One of her closest friends, she said, had been Freud's physician. "He read every word I ever wrote. He gave me courage. He said that there are many roads to heaven and some of them are very strange. He told me I was a writer of the outside way. Avoid the middle way, he told me, and I did."

"Happiness?" she said. "I wouldn't give a nickel for happiness. Life comes from absorption in one's work."

When she taught at Shortridge, Vonnegut was in her homeroom. "He used to sit in a class," she remembered, "with a bottle of fireflies. He was doing an experiment. Vonnegut called me up when I was in Iowa and said 'I'm going to the University of Iowa and I would like to know if I can tell them that I studied with you.' Vonnegut's a brilliant man, more brilliant than his writing. I think that he will be remembered as a cult figure one hundred years from now. He told me once that he didn't want to write like me; he wanted to be popular."

Which Marguerite isn't. I tell her that I don't think I would have found her if it hadn't been for Anaïs Nin. "Yes," she says, "I had innumerable people find me that way. Anaïs was a most grateful person, and I did a great deal for her as well.

"She had two husbands you know, one on each coast. She asked me to come to California where her other husband lived and I said no, Anaïs, I love your husband and I don't want to see a part of your life that he doesn't know about. I think that something of Anaïs will always live—from the charm of her personality. She was a beautiful human being." And innocent finally, she explains, as was Henry Miller. Like many sensualists, they were ultimately cold, the sensuality being a way to get at the thing that for others comes more easily. Theirs was an innocence that Young feels she herself was able to avoid through a recognition of evil, something she didn't have to have two husbands and a boundless romanticism to hide from.

Or what she refers to as "the depleted sentimentality" that plagued midwestern writers. "There is nothing superficial about the Middle West," she writes in *Inviting the Muses,* "but a superficial, mediocre view of it. The Middle West is ultimately a wild, hazardous, romantic experience of the individual and human character in juxtaposition with the coldness of the universe—an experience made all the more wonderful by being invisible."

Young's second two books, *Angel in the Forest,* a lyrical history of New Harmony's utopias, and *A Moderate Fable,* were both nominated for awards from the National Academy of Arts and Letters—for best nonfiction book of the year and best collection of poetry, respectively. *A Moderate Fable* won, and she moved from Indianapolis to New York, where she became a fixture in Greenwich Village intellectual life, a teacher in the New School for Social Research, and a source of brilliant kaleidoscopic talk. And where she spent twenty years working on the 1,200-page prose epic *Miss MacIntosh, My Darling.*

Marguerite Young was a difficult writer, not at all a writer of the middle way. It's quite possible that, as Nin thought, her work is the work of the future, that it will become less difficult as we learn how to read it, that future generations will think we were idiots not to have recognized her genius while she was alive. Or maybe only academics will love her, or maybe her work will suffer the same fate—whatever that fate is—of other modernist texts, texts like *Ulysses* and *Finnegan's Wake.* Long, dense, lyrical, stream-of-consciousness prose that turns off the gatekeeper and was a reaction against cold reason and technology. It's a prose that lets absolutely everything in. Work that believes in the wisdom of the unconscious. Maybe she'll be considered one of the greatest poets of the twentieth century, or maybe a madwoman.

If you've never read her work, I'd start with *Inviting the Muses* and *Angel in the Forest* and then go on to *Miss MacIntosh,* the most difficult and

lengthy of the books. In fact, she says finally, it might have been easier on her readers, she might have been more popular, if she had published the book as a series of novellas.

And beware that nothing has a boundary in her work, that everything becomes and is everything else, that it's all dream and illusion. For Young nothing in life is fixed; life is all transformation and imagination, she writes, "even to the last tenth." In *Miss MacIntosh* she writes of a character who "was the divan, the mirror, the lamp, the rug, all of which might suddenly move away in the evening light, leaving a bare room. . . . She was everybody and the rose petal, too, the cause of this dissolution which was this creation, and she was the street lamp beaming through the fog like one great pearl, a sarcophagus enclosing the moon's flame. . . . And if she was everybody and everything, how could she be she and live, for what was her personal identity among so many transshifting objects and flickering shadows, and how should she walk where the landscape moved like waves?"

Miss MacIntosh loses parts of her body—her hair, a breast—and the central question of the novel, Marguerite says, "is not can you love me at first sight. It's can you love me at second sight. You are other than you seem. It's about illusion and variation and the depth of the psyche. Everything in the psyche is true. Every soul is given to shock and surprise as he sees another the way he is—beyond the mask, in the dream world."

Her obsession with illusion and dream causes her to populate her work with the most amazing lists of very real objects, all of them shaped by her imagination. As Mark Van Doren says, "No one sees the world as well as he who fears that nothing in it will be real." And she doesn't take sides. In his introduction to *Angel in the Forest,* Van Doren writes, "Was the angel there, or was George Rapp, this madman out of Germany, deluded? Miss Young allows the question to float without ever coming down." It's this description of the internal and external landscapes, history and the present co-existing, that lends her work its richness. "Belief in the normal," she says from her bed in her niece's house, "is nothing."

"William James was a great influence on me," she says. "The complete psychology—the stream of consciousness, what it is, and why it's a stream and not a track." Reason would like for it to be a track, would like to find pathways leading from one place to another. The linear pathways are, themselves, an illusion. And so her novel is organized more like spokes radiating out from the wheel of Miss MacIntosh. A visual metaphor of the novel might be one of those computer screen savers of fireworks where images, like sparks, explode from a central image and start fading just as another image sets off more sparks. Or a Cubist hypertext, the windows flattened onto one plane.

In fact, I've known readers who read the novel not linearly at all, from beginning to end, but dipped into it, went in different directions, savored paragraphs. The way that Anne Tyler read it while working on *The Accidental Tourist.*

"When you have examined all the illusions of life and know that there isn't any reality," Young said in an interview with Miriam Fuchs, "and know that there isn't any reality, but you nevertheless go on, then you are a mature human being. You accept the idea that it is all mask and illusion and that people are in disguise.

"All my writing is about the recognition that there is no single reality. But the beauty of it is that you nevertheless go on, walking towards utopia, which may not exist, on a bridge which might end before you reach the other side."

Young is the recording angel of the Heraclitean flux, and as such, is more compatible with the vision of twentieth-century physics than almost any writer I know." when the Rappites became all light and fire, how should the rose be golden. . . . Too many people, the world over, were basing their expectations upon something which, when they were no longer what they were, would be no longer what it was. A wheat field," she wrote in *Angel in the Forest,* "and much less God, does not come to us as an entity—but is many particles, is many sensations."

In her essay "The Midwest of Everywhere," she wrote, "I am in love with whatever is eccentric, devious, strange . . . and with life as an incalculable, a chaotic thing. . . ."

Genre didn't interest her. She started her non-fiction as a collection of poetry, and all the poetry is left in, in the paragraphs. "The poetry of nonfiction is as fabulous as any poetry you could ever write in fiction." Though there isn't a difference, she said, between nonfiction and fiction. "Everything is fiction. Even God is a fiction. Thirty or forty thousand years from now it will all be gone. No Milton. No Spender. Not even a memory of Shakespeare." This vision brings with it a vast freedom, if it's faced, Young said, without illusion or a closed system of eternal dogma.

So does it matter if you recognize the difference between a dream and waking life? She said it was crucial. "Sometimes the dream is real," she explained. "Sometimes the dream is a dream. Knowing this fact is the difference between being sane and being crazy. . . . If you understand hallucination and illusion, you don't blindly follow any leader."

Even in her eighties, and bedridden, Marguerite Young was surrounded by books and binders of paper, and she was still writing poetry, working on a new collection, "modeled on Browning's monologues," she

explained, at the rate of a poem a day. "I, Elizabeth Hardwicke. I, Maria Santos," she read. One day when I visited she was working on one about Eartha Kitt.

"The singer?" I asked.

"The singer." She told this fabulous story about Eartha Kitt's mother tying off her umbilical cord with silk and burying her under some dirt and a pile of leaves. Even Eartha Kitt's mother's mother didn't know she was pregnant. "But the grandmother knew something was wrong," Marguerite said, "and she went out into the forest where Eartha was buried.

"The grandmother crawled along the ground—carefully, carefully. There were leaves blowing everywhere, but she heard this voice and brushed the leaves away. And there was the baby underneath the earth."

"Where did you hear this story?" I asked.

"This is true," she said. "Not a story. I knew Eartha Kitt.

"When she went to sing at the White House, Mrs. Johnson was horrified. She carried some ashes in a kit, stood up and said 'Why are you in Vietnam? Why are you killing babies? What pleasure could it give to you? I was a baby in a grave myself.' They told her to leave.

"When I met her, she was dancing with Truman Capote. I'm writing about her now, and this is all in the poem."

The story had all the elements of Marguerite Young—the fabulous synchronicity, the miraculous cohesion, the magic realism. The repetition of kit, the double meanings. When you tell a story, I asked her, and you bring all the impressions in, what gives them coherence and meaning? You're not an anarchist, I said. "No," she said. "I'm a mirror."

So what gives meaning? Is it the psyche? Is it consciousness? Is there a symbolic coherence in the world? Does language do it for us?

"There's no meaning," she said. "But there's coherence in the work. Things do seem to make sense, over and over, in the world and in your writing. Because," she said, "you make it so. It's logic. In the realm of the surreal, the illogical is logic.

"Someone told Jane Owen that the angel's footprint in New Harmony wasn't real," she said. The angel Gabriel was supposed to have left a footprint above the Wabash River. "And Jane Owen had it removed," Marguerite said. "But she's wrong! The angel is real! He's as real as any angel ever was. All the great angels were created by someone. Jane didn't understand the relationship between angels and the unconscious. She seemed to think New Harmony was really there. Angels are the dreams of men," Marguerite said. "And as long as you're still dreaming, you're alive."

Everything is imagination, even to the last tenth. When the dream emerges into reality, when the luminosity of a dream is touching every

grass-blade, you have Marguerite Young's world. In "The Midwest of Everywhere" she wrote, "a mammoth hoot owl was seen flying around in different parts of Hoophole Township, New Harmony, Indiana. The owl, according to Charlie Chaffin, . . . was so large that some of the boys claimed it was equipped with a motor. It had a wingspread of about nine feet, three horns, was covered with a hard shell instead of feathers, carried a four-inch spur on each leg, had round green eyes, made a noise like a flat tire while flying and had a bell around his neck." Imagination is the thing that allows you to see miraculous fruit in cat's eye marbles and that, years later, allows you, if you're lucky, to grow into seeing something miraculous in that clacking dusty fruit.

The last time I went to visit Marguerite, it was early July. As far as you can get from winter. She was staying in a nursing home on the Westside for a few weeks. A hot cloudless day. I'd driven out there in a jeep with a good friend of mine, and as we drove, we sucked icy Hardee's Coke up through straws and tried not to think about the heat.

We talked to her for about two hours while my friend took pictures, and as she talked she grew more animated, and outside, in the world, the wind began to blow. The old woman in the bed next to her lay with her mouth open wider than any human mouth I've ever seen; she never moved, never spoke, but you could tell she was breathing. In the hall there was the glint and whirr of wheelchairs.

The window turned gray and dark with haze, like a theater scrim, and old men stood in front of television sets listening to the weather. "It's the end of the world," one old man said as the sky began to crash, and a young nurse led him back to his room. Marguerite was talking, and it was hard to hear her above the day's roaring. The middle of July. A summer storm, and rain was gushing in, soaking the floor in the room across the hall, dimming the electric lights, attendants running, and still Marguerite talked. About Chicago in the '30s. About her family. About Jung and William James and Kay Boyle. About her lovers, male and female. About the lover she gave up to another poet, saying he could marry the other but visit her on Tuesdays for the rest of her life. About James Riley and Booth Tarkington levitating the table during séances.

"What do you see?" she asked as we walked across the room to look out the window. A July day, with months of heat on either side of it.

"Ice," we said, "mounds and mounds. You can't believe it." It was flowing out of the gutters like foam.

She died soon after that, and was cremated. Her funeral was held at Washington Park Cemetery, and there were eleven people in attendance,

including the poet Jared Carter, Dan Carpenter from the *Indianapolis Star*, her family, and a few friends who'd flown in from New York.

The front row of seats was taken up by dolls, two of them hose-stuffed life sized dolls, the same size as the woman who had loved them, and it occurred to all of us how much the body in a casket has become a doll—unmoving—and why Rilke was so terrified of them.

"The soul," Marguerite wrote in *Angel in the Forest*, "when it retires within itself, is its own master of events. Only he who feels deeply can tell how the woodpecker becomes the unadulterated angel, how the sewer cleaner becomes a god—though such transitions, like that from all to nothingness, are always going on."

RIVER OF SPIRIT

An Interview with Dan Wakefield

Sometimes I heard the sudden thrash of a fish and saw the silver shape
flash in the dark in Nasim's hands, and then we pulled on to another spot,
moving in a slow, rhythmic cycle, like the very tides, like the earth itself,
as always, forever, in the long dream of life, and the time I had read about
in childhood stories of the Sea of Galilee was as real as the time of that
night and that water I moved across in the dark.

<div align="right">—Dan Wakefield, Returning</div>

From the very beginning, Indianapolis turned its back on this river.
Khaki-colored and sluggish, it never lived up to our expectations.

The river isn't navigable, which is to say that you can't, you *cannot*
move an ocean-going vessel along the surface. It's too shallow, too narrow,
and too inconsistent. It widens and narrows. It opens and closes like a
fish's gill. And we've never stopped sulking about it.

We built our houses facing away from the river, and our restaurants

and shops. We think of it as a completely utilitarian river now, a drainage ditch for industry and farms and spring rains, like a shunt that drains off excess fluid from a swollen knee.

I've kept my distance.

This past summer Dan Wakefield called from Florida and asked if I'd like to join him and a few other friends for a cruise on the river. He'd won the cruise at an auction. A cruise on White River? You've got to be kidding.

It was August, unrelentingly humid and hot, swamp weather, and I imagined the river as its epicenter, filled with mosquitoes and strange odors.

But the company was good and it was only a two-hour ride and he was enthusiastic and his laugh is always infectious. And it made *me* laugh each time I'd say I was going on a cruise down the White River and that we'd even be stopping at the Yacht Club, which is, I learn, something like a small town Eagles Lodge reachable by the most un-yacht-like boats possible— rowboats and canoes and kayaks and Ski-Doos and the occasional pontoon. There's something incredibly midwestern-populist about calling the place a Yacht Club, so I say sure, I'd love to. Though when the day arrives, I wonder what I've gotten myself into.

The host looks like a captain, with a beard and captain's hat. The hostess has short blonde hair and has just run in a triathlon. They're charming and smart and if the river is unhealthy, it hasn't seemed to hurt them. They've brought beer and wine and soft drinks. It will be an hour from their home at 79th Street down to Broad Ripple, near 62nd, and another hour back.

There are seven of us on the boat. Jane Rulon, head of the Indiana Film Commission; Cathy Gibson, director of adult services at the Indianapolis Marion County Public Library; the architect Evans Woollen, Dan, our hosts, and myself.

The air is surprisingly cool out on the water. There's a maritime feel to it. How surprising it is to find that there are some houses with their faces turned toward it, to see children floating on inner tubes and teenagers riding jet skis, to think about how most of the population of the city is sweltering now, complaining about being landlocked when in fact it isn't completely. It has this river—murky, in need of a lot of work, but available. It's just become, from inattention, both broken and invisible. It seems to be a real river, not simply a shadow of its *real* self, which is, we'd thought, some Platonic ideal gone askew, the river it would be if it were only located someplace else.

Just a few days earlier Dan moved from one apartment to another, and it was, he explains, "unhinging."

"But as soon as I came here," he says, "I was fine. It made me feel better to be here."

"This place," Dan says, referring to the place we're gliding through, "it's mysterious because it's a place of power for me. It doesn't seem to have anything to recommend it, but when I was growing up here, it was the center of the universe."

Sometimes it takes someone who's been unhinged, and often, to help you reconnect to the things you've been unhinged by or stopped seeing altogether. "Watching the scattered lights of isolated farmhouses shining like beacons across the fields," he wrote in *Returning*, "we moved through the land I could love perhaps for the first time now that I was leaving it." By the end of the cruise, we'll all be grateful for the way we've been brought back to the place we thought we'd never left.

The basic existential question for anyone born in any provincial city is, as Sonny says in Wakefield's novel *Going All the Way*, "Are you one of those who stays or one of those who goes?"

Wakefield is one of those who went. Dan left Indiana when he left for college, and he hasn't stopped moving—to Columbia University in Boston, to New York City in the '50s, to Los Angeles to write for television, back to Boston, and then to Miami. The rest of us on this trip are ones who stayed. When you stay, there's always the sense that you've deliberately placed yourself outside of history. When you leave, there's always the sense that you've left something essential behind.

What I'm struck by on this trip is how much I admire the people who happen to be floating along this river with me as well as how connected we are—to each other and to the place. It was Cathy who brought Dan to Indianapolis to read at the library, a visit he chronicles in *Returning*. That was the first time I ever saw him, reading a section from *Under the Apple Tree*, and I got that shiver of recognition when I read about the day in *Returning*, a book that is about the return to faith but also about the return to and affirmation of the imaginative space of his childhood.

The connections. There's Jane, who grew up in Indianapolis as well and helped orchestrate the making of Wakefield's novel *Going All the Way* into a film.

And Evans, the brother of one of Dan's high school girlfriends, the son of the couple who appear in *Returning* on the train for New York—the most sophisticated couple in Indianapolis at the time, Wakefield thought, the couple who told him it was alright to be heading east to school, despite his parents' fears.

Evans points out a house on shore that was designed by Kurt Vonne-

gut's grandfather. The last time he was here, Vonnegut, himself a native Hoosier, said how proud he was that Evans had chosen to live in his, Kurt's, childhood home because his grandfather had designed that as well. My own great-grandfather was the head carpenter for the Atheneum, a building that Vonnegut designed. In a larger city, you might be amazed by six degrees of separation, but here in a provincial capital there are no degrees at all. No wonder you have to leave if you want to be anything different than what people expect you to be.

As Wakefield says in his book *New York in the 50s,* quoting Joyce's Stephen Daedalus writers' vow to live a life of silence, exile, and cunning, " 'Exile' was the place far enough from the censure of home and middle-class convention to feel free enough to create." Dan's ultimate concern has been that freedom to create—fiction, nonfiction, himself.

> I cannot pinpoint any particular time when I suddenly believed in God again. I only know that such belief came to seem as natural as for all but a few stray moments of twenty-five or more years before, it had been inconceivable.
>
> —Dan Wakefield, *Returning*

Wakefield describes his return to faith as a "turning." It was "as if I'd been walking in one direction and then, in response to some inner pull, I turned."

One of the things I've always been struck by in his fiction is his characters' passion for this life, their bedrock innocence, and their sense that there's "something else" even when things are going as well as they possibly can. Even when the path has seemed to be a non-spiritual one, it has been, in fact, all the same path, one that has been shaped, ultimately, by spiritual concerns.

What shapes the experience, in all of his books, is an honest seeking of the truth, even when that means finding it in difficult places. When you turn away from God and toward truth, a theologian wrote, you fall into the arms of God.

Earlier in the day, I'd met with Dan in the Abbey Coffeehouse in Broad Ripple, to talk to him about his new book *How Do We Know When It's God?* He describes, in both *Returning* and this newer book, a mystical experience he had right here in Broad Ripple at the age of nine: "I feel or sense—I experience—my whole body filling with light," he writes. "The light is white and so bright that it seems almost silver. It is not accompanied by any voice or sound, but I know quite clearly the light is Christ, the presence of Jesus Christ. I am not transported anywhere, I am all the

time in my room at the top of the stairs in our house at 6129 Winthrop, Indianapolis, Indiana, a place as familiar as my own hand. . . . The light is not frightening to me as a child, but reassuring, like a blessing. It is so real that in fact it seems today like the very bedrock of my existence."

For a while he turned his back on the experience. In the atmosphere of Columbia University and New York in the '50s, he discovered "the dogma of despair." He became, he writes, "a newly minted intellectual atheist . . . adamant in my rejection of the religion I grew up with."

An intellectual atheist, but that early work is filled with references to spirituality, which he finds in nature and in the modernist substitution of the artist and the analyst for the priest. Analysis, he writes "was the Silent Generation turned inward, rather than expressing itself through political action. It seemed like the alternatives were going into the corporate world or going on the road. It was psychiatry as the force of power of change rather than God."

One of my favorite passages in *New York in the 50s,* in fact, describes the Woody Allen dreamscape of New York during the heyday of analysis: "The interpreters of dreams (like Joseph in the Old Testament, except with medical degrees) all had their offices on Madison or Park or Fifth Avenue between 60th and 90th streets, on the Upper East Side of Manhattan, and the sky above that area was like a whole traffic jam of dreams. It was there people lay on long black couches, telling their dreams to the experts who sat behind them in leather chairs, and I imagined the dreams then drifted into the air above those buildings and bumped into all the other dreams emanating from the analysts' offices as thick as factory smoke until they were crowded off into space and finally disappeared because the earth's atmosphere over the Upper East Side of Manhattan simply could hold no more dreams."

When he and his friends would get together, they'd tell each other their dreams. "You wanted the damn things to get their due, wanted some other sensitive, perceptive person to acknowledge the cleverness and complexity of the mind that dreamed it."

In passages like the above, Wakefield proves himself to be an astute reporter of the times he lives in, "conspicuous," as Robert Phelps wrote of him in the New York Times, "for the right detail, the gesture or glance which can tell more than a thousand words of interpretation." There is, Phelps writes, an "expense of spirit" in every page of Wakefield's journalism and fiction.

An *expense* of spirit, paid for in the currency of honesty and courage.

"One balmy spring morning in Hollywood," Wakefield begins *Return-*

ing, "a month or so before my forth-eighth birthday, I woke up scream-ing." He'd gone to Hollywood to write a television series, *James at Fifteen,* an experience he explores novelistically in *Selling Out.* He had "tried to forget about Hollywood by starting a new novel," but the room he worked in was "next to the swimming pool and the service people who came to test the chlorine were unemployed actors discussing casting calls, making it hard to concentrate; besides, the damp seeped into the pages and stiff-ened them, giving the manuscript the texture of corpse."

The texture of corpse—an amazing image, both tactically and emo-tionally accurate. It's this image, more than any other, that serves as a metaphor for Wakefield's experience in Hollywood, the image that defines the spiritual death that begins his return back home.

Faith is, as Wakefield's minister says in *Returning,* elliptical. "By 'ellip-tical'" Wakefield writes, "he meant that the spiritual path was not a straight line, that at times we moved away from the God we searched for as surely as we moved back again toward Him, and the periods of feeling remote and out of touch were not aberrations or indications that our faith was not 'real' but rather were a natural part of the journey."

Wakefield began *How Do We Know When It's God* because he realized it had been a decade since he wrote *Returning* and that many readers saw that as the happy ending to that particular narrative arc. Boy gets religion. Boy loses religion. Boy gets religion back and lives happily ever after.

But *Returning,* he says in the Abbey Coffeehouse, "was about the first flush of rediscovering faith. . . , the honeymoon. And it's not fair to leave it like that. The thing I've always objected to in writing about spiritual experience is making it seem easy," he says. "There's something I like about Anne Lamott. She's even worse than I am. She tells about her past drunk-enness and broken relationships and bad mistakes. I always resented that Alan Watts never wrote about having to drink all the time.

"It's not the bottle that's the travesty," he says, "It's not *talking* about the bottle."

And so, in this latest book, he talks about the bottle. He talks about taking antidepressants, he talks about the pain he's been responsible for in relationships, about a failed marriage. "I want to tell now of the spiritual journey as it looks over the long haul," he writes, "not just the first flush of rediscovery, and speak as honestly as I can of the pitfalls as well as the peaks of such experience."

Later in the afternoon, as we floated along the river as though it were a real river, I would learn that Evans, architect of Clowes Hall, the building

I'd last seen Dan speak in, was the great-grandson of the man, Samuel Merrill, who first came to this part of the state and decided that it would make a fine capital. It was a rational decision, Evans said, it was spring, and at the time the river was swollen and seemed navigable. Maybe you'd have to widen it here and there, build a canal, but it seemed a good place for a capital, and the legislature settled on it.

The decisions that Wakefield describes in *How Do We Know When It's God*, all "post-conversion decisions," were still difficult ones and often destructive. Many of the decisions seem to be, like the placement of this city, rational ones. Marriage is good. I'm a good person now. I should marry my childhood sweetheart, so I will. And he does, briefly. The marriage chapter, in fact, was the most difficult to write. The entire book, he says, "was harder to organize than any other."

But, as he quotes William James, "the universe takes a turn genuine for the worse or for the better in preparation as each of us fulfills or evades God's demands." Wakefield's deity is a personal one, a hand pushing from one side or another as he starts to wobble and fall in the wrong direction, manifesting Him or Herself in instinct. "Part of the understanding of the book," he says, "is that the best knowledge is in the body and not the mind."

Rather than an anxiety caused by metaphysical uncertainty, as it was in his earlier books, the anxiety in this book is ethical and epistemological. How do we *know*? How do we *act*? Why am I still, eternally, so *unfinished*?

How do we know? "A spiritual experience feels as though you're doing the right thing at the right time," he says. "I feel as though it would be pretentious to say that it's God's will, but to go against that inner knowing," he explains, "is crazy."

Do you learn anything from one book to the next? "In the beginning they're all the same in that beginning them is the hardest thing in the world and once you're into them it's exciting. With novels, once you get past the halfway point it's as though they're writing themselves.

"But books are in the end always different," he says. "They're all different because there are different circumstances in your life.

"But what I want to say is that the fact that you make mistakes doesn't mean you're not a Christian."

Is there another autobiography in his future? "I don't want to do this ever again," he says. "With this one, I feel that I've wrenched the last blood out of the turnip. I have a novel in mind that I want to do. I have several novels. I don't want to write out of my self, out of my confessional self, again."

Though any book he writes, he says, will be religious. "A book isn't

religious because it's about religion," he tells me. "It's religious if it tells the truth."

Physicist Philip Morrison of MIT describes our universe as a place that, from the atom to the cell to the galaxies, seems to have a fondness for the two-beat rhythm. Visually, there's darkness and then light and then darkness. There's the nucleus of an atom and then the void and then the swirling electrons. There are skins of walls of swirling iridescent galaxies and then 300 million light-year voids and then more iridescence. Galaxies draw toward structure, it seems, and away from the voids that separate them.

Floating on the river, even the landscape seems to have been created by human beings to reflect this universal rhythm. There are the clusters of houses and then the wildness and then, once again, the houses and finally, always, the wildness. "When I look back over the long haul," Wakefield says, "I wouldn't trade the return to faith for anything." His life has followed this same two-beat structure which seems to be, as well, a spiritual one: Light then darkness then light then darkness and then light again, all of it as elliptical as this river journey, as our relationship to this place.

In three hours the trip will end and we'll all disperse. And I'll spend a lot of time thinking about the mystery of the river. Thinking about friendship and isolation, about language and silence, about exile and return. Thinking about the courage it takes to set out on any journey. Being grateful for words and stories that call us back to things we lose along the way.

SACRED SPACE IN
ORDINARY TIME

I'm beginning to feel the drunkenness that this agitated, tumultuous life plunges you into. With such a multitude of objects passing before my eyes, I'm getting dizzy. Of all the things that strike me, there is none that holds my heart, yet all of them together disturb my feelings, so that I forget what I am and who I belong to.

—Rousseau, *The New Eloise*

Like a deer that longs for running streams, my soul longs for you my God. My soul is thirsting for the living God.

—Psalm 42, excerpted from the liturgy, September 10,
the 23rd Sunday in Ordinary Time

Sunday, September 10, 1995. The 23rd Sunday of the year. It's the opening weekend of the Circle Centre Mall in Indianapolis, and the streets downtown are clotted with cars, the sidewalks with families, their faces tilted

like rows of teacups toward the green glass of the Artsgarden and the elevated walkways. The glass is that lovely clear green of both pop bottles and a certain kind of volcanic rock. Not quite the fresh green of new leaves; this is a bluer green, inspiring a comfortable sun-lit awe, an all's-right-with-the-world awe, the awe you give to an always benevolent and easy-going God.

Isn't this a sacred space? All those steps leading up from the street like stairways to heaven! No matter what you might *think* you should feel about sacred structures, doesn't all this *really feel* sacred on this day? Did those old women and old men in their Sunday clothes emerging into the light from the darkness of their downtown mainstream churches have any more glorious an experience? None of this was here a few years ago and now, mysteriously, it's here right in front of you! These cathedrals of glass and stone!

Inside the mall there are young men standing on platforms with black virtual reality masks over their eyes and toy guns in their hands. They stand almost motionless except for a slight twitch in the arms or an almost invisible weaving of the body, though you know they feel themselves standing in a military landscape, their heads filled with loud cracks and ratcheting gunfire, with all the bright colors and geometric patterns of hallucination. The people sitting at tables and on benches watching them, in fact, remind you of the crowds you've read about, the ones that used to gather at the dockside to watch the "ships of fools" in medieval Europe—ships filled with psychotics who entertained the locals with their madness in the way that show boats used to bring theater to towns along the Ohio River. But the entertainment level in the mall is a nice escape from all the objects, the glittering red bottles of cologne and the 200,000 shoes and the cast members in the Disney Store bemoaning that California has set their computers' clocks to "whatever time it is they think Indiana's on but isn't" and waiting to sing "Now it's time to say goodbye to all our company" to the shoppers at closing time. The mall is exciting in its way, but there is almost too much of it, and you for some reason feel this restless agitation you often feel when you spend too much time in a mall or in front of the television. You see the same agitation in the children starting to whine and pull at their parents' hands, in the anxious lines of shoppers at the escalators. You realize that something is being desperately sought here and not quite being found.

According to the author of *Hoosier Faiths*, L. C. Rudolph, on any given weekend almost 2 million people in Indiana attend one of more than 10,000 places of worship. And still, theologians write, the most authentic religious experience in relation to sacred space, in modern times, is home-

sickness. The sense that we're cut off from something essential. That feeling that we've left something behind. So on this Sunday, in order to determine what it is we've lost, I decide to go to as many church services and sacred spots as I can in one day.

Outside, between the mall and the Pan Am Plaza and the RCA Dome, sits St. John's Catholic Church, designed by the architect D. A. Bohlen; it's been standing here since 1837. The exterior style is romanesque, early gothic, a simple brick with tall towers. The church is dwarfed by parking garages now and impossible to see if you're walking west on Georgia Street, and it emerges in your line of vision at the same time as the stadium, where the church is dwarfed by the stadium's dome, all white and billowing like a sheet on the line in the late-summer glare.

It's Sunday, and parking spaces are at a premium, but the church's parking lot is empty. It's two hours after mass, but people respect the "church parking only" sign even on this day when downtown spaces are rare, and this is a prime location.

Inside St. John's, the altar is placed on the east side, as are the altars in European cathedrals, to catch the morning sun and to face Jerusalem. But the large window above the altar went dark when the parking garage next door was built, and now there's a perpetual spotlight on the garage's exterior to supply artificial sunlight and illuminate the figures in the colored glass so the parishioners can see them on Sunday morning.

All sacred space becomes, finally, almost by definition, contested space, space worth fighting for.

How can I explain how mysteriously beautiful the inside of St. John's is, skeptic that I am. It's impossible, William James would say; like all *true* experiences of the sacred, it's ineffable, beyond words. But the feeling resides in the architecture itself, and in the perpetual glittering of hundreds of red and gold and silver candles, bubbling like fireflies, each tiny flame representing a departed soul that someone living wants remembered. And in the mystery of the priest, buried in the floor of the church, who was born in France in 1815 and died in Indianapolis, a pioneer, "in the hope of a blessed immortality." The stained glass windows are deep blood red and cobalt blue, and statues and altars line the walls.

What makes architectural space sacred? When I drove through Batesville a few weeks ago, there was a white frame church with beautiful stained glass windows and a Talk to Tucker sign in the front yard. There's another old church for sale on Highway 31 North, near South Bend, stained glass still intact on the first and second floors, plywood covering the circular hole in the bell tower where a window once was, like a patch on an eye gone dark. When the insurance company or real estate agency

that buys it moves in, will these buildings continue to be sacred? At what precise moment will they stop being so, or have they already been profaned by the sign itself? Or were they profaned earlier, when the human beings who built them stopped honoring the place with their rituals?

In Indiana, sacred space seems to be fluid like this, and our sacred places are almost exclusively architectural. Maybe it's because this is a landscape that's been changed so completely by human hands. And the natural features, the dense forests and swampland that might have resonated with non-human power, have been erased. In Greece, for instance, you can tell when you're nearing the temple of a god because of the feeling that's engendered by the landscape, the particular view of the ocean or mountains letting you know that you've arrived.

But architecture plays chords of feeling as well. It's lyrical and, like lyrical poetry, it exists to praise something in particular. It engenders feeling because it begins with feeling. A particular type of building causes particular emotional strings to resonate, and as long as that building stands, it will continue to play its own particular music in the human heart. And it's an art that both captures space for a particular use and serves as a living historical document.

I suppose that one question you need to answer when trying to define sacred space is the question Frost asks about fences. What are you walling in or walling out? In the case of the mall, what's being celebrated is the marketplace, and the feeling is an agitated desire to buy. The history that's recorded in its style is late twentieth-century postmodernism. Past styles are alluded to in fragments—in the facades of storefronts and in the old Ayres clock—but it's all pastiche, a mask, a borrowing from different styles and different times, covering what is in fact a shell of the standard Nordstrom's, like a McDonald's that has an airplane for Henry County's Wilbur Wright but is, inside, the same McDonald's you'd get in any city.

In the case of a church or synagogue or mound or mosque, the feeling is mystery and awe and grandeur and faith, something invisible, like a ghost, that some group of people at one time or another thought important enough to throw a sheet over, a sheet made of stone and glass and earth, to show that it was there. It may not rise from the landscape itself in Indiana, but from the human heart.

The definition of the sacred, at the end of the twentieth century, is as contested as the space itself. The theologian most well known for his work on sacred space and time, Mircea Eliade, writes that sacred space is something that mediates between realities, and that it is a manifestation of the "real," the ultimate non-contingent reality. In other words, that there is in fact something sacred at the heart of the sacred. But historians David

Chidester and Edward T. Linenthal argue that, rather than being a manifestation of the uncanny, of ultimate meaning, sacred space is an empty signifier, a symbol that's nothing more than a bowl that human beings fill with significance and expressions of power, and that something is most sacred when it's "at risk of being stolen, sacred if it can be defiled."

To live in the twentieth century, according to historian Marshall Berman, is to live "in the thrill and dread of a world in which 'all that is solid melts into air.'" We are, Mexican Nobel prize winning poet Octavio Paz explains, a society "cut off from the past and continually hurtling forward at such a dizzy pace that it cannot take root, that it merely survives from one day to the next: it is unable to return to its beginnings and thus recover its powers of renewal."

Another Sunday morning in Indianapolis, ordinary times. Model T drivers are driving their Model T's in a row along Kessler Boulevard. At the bagel shop in Broad Ripple there are young couples with new infants, their skin and hair as soft as what? As infants' skin and hair.

At the Spiritualist Church, ten minutes before the healing service, a woman in knit pants and T-shirt bends over to pick a weed out of the garden.

At the Broad Ripple Baptist Church elderly women with pastel blouses talk in the parking lot. Every day the phone lines blaze between them. In the sun their hair is as fiery white as the floodlights on the altar.

In the gothic cathedral of Second Presbyterian, the early service is in the chapel, and it's packed. The men wear jackets even on this hot summer day, and the women are chips of stained glass in red and turquoise linen.

This is Henry Ward Beecher's former church. His wife, Eunice White Beecher, wrote an angry novel, *From Dawn to Daylight*, about a frontier preacher's family who was never paid by their congregation. Second Presbyterian, thinly disguised. There's a scene in the novel when the preacher's sister, a famous novelist, Harriet Beecher Stowe thinly disguised, pays a visit to the frontier home. The book was, for a time, removed from the shelves of the Indianapolis Public Library.

Beecher wrote *From Dawn to Daylight* when Indianapolis was a swamp and horses sometimes walked through mud up to their necks. She didn't understand the frontier attitude toward paying preachers, that it was considered vaguely sinful. This was a gift and barter economy, and in the best of all possible worlds you paid money for something only when there was no human connection between you and the person being paid.

This morning at Second Presbyterian someone's watch beeps the time as the minister gives his sermon. The cybernetic revolution has come, he

says, like a thief in the night. Our creator, he explains, has given us a choice to program the computers of our souls to bless him or curse him. (You're living, my 90-year-old aunt explained to me the night before as she described trying to get through a voice mail tree at Methodist Hospital, in a terrible, terrible, time.)

At Allisonville Christian Church they're saying goodbye to the old sanctuary and blessing the new one. For months workers have built the new sanctuary: hammering, glazing windows, placing the new steeple. The new roof blazes copper. The old sanctuary is blue, like water, and without the pews and flowers smells musty. We give you thanks, the minister says as he walks us from the old space to the new, for dreams that harden into steel and stone and mortar.

The point of the sermons at the conservative Reverend Greg Dixon's Baptist Temple (where you can buy "How and Why to Form Your Own Militia" pamphlets in the lobby) and the liberal All Souls Unitarian (You can be a Christian Unitarian, someone explains to me, or a Buddhist Unitarian, or an Emersonian Unitarian, or even a pagan Unitarian) are strangely similar. This is a time of groupthink, we're told, and these places are the last bastions of free thought. The style of the sermons is different, of course, the syntax and word choice, the examples, the intonation. But the message, on this day, is the same. You could attribute it to synchronicity, to the collective unconscious. But I decide that it's because both Baptists and Unitarians love ideas, albeit different ones, and they both have a deep wish for utopian perfectibility somewhere out there in the future, albeit different utopias and different futures.

The first Protestant church in Indiana, in fact, was a Baptist church. And what was appealing to pioneers about the Baptist faith was its sense of independence. Since there was no direct authority, no human authority, beyond the word of God, settlers could "personally use the Bible as a direct guide to reconstitute the pure apostolic church at any time or place." For the non-doctrinaire Unitarian, there is no authority beyond the individual's own most quiet inner voice.

Tell your stories, a former minister, HIV positive, says to a congregation of men and women with AIDS. Your stories are sacred. Make people call you by name. This process, he says, going through hell and coming out the other side, has a name as well. It's resurrection. To love another person is to see the face of God.

At the downtown Spiritualist Church, there's a small gathering. I imagine what it must have been like in the late nineteenth century when

there was that resurgence of interest in the occult, in the belief in a permeable door between the world of the living and the world of the dead.

The Spiritualist Camp Chesterfield, north of Indianapolis, was founded in 1888, and New Harmony's Robert Dale Owen published his autobiography, *Threading My Way*, in which he recounts his conversion to Spiritualism, in 1874. In 1883, in Indianapolis, Booth Tarkington's sister, Haute, discovered she had a gift for levitating tables, a gift that disappeared, along with her singing voice, when she married.

For fifteen minutes there's a brief service with old-fashioned hymns and a sermon. On the altar there are white candles in tall glasses like milk. "In the name of Christ," a woman prays, "we come to you for healing." After this, an unusual part of the service begins. The three mediums give their messages to each member in the congregation. "As I come to you I'm seeing: daisies, gilt-edged, almost an artificial look; a syringe, a Bavarian building with cobblestones, white baked bread, a pinwheel off center." Mediums are poets and they deliver their messages from the dead in the language of metaphor.

I drive south of the city to the Jewish Cemetery, space purchased by the Indianapolis Hebrew Congregation in 1858 for $125. Until 1824 "not a single congregation (of Jews) existed within 500 miles of Cincinnati." But by 1859 there was a population of 3,000 Jews in Indiana, primarily spurred by German and then Eastern European migration. The cemetery's stones are close together, and in front of each stone there's something like the foundation of a house bordering the plot. And within the foundation, piles of other stones commemorating the life of the dead.

The feeling here is of something singular, solid, and everlasting as granite. Unlike flowers, stones endure, they're bedrock, and when a mourner brings one stone and places it by or on top of another there's a community of mourners stretching across space and back through time.

Next to the Jewish cemetery is St. Joseph's Catholic cemetery. You drive in the front gate off of Meridian thinking nothing much different here, no stones shaped like tree trunks or dollhouses, no stones leaning one way from military target practice, as there are in Bartholomew County. But then you reach the top of the hill and make a right and, like the Jewish cemetery, you're once again in a world of stone, the fluid universe all hardened and fixed. Both cemeteries are almost terrifyingly holy. This is death. This is what you can count on. A sign tells us that this is "a resting place until the day of resurrection for the bodies . . . once temples of the holy spirit whose souls are now with God."

The stones here are tall with thick pale crosses, and you get a sense of movement, strangely, the white rock crosses on top of the monuments like

a large flock of birds taking off at once, with you standing in the center. And at your feet row after row of nineteenth-century nuns and priests. German, many of them. *Heir ruchet in Gott.*

I end up at the grave of a Brother Mark Schaefer, 1841–1905, and I feel a chill. Schaefer is my father and brother's name, my childhood name, same spelling; the family has been in this city for generations, and this could be a relative.

My grandparents, Schaefers, went to Zion Evangelical, the German church across from the Murat Shrine, and once, as an adult, my brother went there on a whim and said that he was immediately surrounded by great aunts who greeted him without surprise, as though he'd never left, even though he'd never been there. I had the same experience everywhere I went. People I hadn't seen in years—my cousin's mother-in-law, my fifth grade teacher, retired professors from Butler, second and third cousins, grade-school friends with their now grade-school-aged children. Even here, at St. Joseph's. So this, I think, is where you've all been hiding.

The last thing I do is look for a storefront church I used to drive by on my way to work.

But they've torn down the wall between Marty's New and Used Furniture and Ebenezer Gospel Ministries, and Marty's daughter tries to tell me why. "They only had ten or twelve people anyway, never paid their rent, never paid the utilities. They'd stay in here all night and then hide out or leave when we came in the day. So we had them evicted, locked them out, the whole thing.

"It wasn't a real faith anyway," she says, "not a real church.

"It was a ranting and raving full Gospel holy roller thing. Not any kind of faith."

This had been an urban block with two storefront charismatic churches and several junk shops. At night, for over a year, you could drive by and the junk shops would be dark and murky and there in the middle of block, in the one rectangle of light, a woman in a long white robe would weave and wave her arms and you could watch young men and women jump up and swoon and shout in their plain white shirts and black pants or skirts—the universal uniform of school choirs. They were the initiates, the family, a community of ecstatics.

And the whole block except for that light would disappear, all the cast-off man-made objects of this world and their embarrassing decay—the fraying fabrics and hideous shapes, the colors that we loved once and grew to hate through familiarity and the need for change; they were nothing but old husks, old bodies. Someone, somewhere, felt well rid of them.

But across the street, I see, there's another storefront church. And two more a block over. And a center for Islam. Sacred space disappearing and reappearing, the spirit in the buildings, windows burning and extinguished and burning again, like flickering candles.

Throughout cities, there's this countermovement, this undertow to the story of the mall and St. John's. When Marty's New and Used moves out, as landlords abandon buildings or accept smaller and smaller rent checks, Ebenezer's Gospel Ministries or some sister church will probably move back in, and the block, like many like it, will become a sanctification of space, a resurrection of stuff. And this, I think, is the story of Indiana's sacred places, the sacred fighting for its place in a world of civil government and commerce, reemerging over and over in all its diversity, its multitude of eclectic styles.

"The Miracles of the Church," Willa Cather wrote, "seem to me to rest not so much upon faces or voices or healing power but upon our perception being made finer, so that coming suddenly near us from afar off, for a moment our eyes can see and our ears can hear what there is about us always." On the way home, I drive by *A More Excellent Way Outreach Ministries: Holy Ghost and Fire.* It shares a building with the Soul Food Cafe, a fiery dove painted on a window next to a painted steaming cup of coffee, the steam and dove rising, simultaneously, into the blue air.

QUAKER ZEN

On Jessamyn West's *The Friendly Persuasion*

Bliss is a feeling unsought, almost indescribable. It comes when the body, which is flesh with definite boundaries, escapes those boundaries and is a part of sunlight or wind, of starshine, or of the known and loved order of the pieces of wood called "furniture" in a building called "home."
—Jessamyn West, *The Life I Really Lived*

First, a personal confession. I've always loved this book in part because I love lyrical writers—writers whose imagery is startling and who use language like a poet—and West is one of them. Eudora Welty was a fan of her work, and she wrote a glowing review of one of West's shamefully out-of-print books about Indiana, *The Witch Diggers,* a book that reads like a lost novel of Willa Cather's. When in *The Friendly Persuasion* West's lyrical gifts present us with cherries as bright as Christmas candles, or she notes

the day the season turns and a "rose that very morning, round and firm to the eye as an apple, dropped its petals . . . as suddenly as if winter had exploded in his heart," she's writing not to show off—she's a Quaker after all—but because it's in her nature to be still and to see, to live in a kind of Quaker Zen, following St. Augustine's advice: *We shall rest and we shall see, we shall see and we shall love, we shall love and we shall praise, in the end which is no end.*

When you read this book, you remember there's such a thing in life as joy and wonder—those largely unexplored emotions in twentieth-century fiction. Joy? I like to be reminded of it, and the way her characters live within the natural and human world makes me homesick for something I've never known.

When I teach midwestern literature classes, I focus on despair. I've often thought that my students love *The Friendly Persuasion* in part because it comes in the middle of a semester of *Native Son* and *Winesburg, Ohio* and *Elmer Gantry* and *Sister Carrie* and *The Magnificent Ambersons,* all stories about the Fall from Eden.

The book begins in the garden, purposely, and in the tone of a fairy tale:

> Near the banks of the Muscatatuck where once the woods had stretched, dark row on row, and where the fox grapes and wild mint still flourished, Jess Birdwell, an Irish Quaker, built his white clapboard house. Here he lacked for very little. On a peg by the front door hung a starling in a wooden cage and at the back door stood a spring-house, the cold spring water running between crocks of yellow-skimmed milk. . . . In spring, meadow and roadside breathed flowers; in summer there was a shimmer of sunlight onto the great trees whose shadows still dappled the farm-land: sycamore, oak, tulip, shagbark hickory.

While most midwestern literature (and most American literature) is the story of the fall from grace, *The Friendly Persuasion* is the story of how it might be partially regained. If everyone lived like Jess and Eliza Birdwell, West argues, this place could be an Eden. How? It's Quaker Zen. Be still. Be quiet. In the silence you will hear and see and love, and in that loving you will lovingly praise. And the moment will be experienced as eternal. The most compelling characters—Jess and his preacher wife Eliza, their daughter Mattie and the boy Jess befriends at the end of the book—have that gift.

You can "taste eternity," Jess says, "on a May morning in a white

clapboard house on the banks of the Muscatatuck." Eternity, Jess says, "is experienced in life by sampling as many of the elements as is possible," and eternity is "the depth you go."

Like his friend Homer, Jess "was filled with wonder at a hundred sights: with the colors a colorless icicle took on when the sun touched it, and the way flames leaped in to attack a hickory burl, then leaped away again as if the burl were fighting for its life; he noted how the smoke on a cool evening curled about the house like a tongue, and the way grass could push a stone over, and how through the buckwheat batter, bubbles like eyes would make their way up to the surface."

"You want to know the meaning of life?" Ray Bradbury asked when he spoke at Butler. "I'll tell you the meaning of life. It's to witness."

West would agree.

"Eliza," Jess said, "when I get to heaven and the Lord says 'How's things on earth?' I want to be able to answer: name the stars, say how the fruits are developing and what fish live in Rush Branch."

"He made them," Eliza said. "He'll have no need to ask."

"He don't see them from this side," Jess said.

If I were going to talk about the book and how it affects me personally, this sense of wonder is one of the things I'd talk about.

And if I were going to talk about this book in this particular month as the evening news is filled with talk of war, I'd talk about it as an exploration of nonviolence. It's not an accident that the book came out in 1940 and stayed in print throughout World War II, or that it went out of print and came back during the Vietnam War.

When Eliza and Jess's son Josh want to join the fight against Morgan's raiders, to join in a just cause in a war against something Quakers stood for—antislavery—we get the only real conflict in the book. At the center of the Birdwell's faith is nonviolence. When Josh makes the decision to join the militia, Eliza tells him calmly that she knows he might die—that it is in the Lord's hands. What terrifies her is the idea that he might have to kill someone.

"Any of us here, I hope," Jess says to Josh, "is ready to die for what he believes . . . but there are times when it's the only answer a man can give to certain questions. Then I'm for it. But thee's not been asked such a question now, Josh. Thee can go out on the pike, and if thee can find John Morgan, die there in front of him by his own hand if thee can manage it, and nothing'll be decided . . . and thee'll be back there on the pike just as dead and just as forgotten as if thee'd tied a stone round thy neck and

jumped off Clifty Falls. No, Josh, dying won't turn the trick. What thee'll be asked to do now—is kill." In this book, and in others, particularly *The Massacre at Fall Creek,* West doesn't back down from her belief in non-violence. That radical idea, as Vonnegut called it in *Nuvo Newsweekly,* is the other tenet that would bring this world back closer to Eden.

VONNEGUT

To hell with the talented sparrowfarts who write delicately of one small piece of one mere lifetime, when the issues are galaxies, eons, and trillions of souls yet to be born.

—Eliot Rosewater in praise of Kilgore Trout

Whenever my children complain about the planet to me, I say: "Shut up! I just got here myself! Who do you think I am—Methuselah?"

—Kurt Vonnegut Jr.

The Hamptons

He lives a couple of houses down from the general store and post office. You have to walk or drive there to get your mail, but if you're hungry, you can pick up a peach the size of a softball or fresh-picked Long Island berries, and you can exchange a word or two with your neighbors before you go back to your solitary life. His house is less than three hours from Manhattan, in the midst of farmland, and it's a mile or two from the

ocean. E. L. Doctorow lives nearby. John Irving used to, until he moved back to New Hampshire.

His house is pure Yankee: weathered gray siding, simple. No shutters, no gingerbread, no hedge, no driveway. There are bright blue hydrangeas by the front door and orange daylilies in the back. His Honda is parked in the yard. There's a brass dolphin on the front door, and you can pound as hard as you like with it, but he probably won't hear you. He's in his office around back typing; there's jazz on the stereo and a friend on the roof replacing wooden shingles.

His ancestors were free-thinking Germans who became atheists after reading Darwin. His immediate ancestors were Indianapolis architects and hardware salesmen. He's said that language is holy to him, and music, and tools. "A hammer is still my Jesus," he writes in *Palm Sunday*, "and my Virgin Mary a cross-cut saw." And so today, with a roofer pounding and a volume of Shakespeare on the desk by his typewriter, he's surrounded himself with as much holiness as a skeptic will allow.

"Come in," he says. "I want to show you how Hoosier I am, that I haven't gone eastern seaboard on you."

In among his daughters' paintings and pictures of his family (at the time of this interview "an eight year old daughter and six other children all going through midlife crises") and the Mark Twain coffee mug on the fireplace mantel ("If you grow a mustache, you automatically look like Mark Twain") are reminders of Indiana. A key to the city of Indianapolis on the wall by his desk, a painting of Eugene Debs, a metal toy from the Children's Museum ("My father was one of the founders"), and a minia-ture wooden Erie Canal boat ("my family's Mayflower"). They're like the Indiana references scattered through his books, a gift he gives to any Hoosier who reads him. Even in one of the later books, *Hocus Pocus,* when it had been years since he'd lived in Indianapolis, the narrator's name is Eugene Debs Hartke, he teaches at Tarkington College, and his father was a groundskeeper at Butler University. There are puns on Indiana names: a Sam Wakefield (novelist Dan) and an Episcopalian priest named Alan Clewes. (Allen Clowes went to Orchard School with Vonnegut's sister Alice. They were the king and queen in a school pageant.)

These are the images he was born with, the ones he was given to work with, but they're also a private joke between friends, an attempt to stay part of a community that was essential to him. Only someone from Indi-ana would remember Vance Hartke—one of the first senators to speak out against the Vietnam War, and a Hoosier. The images say what Hazel Crosby says in *Cat's Cradle:* "I'm a Hoosier too. Nobody has to be ashamed of being a Hoosier." And like almost every line from Vonnegut, they ex-

press a paradox: a yearning for something that feels beautiful and necessary along with a sense of humor that says everything we yearn for is probably, in the end, absurd.

For instance. Nothing is more necessary for human beings than extended families and communities. "Americans are very unhappy, feel unbalanced, lonely, and all that," Vonnegut says. "They get enough Vitamin C, but they haven't got enough people around them." So how can we fix it, make it better? "Maybe invent artificial families," he suggests. Give them middle names like Daffodil. Daffodils can meet each other in Timbuktu and immediately have something in common, like Hoosiers. Maybe it would work. It works online.

But no. The community would become a "granfalloon," a false association like "any nation" that is "meaninglessness in terms of the ways God gets things done." Granfalloons become filled with self-righteousness; at their worst, with a destructive ideology at their center, they wage war. We're fairly absurd beings, aren't we, with brains that are big enough to create a lot of havoc but not big enough to know what anything means. But still, we're Hoosiers together, and still, there's this yearning.

"I write as a Hoosier," he says. "That's all I've ever been. Eastern seaboard people who don't know much about the Middle West think we're all fundamentalists, really primitive people. But Indiana is a great seat of free-thinking and religious skepticism. It's not the Bible Belt.

"The first American to win the Nobel Prize was Sinclair Lewis, a middle westerner. It was quite a shock. People had to take another look at him; they'd thought he was a barbarian, that you had to be a Bostonian, to have gone to an Ivy League school to be a person who had any skills with language, any sort of sensibility that a civilized person would respect."

It's been an advantage to Vonnegut, in a way, to be from the Midwest. "To be a writer or maybe any sort of artist," he says, "I think you have to feel slightly off balance; something isn't quite right. You know you're not central to your society—of course central to your society would be Boston or New York City or whatever. But the most prolific and interesting people have been on the edge of European society, the Irish for instance.

"What the reason for it is, I don't know. Nobody knows what causes hiccups either.

"But you get Oscar Wilde, Synge, the great Irish playwrights. They're really on the edge. They're not only a despised sub-race on the British Isles, but they're *Catholic* for God's sake.

"Characteristically, a person who's born at the center of his or her society has no place to go, really nothing much to do. You don't have

enough energy to be an artist. Writing is an expression of discomfort in a way. You want to fix something."

There are so many things Vonnegut wants to fix, and he always moves back and forth between the architect's need to design and improve, and the skeptic's pull back down to earth. It's a kind of breathing that gives his work its tension and its humor. It's maybe even a particularly midwestern breathing, a result of the two waves of migration into the central states, and particularly, into Indiana.

"They no more mixed than oil and water," he says, "the Anglos coming up from the Carolinas and the Northern Europeans coming straight across on the Erie Canal."

We have to work at knowing why. We have to act as though we have free will. But no one can ever know why, and everything we do is determined by God or chemicals. Maybe we can reason it out! But who do you think you are? Relax and grow a few tomatoes. There's the grid-like net of reason, the world of the spirit, and then there's the material world, and they don't quite meet.

The best image of this tension between the abstract and the concrete is in *Cat's Cradle* when obsessed scientist Felix Hoenikker strings a grid of threads around his hands and shows it to his child, and the child sees his father's face through the string and thinks, "There's no damn cat and no damn cradle."

When Vonnegut taught writing at the University of Iowa, he told his students that all they could do is say what happened; anyone who was grandiose enough to think he or she knew *why* something happened was making a mistake. Yet no one, in his writing, seems any more driven to understand.

He's a fourth generation German American, fought in World War II and was a prisoner of war during the fire bombing of Dresden. He's written a lot about that war, most notably in *Slaughterhouse Five* and *Mother Night*. He's looked for causes in the human soul and in the German character. "The Germans came over here because they were against militarism, and a lot of them arrived just in time to serve in the Union Army," he explains.

"When the first World War broke out, the Germans—which included a lot of German Jews—the hatred that came out into the open was the hatred of the Anglos for the Germans. My God, the head of the hospital was a German, the director of the symphony was a German, the principal of the high school was a German.

"The same thing happened to the Armenians in Turkey, because they read books and had all the good jobs. They spoke other languages. They

were ambassadors, could keep track of where the money was going, so finally the Turks killed all the Armenians.

"I asked Tom Wicker, who writes historical novels, what the quality of the German troops was in the Civil War, and he said very poor. They didn't want to be soldiers; they were gentle, affectionate human beings. Just because you grow up in Germany doesn't mean you're a natural Nazi. The Nazi thing is arousing the mob. You can see the mechanism for it now. If you say to the crowd, nice enough people, that you're against our 'great victory' in the Persian Gulf, they'll hate you. You don't have to have censorship because the crowd will censor you.

"I asked Heinrich Boll, who became a good friend toward the end, what the basic flaw was in the German character, and he said 'obedience.' That's being encouraged as a desirable characteristic for Americans now. You speak ill of your country and everything will fall apart."

Vonnegut spoke out against the Vietnam War, the first Gulf War, and the war in Iraq.

"This hero business is baloney," he says. "I've got a purple heart and a combat infantryman badge. I'd just as soon somebody threw them in my casket with me because I'm proud of them. But we never thought we were heroes, and our relatives never thought we were heroes, and our girl-friends never thought we were heroes. We were just Shortridge jerks. We came home and tried to get our love lives going again and tried to get some kind of a job because we were thinking about the future.

"When my generation went to war, every citizen soldier feared two things, not one: One is that he would be killed or wounded, and the other is that he would have to kill or wound somebody. And now it's just wonderful when you kill somebody. It's a lot of fun and everybody should enjoy it on TV. We've been dehumanized, and it's TV that's dehumanized us."

Our reactions in Vietnam and in the Persian Gulf stem, in part, from World War II when it turned out that what we were fighting really was evil. It gave us such a sense of our own virtue that we find it almost impossible to believe now in our *own* capacity for evil. "There are plenty of good reasons for fighting," he warned in *Mother Night*, "but no good reason to hate without reservation, to imagine that God Almighty Himself hates with you."

Innocence, both in the individual and in institutions, is one of Von-negut's major themes. Innocence is understandable, probably unavoidable ("our brains are two-bit computers, and we can't get very high-grade truths out of them") and human—he's a compassionate writer—but it is also, often, destructive.

Human beings are built in such a way that if they think of a project, even if it's a concentration camp, they're likely to go through with it. And if

they build a weapon, it's going to go off, no matter how well intentioned they are. Vonnegut was on the ground during the two worst massacres in European history. He was fired at by his own troops in Dresden in the midst of the Holocaust. Each side acted, in Vonnegut's vision, out of innocence, ignorance, and pride. And tragedy was inevitable.

In *Cat's Cradle* Vonnegut invents a nuclear metaphor he calls Ice Nine, an ice that remains stable at room temperature. It's created in all innocence, just to see if it can be done. In one of the strangest combinations of slapstick and horror in literature, a third-world dictator ingests a drop of Ice Nine, an airplane runs into a piling during an air show, the dictator's castle falls into the ocean along with the dictator, and the entire world is destroyed by tornados and ice.

In his novel *Deadeye Dick* a boy whose father is a gun collector goes up into the cupola of his house and in a fit of joy shoots a gun into the air. The bullet of course makes its way across town and kills a pregnant woman and her unborn child. And the townspeople, out of their own self-righteous innocence, torture the boy.

Vonnegut's father was a gun collector as well. Was he anything like Deadeye Dick's father? "No, my father was a very good man.

"But there was one thing you absolutely could not do back then, and that was to be a homosexual or even to show womanly characteristics: too much pity, too much empathy, to love cooking if you didn't own a restaurant. People in a city the size of Indianapolis need artists, and yet what artists did was considered effeminate. My father was an architect. He was talking about taste and color. Meanwhile other guys are talking about a football game or about coal or iron. I think my father was a gun nut because it was a way out of demonstrating that, although he could talk knowledgeably about textures, about fabrics, about pretty design, that he was not gay. So he'd go out and kill animals with other guys. On cold mornings, they'd have a flask of booze with them. They were all bundled up, and they'd kill rabbits."

Vonnegut's father, like Vonnegut, was an atheist, but he joined the Unitarian church. It was like the guns. "Atheists, especially if they were artists, would join a church to prove that they were like everyone else." And the Unitarians believed essentially "what my atheistic ancestors believed anyway, the free-thinkers, that if what Christ said was wonderful, what did it matter if he was the son of God or not."

It's another one of those paradoxes in Vonnegut that he claims he's an atheist and, perhaps more accurately, a skeptic, but in his novels and in conversation he talks about religion and specifically Christianity as much

as devout Catholic fiction writers, such as Graham Greene or Anglican John Updike.

"John Updike is a friend of mine," he says, "and one time we had him here as a guest. On Sunday he and his wife disappeared. That's sort of tough, to have your guests disappear and have no idea what happened to them. It was a complete mystery until they came back.

"They'd gone to church. We'd never had a guest do that before.

"Anyway, he said to me 'You make a pretty funny atheist. You talk about God more than any theologian I know.'"

Does Vonnegut think that's true? "Sure," he says. "So many people are influenced by God whether He exists or not, and so you have to deal with that. Skepticism is "intellectually honest. There is no evidence for the existence of God or any sort of God that's been described by human beings. But Nietzsche said a wonderful thing. He said that only a person of deep faith can afford the luxury of skepticism. It means that everybody else is too scared."

Emerson says something similar, that the skeptic "denies out of more faith, not less. He denies out of honesty." Dogmas seem, to the skeptic, to be nothing more than caricatures. "Say what you will about the sweet miracle of unquestioning faith," Vonnegut said in *Mother Night.* "I consider a capacity for it terrifying and absolutely vile."

If Vonnegut has the deep faith of a skeptic, what's that deep faith in? "Who knows," he says. "It's not a club. It's not a building you go to. But something very important is going on. Maybe you can know what it is, but so far we don't. I think that perhaps we will know sometime. I'm not arrogant in my skepticism."

His skepticism has led him, often, to a fairly bleak determinism. "What sweet mysteries of life are chemical?" he asked in his book *Wampeters, Foma and Granfalloons,* and he answered, "All of them. Biochemistry is everything." In *Breakfast of Champions* he had a vision of human beings as machines. "I had come to the conclusion that there was nothing sacred about myself or about any human being; that we were all machines, doomed to collide and collide and collide. I no more harbored sacredness than did a Pontiac, a mousetrap, or a South Bend lathe."

So why do so many of his characters feel such remorse if they can't help what they do? "They're the kind of people who have consciences," he says, "that's all. They came into the world with them. These seven kids of mine are what they damn well are. Some are very affectionate, some are not very affectionate. Some feel terrible remorse about things that nobody else would feel were very bad."

In some of Vonnegut's later books there's been a vision of something sacred at the center of each human being, a vision of something like a soul. It's a vision, finally, that the Mark Rothko-like painter Rabo Karabekian, one of Vonnegut's characters, communicates to Vonnegut in *Breakfast of Champions*, and it brings him back from a depression so deep he's contemplated suicide. "You're afraid you'll kill yourself like your mother did," one of his characters says to him.

"The soul," Vonnegut says now, "is at the center of everyone. It's the part that receives all the information, and if you're going crazy, it knows that too. It does not go crazy. It always knows what's going on, and that's the soul. That's represented in the Karabekian painting by the band of light. I can find evidence for it. My son Mark went crazy and recovered completely. He was in a padded cell, in a straitjacket, and he recovered sufficiently to graduate from Harvard Medical School. He's practicing medicine outside of Boston. But he remembers every minute of it. All the soul can do is know what's going on. It just rides around. It can't act."

Why can't the soul act? "Well, you didn't design it," he says. "I think we're very badly designed. If you think Mother Nature's creative, what the hell do you think of a rhinoceros? Or the Irish elk—a miracle of evolution. Every generation this poor animal's horns have gotten bigger until they can't go in the woods anymore because the horns get tangled up. These horns are a very bad idea."

Vonnegut takes up evolution in his novel *Galapagos*. "I did a lot of research and I was scared to death because Stephen Jay Gould, who is not only a better writer than I am but also the expert on evolution as it's understood now, read it. He said it was okay. He congratulated me, and he uses it in a course now. He approves of the randomness of it. Evolution can take all kinds of crazy turns. It isn't nature sitting there and saying, okay, what's the best kind of animal I could make now."

We're sitting on a picnic table bench outside his back door in the Hamptons. He stands up and demonstrates the dance of the blue-footed boobies from *Galapagos*. They do exist, and so do the vampire finches. "The boobies are beautiful. They look like they're wearing blue rubber gloves; that's how bright the blue is, and how shiny." In their mating dance, the male picks up a foot and waves it around in front of the female. "The female says, 'Who is this creep? What is he doing?' Then he gets closer and closer and pretty soon they're doing this dance together."

In *Galapagos* the characters wonder what the dance of the blue-footed boobies means. "It means," Vonnegut finally writes, "the birds are huge molecules with bright blue feet. And they have no choice in the matter."

Vonnegut is wearing khaki shorts, an old blue polo shirt, and a

sweater with frayed sleeves. He's tall, athletic, much younger looking than sixty-eight. He's here in rural Long Island and has had, he feels, very little choice in the way his career has gone. "What I thought I wanted to be was a journalist," he says. "If everything had gone right according to the plans I had in high school, I'd be a middle western journalist."

Now, he says, "I'm one of the few people in American society who can say whatever he goddamn well pleases to any kind of audience. It's because I'm middle class, I'm successful. I'm one of them. They're conservative Americans and they pride themselves on allowing free speech, but they only allow it to a few people.

"I'm an institution. No, I am. Like *Newsweek* or *Time* or something like that. I'm an institution even though I'm just one person.

"But there's no way I could have achieved it. It was up to somebody else, to other people to buy my books and allow me to speak. There's no way I could control that; it just happened.

"Here I am. I'm sixty-eight years old now. My father became the dean of Indiana architects by living as long as he did. I'm becoming one of the elders of American letters simply by living so long. James Jones is gone, Truman Capote is gone, Irwin Shaw is gone, Nelsen Algren is gone. They were all friends of mine."

How does it feel to be an institution? "I hardly see anybody. Here you are. You'll be my only visitor today.

"But it's the nature of my job that it's lonely. There's no way I can have a colleague. There's no way I can have a staff.

"One reason that novelists make such very poor mates is that it calls for extraordinary concentration. Because it's a lie, and it becomes more and more elaborate, and you have to remember how the lie has gone so far so that it can stand cross-examination. In *Gone with the Wind*, there's a fourteen-month pregnancy. It has to become real for you. Once you get past a certain point, usually about seventy-five pages in, you have to inhabit the novel, and that makes you very absent-minded when talking to other people."

And of course an atheist's life is, perhaps by definition, a solitary one. Wherever you go, you have only yourself and your memories to carry with you. The music of the spheres is the existential hum. If you're at the same time transplanted from your home, and you're a novelist who is such an institution that phrases you've coined ("and so it goes") appear in the middle of politicians' speeches or magazine articles about omelets, and your face is so familiar you appear on Barnes and Noble's shopping bags, it's bound to be even more so.

But if you go in the front door of Vonnegut's house, the first thing

you'll see is a picture of his children when they were young, all sitting around a dining room table. "The family I once had," he says. He's proud of them, the way his family stretches forward into New England and the way it stretches back into Indiana. Members of his family designed the Atheneum, designed churches and homes all through the city. He reaches back into Indiana and pulls memories clear across the country and into his books. He's made his own community, characters that move with him from book to book: Eliot Rosewater, Kilgore Trout, Paul Slazinger, Rabo Karabekian. They have lives of their own. Even when Vonnegut tried to kill off Kilgore, he still came back, still talking of course, from the "blue tunnel into the Afterlife."

Vonnegut has said that the only truth we have is the one we make ourselves. "You are pooped and demoralized," says Kilgore Trout. "Why wouldn't you be? Of course it is exhausting, having to reason all the time in a universe which wasn't meant to be reasonable."

FREE SINGERS/BE

On Etheridge Knight

If you should see me walking down a road, and I am stumbling and weaving back and forth like a drunken man, that does not mean that I am on the wrong road.

—Leo Tolstoi, as quoted by Etheridge Knight

John Berryman's definition of a poet is a man or a woman alone in a room with the English language. There are human endeavors which are communal, and there are others which are deeply solitary, and poetry, we believe, is the most solitary of the solitary. Now and then the poet will slither out into the world with tea-stained teeth and will blink and stammer at other human beings, but most of his life will be spent in that room, in a prison of his own making, in an attempt to forge the spirit into words. Now and

then he'll release poems from the room like messages on carrier pigeons, or prayer, and he'll wonder why they always seem to come back to him unanswered.

Etheridge Knight was an Indiana poet who did some time in prison, but never in a rarified one. In the Michigan City prison, he wrote, "I died and poetry brought me back to life."

After serving six years of a twelve-year sentence for armed robbery, he went on to live his life as a poet and a teacher *in the world,* eventually winning the American Book Award for his University of Pittsburgh Press collection *The Essential Etheridge Knight.* In his poetry, and in the workshops he taught, he brought street poets, academic poets, jazz poets—all poets—together in one place in ways hardly any other American poet has accomplished. Maybe Allen Ginsberg, but still, no one was ever quite like Etheridge.

Insisting that poetry is both deeply political and deeply communal, wherever he lived, he established what he called his Free People's Workshops. There were two or possibly three incarnations of the workshop in Indianapolis, including the one he ran the year before he died.

The workshops usually met in bars. "Sometimes Gwendolyn Brooks or Robert Bly would stop by and sit next to the drunk who wrote poetry on scraps of paper," Fran Quinn is quoted as saying in an article by Amy Lifson. It was Etheridge's belief that poets should attempt to insert the poem into the verbal texture of the community and into ordinary speech. You might not even be aware that it's a *poem* you're listening to, with all that implies. If, with your language, "you can stop a man with a full kidney of beer heading for the men's room, then you've got a good poem," Quinn remembers Etheridge saying.

"There's always an aura of some kind of excitement around Etheridge," Boston poet and Etheridge's companion Elizabeth McKim said of him. "In every place he's been, he creates community, so the sound keeps coming out when he's gone."

"Every place that Etheridge *is* was a workshop," Indianapolis poet Francy Stoller said. "Even if you're not a poet, the discussion always got around to poetry and poeting." Stoller became a member of Knight's Free People's Workshop after running into him outside the art gallery she and her husband, painter Steven Stoller, ran in the Mass Ave arts district. "We found each other on the street," she said. "He had moved into the Barton House, and I called him into the gallery. He thought I was a gypsy. He came right into the gallery and said his poem 'Circling the Daughter.' "

Francy had been burned in more traditional workshops. "In Atlanta,"

she said, "people said my poems were too earthy, that I talked about my children too much." But Knight always stressed writing that came out of a person's life, out of your own genealogy. Other students echoed the importance of that teaching. Poet Ron Price of Memphis said that one of the things Etheridge gave him was "an acknowledgment that the world I lived in was as relevant as any other. It was a profound shock to me."

"There was a very bad sense of community in Memphis before he came," Price went on to say. "Memphis was under the sway still of the Fugitive Poets, the agrarian poets who started the New Criticism." So students were criticized for not being "universal," a criticism traditionally leveled at the work of both minority and regional writers.

"There's a wonderful story that Eth tells," Price said, "about the Louis Simpson review of a book by Gwendolyn Brooks. He said she couldn't write without reminding people that she was black and a woman, so of course she couldn't 'rise into universality.' Then I ran across this little off-the-cuff remark that Galway Kinnell made, that if you went deep enough into yourself, it's that point where you share some common bond. That's what Etheridge taught. It's amazing. Even the metaphor is different: not rising, but diving. It indicates a different sort of psyche. Those things like grief and loss. If you go there clearly, you'll find a place that other people have been.

"So what Etheridge did was bless me to go off and find my own material."

"Go beneath the demons," one student remembers Knight saying, "in the pit of the belly to the clear lake of truth underneath. That's where the better poems come from."

"Many people here had a limited sense of what poetry could be," poet Margaret Hass said of the Minneapolis workshop. "There were a lot of loons and lakes in our poetry then. He taught us that it was possible to write about these very intense personal things."

In diving into the personal, Knight taught that deep sense of humility that is integral to any work of art. Not self-effacement, but humility. I'm a human being, and there's only so much I can know. I can be angry and honest about how I feel, but I have limits, and my faults can take me by surprise and blur my vision. It's an attitude that was evident in his work and in his teaching. For example, in these lines from his poem "The Sun Came: For Malcolm":

> The Sun came, Miss Brooks—
> After all the night years.
> He came spitting fire from his lips.

And we flipped—We goofed the whole thing.
It looks like our ears were not equipped
For the fierce hammering . . .
The sun came, Miss Brooks
And we goofed the whole thing.
I think. (Though aint no vision visited my cell.)

In that "I think" there's the pulling back from the artist's ego that wants to glorify itself.

The humility in Etheridge's personality was disarming. Over and over his students commented on his empathy, his ability to listen. While it's traditional to dismiss content in a writing workshop and to pay attention to technique alone in a New Critical way, it was common for Etheridge to respond to a poem with "I hear you." And his students sounded different from each other because of it. "It has a lot to do with how interested Eth was in other people," Steven Stoller said. "He was so interested in someone else that that person suddenly became interested in himself. By confronting himself all those years, Etheridge formed the ability to lay his own life out there.

"You meet someone like that," he continued, "or anyone, and there are at least five things you're worried about this new person finding out about you. But Etheridge would tell you all his own faults immediately. And before you know it, you're believing in your own voice, that you have a voice that's real and valid. If someone like Etheridge is interested, then you have authority."

Though he could be tough as a teacher.

"I worked six months on this poem about my son," Francy Stoller remembers, "about the first three years of his life, when he was a wild boy, eating mushrooms and picking berries. We moved from the country to the city then, where he was afraid of the streets. So those first three years were like a dream to him. The child forgets everything he knew in the past.

"I thought the poem was great. This was the 'Big G' coming out. So I read the poem to Etheridge and Liz and Jean, and to Kahlil and Abdulah. I didn't even care if they knew the language. I wanted them to think that I was on my way, becoming a real poet.

"Then Etheridge said 'Listen, you're not Charles Lawton, sitting in the pine trees, sipping piña coladas.' My ego was real damaged, but I had to confront all that, to confront myself. I had to change the delivery. 'The poet's voice,' Etheridge said, 'means the pure poetry coming out without forcing it.' The poet may be saying it, but the poet's voice shouldn't glorify *itself* or try to edify the audience.

"As a teacher, he was real hard. He's a very gentle man, but he'll disarm you. And you love him so much, you listen to what he says."

"There's that whole group of poets who looked more toward Malcolm X than toward literary predecessors," Ron Price explained, "and every one of those people seemed to have walked away with an attitude that wasn't locked in on his individual ego, Etheridge included. It shifted the emphasis away from the ego of the individual artist and placed it more on the activity."

Music. Etheridge taught that a poet should hear the poems, to "say them," to make the poems "make sense in the air," the emphasis being on the community that the poet forms with the audience. The Writer's Trinity, he called it: *The Poem, The Poet, and the People.* Chris Gilbert remembered Etheridge saying to "just read the thing and not worry about how it looks on the page." In the workshop, Gilbert's voice "grew a little different. It grew less abstract, more concrete. The poems went from being entirely written, disembodied things, to being poems that could be spoken."

"Though most of Etheridge's poems are really well written, crafted poems," Gilbert went on. "What he's a proponent of is not always what he did in practice. He would say 'the poet doesn't need a pen,' but he revised all the time. That was part of Etheridge, those contradictions. His poem 'The Idea of Ancestry,' for instance. Such a rich poem. It went through a lot of filtering. The symbols in the poem are united and linked and working together."

But still, it's the mouth and the ear that loves Etheridge's poems. There's the consonants spitting anger in the lines "Make empty anglo tea lace words/Make them dead white and dry bone bare," or the syncopation formed by the line breaks in:

> We free singers be
> Come agitators, at times, be
> Come eagles circling the sun,
> Hurtling stones at hungers, be
> Come scavengers cracking eggs
> In the palm of our hands.
> (Remember, oh, do you remember
> the days of the raging fires
> when I clenched my teeth
> in my sleep and refused to speak
> in the daylight hours?)

I myself will never, as long as I live, get the rocking, rhythmical sound of Etheridge reading his poem "Ilu the Talking Drum" out of my head. It's hypnotic and moves into the fibers of your body, like music.

In his workshops, he taught his students that the poem lives in the sound of the human voice as it physically touches another human being. Poetry lives, he would say, in the way that music lives: not in the notation on the page, but in the *sound*. And in particular, poetry builds community, a connection between the singer and the sung-to. And, he would insist, it could save your life in the same way that it saved his. If only you'll let it.

The impact Knight had on urban centers of poetry in the last quarter of the twentieth century was profound. The impact was partly a result of the work itself and partly a result of his teaching. Many of his workshops included a poet who went on to win a major national award. A teacher who mentors only one award-winning student in a lifetime would feel blessed, but former members of the Free People's Workshop include Walt Whitman Award–winning poets Chris Gilbert from the Worcester, Massachusetts, workshop and Jared Carter from Indianapolis; Alice Friman, winner of the Consuelo Ford Prize from the Poetry Society of America, again from the Indianapolis workshop; and Yale Younger Poet David Wojahn and National Poetry Series winner Mary Fell.

Etheridge Knight came back to Indianapolis, where he was born, for the last two years of his life, after he was diagnosed with lung cancer. He lived in public housing in the Barton Towers near the Atheneum. He called the place the Triple Nickel. The entire time he lived here he was dying, and I can truthfully say that I have never seen someone more alive. He created a community around him, went on teaching his Free People's Workshops. His partner, Elizabeth McKim, moved here from Boston during his last days. They wrote poems together and put them on the apartment walls. They were signed "Elizabethridge."

I first met him when he gave a reading at Butler. Once you met him, he would never lose touch. Any time he came through town he'd call you up, or he'd write notes from wherever he was. He'd hit you up for a reading, and his readings and his poetry were so incredibly good, you'd always scrape some money together. He would always need the check that day, and often, you'd have to take him to the bank to cash it, and two different times he asked to be driven to see an "uncle" or a "nephew," and he'd disappear inside a house or housing project in downtown Indianapolis and come out an hour later, the money gone. All his life he struggled with addictions. He was a thief. Fran Quinn remembers patting him down before he left his apartment. Even in the last year of his life, Elizabeth couldn't fully trust that he was faithful.

As much as we might like to think otherwise, I've always thought Flannery O'Connor was right, that you've got to fall in order to have the

humility that vision requires. Pride blinds. Oedipus had to marry his mother and kill his father and then blind himself before he could see. And some people have to fall again and again. Etheridge had flaws, and those flaws were part of what gave him empathy. And as he said in one of his poems, "I never stopped loving nobody."

In his last year, poets gave benefits for Etheridge in cities all over the country. The one in Indianapolis was held in the Atheneum, and it was probably the largest concentration of major living poets ever gathered in the city. There were Robert Bly, Sharon Olds, Galway Kinnell. There were Dudley Randall and Donald Hall and Mari Evans and Haki Madhubuti and others, as well as members of the Indianapolis Free People's Workshop. People were willing, anxious, to say what Etheridge's work and teaching meant to them.

"How much sadness has come into all of us because we can't keep out lies," Robert Bly said, "every moment of our lives we exchange comfort or discomfort for statements we know are lies, or mostly lies. How sad and addicted our truth-receiver is, a bagman, who spends the day without hope. All of us who have read Etheridge know entire poems in which the truth receiver feels expectant and proud, stanza after stanza, for the entire poem.

"Etheridge Knight puts his pain on us, but we don't feel burdened by it."

"The weight of his truth is so anguished," Chris Gilbert wrote, "I find myself wishing for his sake that the statements were fictions, just figures of speech."

"The tribute in Minneapolis," Margaret Haas said, "was a really loving event but had some elements of difficulty too. Parts of his character were not model. People would say 'I love Etheridge but he owes me money.' His influence is not completely without the difficulty of taking on a person who has struggled with drugs all his life, and with money."

Everyone who ever met Etheridge had a story. There was the time he sold his car to three people and left town driving it. There were the loans he never repaid. The stories had, from one city to another, the similar, archetypal quality of myth, stories of the trickster hero from folk tales.

Very few people are comfortable sitting in the contradictions of their own lives and wrestling with them. A lie is often a way people who feel powerless have of gaining a sense of freedom, and he was brutally honest about those lies and cons in the poems. If he weren't, he would have been another charming, but self-deluded, liar. Again, the poetry saved his life.

"The distinction between a liar and a good story teller is a matter of context," Price said. "The same person tends to be good at both. Etheridge

is good at words. Sometimes he uses them to con people and sometimes to amaze people. It's part of what you either accept or reject if you accept or reject him."

"He inspired people," David Wojahn said, "because, even though he had more than his share of faults, one of the things you realized is that fundamentally and basically, he was good. One of the sources of his goodness is that faith in poetry as being the thing that sustains us and makes us human. Most people are too reserved to commit themselves to it as deeply and urgently as that. Etheridge believed that words are sacred, that they have a sacramental impact."

"I hardly ever get this sentimental," Wojan continued, "but I've been thinking about him a lot lately. It's rare that people have that deeply romantic way of looking at poetry. He believed that totally and honestly. He had that faith."

If poetry is a sacramental art, and if, as theologian Simone Weil wrote, to pay attention is to pray, then there was an Etheridge that spent every day of his life in prayer. In the introduction to his book *Belly Song*, Knight described the sources of his faith in poetry when he wrote about his time in solitary confinement:

> Not knowing night from day, I begin to lose track of time, the days the weeks; I become disoriented, out of touch/with myself and almost out of breath. So I start re/membering: my grandmother, grade school classmates, guys I'd been in the army with. . . . I was so disoriented, so desperate to regain a sense of my self, of who I was. . . . So I started making up/lines and phrases out loud, memorizing them, and I started to breathe again.

Looking back through this essay now, as I prepare it for this book, I realize it's been fifteen years since Etheridge's death. He died in 1991, at the age of fifty-seven. And I wonder why I didn't just let his poems speak for him: "The Idea of Ancestry," or "Hard Rock," or "Circling the Daughter," all those brilliant poems. At the time I wrote this essay for *Arts Indiana*, I wanted to say, Look, here he is. He's here right now, and let's celebrate his life. And now, in going through it again, I want to say, Let's not forget him. I am, right now, close to the age he was when he died, and I have seen how easy it is to forget.

I look back through the folders and find his obituary from the Indianapolis paper. It mentions his writer-in-residence positions at the University of Pittsburgh and Wesleyan. It mentions his four books. It mentions his survivors. And it focuses, as my essay does, on his time in prison

and his divorces. And it quotes one line: "I died in Korea from a shrapnel wound and narcotics resurrected me. I died in 1960 from a prison sentence and poetry brought me back to life." All the articles in the folder define him in this way: black, drug addict, prisoner, poet.

And I realize now that he was very young when he died. And I realize how little we talked to him about his dying, because it was so hard to talk about. And I wonder what else we avoided talking about. And I wonder how well we really knew him.

Writer Thomas Glave, a young African American gay fiction writer wrote an essay, published in *The Massachusetts Review*, titled "On the Difficulty of Confiding, with Complete Love and Trust, in Some Heterosexual Friends," and I want to quote from it. When Glave read at Butler, he talked about how much Etheridge's work meant to him in the beginning of his own career. Glave's essay is about friendship between those whose worlds are completely different from yours, the way you wonder, always, when and whether you're seen for who you are and when you're not seen at all. One of the essential tasks of being human is to see other human beings as real, which is why literature is essential finally. Each one of Knight's poems says "Here I am. See me."

But in his life? He lived most of it among academics and poets, not in prison. But we still talk of him as a thief. Looking back now, I wonder how much it cost him to be, for all his life, the "prison poet." Glave's essay speaks for any of us at times, but particularly, perhaps, for Etheridge. Glave writes:

> For when, given what they have revealed to you over the years of your "friend"-ship, were you ever completely certain that they truly were friends? That they really considered you and others like you an actual person, not an aberration? Not something experimental and "interesting," nor one of "those people" who can be so funny, so acerbic and outrageous and—when? And so it has been true that from time to time—often—you have wanted to confide in them. Very much . . .

> But then who are these people, finally? Who have they been all along? But they are anyone, of course: those whom, in a few cases, you have most loved and adored; those whose counsel and wisdom pulled you back often and gently enough from savage mistakes and stupidity. . . .

> The years taught you well how to absent from their lives (and not only from their lives) those most You parts of yourself. You became, with them (but hopefully not with others) one of those players supremely adept at compartmentalizing his A (what must never be welcomed) from his B and C (what fights to prevail). And so with some sadness, a

little time-tempered anger, you realize that you, too, share some of the weight for this distance . . . for truths never entirely disclosed. . . .

The year 1991.

Number 555 Massachusetts Avenue. The Barton House in Indianapolis. The Triple Nickle. The last months of Etheridge Knight's life. He'll die soon, but we don't know that yet. He's still full of so much talk, so much life. He'll be buried in Crown Hill Cemetery, and the poets who came to his benefit reading will come back to honor him at the funeral.

But today, old people sit around the first floor day room, passing cigarettes. In the center of the room, overly varnished picnic tables are filmed with ash. "Years ago I could stay outside on the street all night drunk, pass somebody and say 'hey let's go get one.' Now, they'd just kill you," a man says. He's a good talker, the only man. The women sit with purses on their laps as though they're waiting for a bus.

In the office a woman with long gray hair is wrapping a blue and red pin in tissue paper. "Etheridge is a personal friend," she says. "I stop by and see him. Some of the people here know how famous he is."

Up to the 18th floor, Etheridge Knight's apartment. One narrow room with an attached bedroom. There are baskets on the wall, posters and photographs. A waxy caladium flower on a desk, eucalyptus leaves, Elizabeth with a watery blue headband in her silver hair, the sound of a fire truck outside the window. A poem on the wall: "A little hope is all we need," signed, "Elizabethridge."

Etheridge talks about how it was to write in prison. He spent, he says, seven or eight hours at the desk. He had a fish tank on the desk, and after lights out, he could still write by the fluorescent glow.

"It was different when I was outside, writing. I traveled more, talked to people more, engaged with a wider world. I could have made more time to write. You're be-boppin around. I think I spent less time at a desk, and as the years went by, I spent less and less." There was a writers' community in prison, he says, and he talks about a fellow inmate who wrote sex-and-violence stories and then sold them for $500 to magazines.

Did Etheridge, with all his money problems, ever think about doing that?

"No," he says simply. He was writing love letters for friends to send to their girlfriends, telling stories, gambling for cigarettes, writing poems. Words meant too much.

The room is crowded with voices, as it often is. The phone rings constantly. Sometimes Free Peoples will meet here, sometimes in the Mug-

wumps bar, sometimes out on the grounds of the Barton House. This room is small. Space is an important image in Knight's poems—"The Violent Space," the enclosed area in "The Idea of Ancestry," the room in "As You Leave Me"—all poems with a speaker inside, looking out, wanting freedom. After prison, Etheridge ranged across a whole country's worth of it.

"In the workshop," I remember Chris Gilbert saying, "he kept emphasizing 'you have to take the space, and you have to define it. You have to take over the space with your voice, your physical presence.' It's emblematic of an African-American struggle. You live in an oppressive language situation. Everywhere you look, the terms aren't your terms. You turn on the TV and the news isn't your news. The mayor isn't your mayor.

"So you take over the space by filling it with your own language."

Etheridge is quiet today, more tired than usual. The row of windows in his apartment looks out over the city: the clouded ice of the AUL building, the gray-blue square of the War Memorial, the layered stone of the Murat Temple. Down on the street, a Metro bus glides by like a fish.

Etheridge goes into the other room, to sleep. The voices of his friends, his students, are still saying poems. On the wall by the apartment door, he's hung a haiku by Basho:

> The temple bell stops
> but the sound keeps coming
> out of the flowers.

ON WILDNESS AND DOMESTICITY

An Interview with Scott Russell Sanders

"It's a terrible emptiness—" I waved my hands, trying to gesture at what I could not name. Margarine on my fingers, embedded in the knuckles. How could I ever eat this sandwich? Dead pig. "I see myself sinking through the dark, sinking and dwindling, like a spark falling, until I vanish. There's no me anymore. I wake up in the middle of the night and know—not like some sentence out of a book, but deep down in my blood I know—that my brain's eventually going to flicker and go out. . . ." She watched me intently. This strange panicked animal, her husband.

—from *Fetching the Dead*

In several of the stories in his collection *Fetching the Dead,* Scott Russell Sanders describes young men at the beginning of their adult lives, terrified of commitment and terrified of death. These are terrors that go hand-in-hand —there are times when commitment to a direction seems like oiling up the highway to your own extinction. One option is to try on lovers, try on jobs, try on place after place like you'd try on a shirt and then fling them all on the

closet floor, reaching for another, until you convince yourself you're avoiding death, a large Passover cross printed on your forehead—oh no, not me, as you can see I'm still young, just getting started, still trying to choose.

But in his stories Sanders's characters consciously choose the life they have, perhaps unconsciously, chosen and in that choice face their own terror, their own finiteness. "I wanted to cry out," he writes, "Don't let me grow old, don't let me die. But I held my tongue. The chafe of loving still warmed my chest. My body denied its death. In the dark I reached for Brenda, to lay my hand on her stomach as it rose and fell, and in the dark I found her, there she was, the earth. . . ." Rather than running from the current of his life, as does one of Sanders's other characters who dies chasing a chimera ("But Jesse says Chicago is some roaring place and the times he says O Ransome the times we'll have. Come Ransome because this whole land is on the move and if we stand still it will move on without us."), this character accepts his marriage, his life, his place, the reality of his own eventual death—and in doing so, chooses to live a rooted grounded life.

Ten years later, in his book, *Staying Put*, Sanders consciously states, in essay form—words he chooses to stand by—some of the same themes that were layered in his earlier fiction. "*Staying Put*," he says, "recognizes that you're finite, that it's better to know some things in depth than a great many things shallowly."

We're sitting at a table on the enclosed porch of his Bloomington, Indiana home. He's made lentil soup and homemade bread. "Do you make a lot of bread?" my son Steven asks, helping out with the interview. "I like to make bread," Scott tells him. "Bread is alive. You put yeast in it. That's the reason it has holes, it's not just like pudding. It's a kind of a plant. It multiplies, feels good, smells good, tastes good."

He did the carpentry work on the porch himself, has rewired the house, landscaped the yard, planted wildflowers—Dutchman's breeches, Dogtooth violet, hepatica, bloodroot, celandine. "I transplant wildflowers and ferns into my yard every year," he says. "Towns and wildness ought to be able to coexist."

That connection he sees between wildness and domesticity is one of the reasons he's been asked to write the introduction to next year's Sierra Club calendar. "They wanted someone," he says, "who would make a connection between wilderness and home." The founder of the Sierra Club, John Muir, began his famous 1,000-mile walk to the gulf from Indiana (actually, he took a train through the Indiana part; presumably because he'd already wandered much of Indiana and was anxious for something new). Muir spent most of his life alone in the wilderness. But

Muir and Sanders are more than 1,000 miles apart. "Muir said Thoreau didn't know true wilderness," Scott says. "What Muir's comment about Thoreau said to me is that he couldn't allow himself to see the spectacle in the ordinary, in the human.

"We live in the present, in human structures, in effect. In the midst of human community we can recognize our groundedness in the natural world.

"I see myself as much closer in spirit to Wendell Berry. I'm concerned with how to live in place—shelters, schools, parks—rather than wilderness." Berry is a presence that midwestern writers almost have to contend with—like Faulkner in Mississippi—an influence it's hard to ignore. Sanders acknowledges that influence: "I've found many of the same guides in the American tradition—Thoreau, Emerson, Jefferson," but adds that "Berry is more confident of his rightness. What moves me to write, often, is confusion."

While he has had the same teaching job, lived in the same house and in the same marriage for most of his adult life, he acknowledges the difficulties in staying put, as well as the comfort. "I feel that tension, to unwind myself from all the responsibilities and assumptions. I sometimes feel the panicky need to move, the attraction of novelty. And there's the irony that the longer I stay where I am, writing about the place and the people, the more requests I have that would take me away from writing about the place.

"But the fulfillment of continuity and rootedness is much deeper to me than the temporary satisfaction of novelty. What I'm saying in *Staying Put* is that movement shouldn't be, in itself, the good thing.

"Continuity and stability is the good thing."

Does that mean that you should stay put no matter what? Berry, when he talks about discipline—in farming, marriage, poetry—seems to say so. You never know when you might be inflicting damage, or you can't predict what the future will bring—maybe a day when what you need will align itself with what you have.

"I am convinced that you marry a place, if you truly want to live there, as you marry a spouse, for better or worse," Scott writes. But he doesn't mean a passive lingering or inertia, or even a rigid teeth-clenched virtue. "I know I don't believe that one will inevitably find something meaningful or nourishing if one stays put. Some people are trapped in situations that are never going to be good for them. Sometimes you need to move for self-knowledge or growth.

"But I don't think we'll find anything at all unless we look for it. I'm convinced that if we don't look for it, we won't find it." And that's the key

to *Staying Put.* When the spirit drops out of the form, you don't maintain the form for its own sake (Once the Way is lost, says the *Tao Te Ching,* then comes etiquette, the rising point of anarchy) or passively wait for the spirit to return. You look for it. Work for it. You "align yourself with the grain of your place and answer to its needs." Commitment means work.

"And you can include the possibility of movement while staying put—circular journeys away and back, intellectual journeys—enlarging one's vision of things through study or meditation.

"An analogy," he says, "is the difference between marriage and affairs. The satisfactions and the goodness of marriage are so much more satisfying to me."

He quotes Thoreau: "The man who is often thinking that it is better to be somewhere else than where he is excommunicates himself."

It takes a certain amount of courage for Sanders, as an artist, to take the stand he does. Not because it's unpopular, but because it's such a pervasive western myth that creativity requires restlessness and a constant re-creation of the artist's self. In a recent article in the *New York Times,* critic Camille Paglia says, without apology or even any irony, that the artist is a vampire, feeding off the blood of everyone around him. You think of Gauguin or Hemingway, or Yeats's rough beast that's born in Bethlehem out of immense chaos.

"It's very much a post-romantic notion that creativity rises out of destruction—of your friends, your body. Certainly the world has received great art from people who lived those ways. But we need," Scott says, "to hear and think about how human beings can live in sanity as much as they live in extremity or disarray."

"I'm aware that the way I live is very unfashionable," Scott says, "very un-artsy. I write about the things that are important to me. I think I'm aware of being marginal—not from the planet, but from the literary community. I would like to do the real work, not what the literary world pays attention to."

Which is what? "Urban angst. Social and familial disorder. The exotic."

Particularly, he notes, in fiction. Sanders, with several published novels to his credit, has been an outspoken critic of contemporary fiction. In an essay that was first printed in the *Michigan Quarterly Review* and later collected in Sanders's *News of the Universe,* he argues that contemporary fiction is shallow because it's missing "any acknowledgement of a non-human context. However accurately it reflects the surface of our times, fiction that never looks beyond the human realm is profoundly false, and therefore pathological."

He sees encouraging signs of change in fiction over the past few years, however. Annie Dillard is writing fiction now, and he admires writers such as Barry Lopez and Rick Bass.

"But there's still a lot of urban-dysfunctional and isolated-relationships fiction, which doesn't interest me very much. But that's often what gets reviewed." Why? "Because most of the review media are in large, dysfunctional cities. They're not reviewing those writers who pay attention to the human community within the natural community."

Several years ago he began concentrating on the essay form and has published three critically acclaimed collections and is working on a fourth. His work appears regularly in *Best American Essays;* he is known as one of the finest contemporary nonfiction writers in the United States.

"I haven't abandoned fiction," he says. He has recently published works of fiction for children and is "working on a new book of short stories about a character named Gordon Milk and his family. And I've been taking notes for a present-day Indiana novel. But there was a sense of urgency about issues and events that led me to essays."

And it was, he acknowledges, freeing to switch genres for a while. "I liked that sense of at last being able to speak more directly and not having to filter things through a character." There were all these constraints, he explains (artists in other fields, architecture for instance, have talked about similar constraints), that American writers felt in the past decade. "Constraints," he says, "that fashion or editors or university politics place on fiction. You're not allowed genuine passion, for instance, unless it's ironic or tongue-in-cheek or dismissive."

"The essay," he writes in *News of the Universe,* "has taken over some of the territory abdicated by contemporary fiction. Whittled down to the bare bones of plot, camouflaged with irony, muttering in brief sentences and grade-school vocabulary, peopled with characters who stumble like sleepwalkers through numb lives, today's fashionable fiction avoids disclosing where the author stands on anything."

In an essay, he says, the author can't hide.

"There are things in nonfiction you can do that in fiction would seem contrived, a cheap shot," he says.

For instance: In *Fetching the Dead* there's a character named Jeremiah Lofts, a mad prophet. Sanders writes about him again in an essay in *Staying Put.* In the fictional version, he doesn't mention that the real Jeremiah Lofts worked in a balloon factory. It was too much—lofts, balloons, the prophet who wants to rise above his earthly life. "In nonfiction," he says, "you're responding to a found world. And the fact is that the world is full of these extraordinary conjunctions of people and events and objects."

Such as the fact that we began the interview during a tornado warning —all the alarms going off in Bloomington, the streets filling with rain-water, the sky all green and black, the police taking over the radio stations —when one of the first essays in Scott's book describes this very scene, including the fact that we stay sitting on the porch watching it all instead of heading for the basement.

It would be harder to let that happen in fiction. "It's that continuing reaction to the nineteenth-century melodramatic overuse of coincidence." We aren't as aware of those overused devices in the essay, or they're easier to throw off. Like the New Journalists realizing that they could throw off many of the formulaic devices of journalism. Realizing you have that freedom can make you existentially giddy. Or it can make you undertake a circular journey that allows your art to grow and at the same time stay rooted.

There's an element of staying put that an artist seldom gets credit for, and that's the fidelity to the art itself. Scott began his career as an academic, publishing a book of criticism about D. H. Lawrence.

"I was drawn to Lawrence because of the dynamic of relations between the mother and the father, very present in my household. I wanted to wrestle with that. And his feeling for the natural world, for the landscape and plants, the inwardness of animals. That's an eloquent and powerful dimension to Lawrence. Though I have trouble with his misanthropic streak; he really wanted to rid the world of us—with his over-dramatized attitude toward women, and the way he was so single-mindedly opposed to science and technology. He never seemed to appreciate the beauty of science."

But he kept working on his own fiction. His first published collection was *Wilderness Plots: Tales About the Settlement of the American Land*, but by the time it was published he had written four other books. The first one, a novel about a Vietnam War resister, was "never published, thank God."

"I kept writing books in the '70s and wasn't able to get them published."

What kept him going? Writing fiction wasn't going to help him with tenure, and his children were young—there's that tug where you ask yourself why you keep doing it. He answers easily. "My wife, Ruth, has always known that writing was central to me. If your spouse were echoing your own doubts, it would be demoralizing. And writing has always been my way of understanding my life. It's the way I needed to think about what I believed and what mattered to me."

And it's that awareness of mortality, that physical shudder that many

artists feel, that panicky tap on the shoulder that says this is the ultimate question, when you *know, not like some sentence in a book*—that is what Scott describes so well in the stories in *Fetching the Dead*. Freud said that no human being believes in the reality of his own death, but maybe he didn't talk to many fiction writers. It's the curse that comes with the imagination. You can try to escape from it—it's probably one of the reasons there are so many hard-drinking writers—but there's not much choice about whether you feel it. The alternative to escape is to commit yourself to facing mortality over and over again, and to weaving nets of words around it.

"I think it's very close to the source of why I write," he says, talking about that feeling. "The writing is a way—not of defeating it—it's what you're offering over and against annihilation. What kept me writing? Part of the need was the sense of how brief life is, and wanting to make a sense and a celebration of it."

Celine said that no art is possible without a dance with death, and that's probably the dance he means.

That dance drives theologians and philosophers as well as fiction writers, and in his new book, Sanders is much more explicitly concerned with religious questions than he has been in his earlier work. The question he's asking over and over is, Where is the solid ground? The ultimate ground? And how can I reach it? His search, like the scientific one he undertook as a student of physics in his younger days, "is inspired by the conviction that there *is* a ground, a single source. I will more and more address ultimate questions," he says. "It will drive much of what I do."

Does he see himself choosing one discipline from among those he's been influenced by—Christianity, Buddhism, Native American religions? "Temperamentally no," he says. "I don't see myself doing that. I think of someone like Simone Weil, wanting so much to belong to one discipline.

"Thomas Merton has meant a great deal to me. Merton started out as an orthodox Catholic. Toward the end of his life he became fascinated with Buddhism. But I've been extremely uncomfortable using any of the traditional language when describing what I feel. There are a lot of thoughtful, well read people who have religious questions but are uncomfortable with the devalued language and symbols."

What causes the de-valued language? "Christian TV evangelism, knee-jerk non-Darwinian evangelism. If we were living in Japan, Zen Buddhism would seem more encrusted with stupidity."

A bird lands on the feeder outside the window and Steven picks up a pair of binoculars that are lying on the sill to look at it. "Steven," Scott says, "do you know what a nuthatch is?" The table in front of my son is covered,

I'm ashamed to admit, with yellow McDonald's wrappers from an Extra Value Meal. I'd just picked him up from camp, and the first thing he wanted was McDonald's.

A week at camp can't erase the fact that until this moment he didn't know what a nuthatch is but he knows nine years worth of McDonald's Happy Meal toys. Scott and his wife Ruth have two children of their own. "Ruth?" Steven says. (In this synchronistic world of nonfiction, he's actually eating a Baby Ruth and he and Scott get into a discussion of why Baby Ruth is, as the wrapper states, the official candy of the NFL when it should be the official candy of baseball.)

"The world is constantly telling our children," Scott says, "that whatever you own, it's outmoded. Consumerism requires that things be thrown out rather than worn out. Our kids are being told that the good life requires the constant consumption of things. That's a devastatingly false claim, spiritually."

How can you pay attention to ultimate things? We look at the nuthatch. Wildness and domesticity. "What God speaks," Scott writes in *Staying Put*, "I humbly submit, is the universe." The storm picks up and leaves the county. The mailman hand-delivers packages. Steven talks to Scott's son about basketball. A neighbor waves from across the street. The nuthatch sings. We all sit still and listen to her voice.

THE GOSPEL ACCORDING TO LISH

This was years ago, it happened in Lake Forest, Illinois, and I'll never forget it.

It was a weekend writer's retreat. I stayed in an inn that was so perfectly tasteful that the desk clerk, when I asked if the dining room had coffee to go, said in a possibly fake British accent that they certainly had nothing to send coffee-to-go in, and that I should go to a gas station (disguised as a cottage) that was hidden two blocks away. In the gas station they sold coffee made in restaurant-quality coffeemakers with half-and-half in a straw basket, but they did keep a supply of Styrofoam cups. At night a friend, who had come with me to Chicago to attend a wedding, ordered potato chips and they came to our room in a sterling silver bowl. We ate the chips in rose-colored wing back chairs, facing a fireplace. Under our window, long white limousines came and went. The inn was not obscenely expensive, about fifty dollars less per night than the Holiday Inn in downtown Chicago, but the veneer of the place shone old money. They kept their one Coke machine hidden in the basement.

Over the years I've talked to other people who were at this retreat,

people I didn't even know were there. Antonya Nelson. Diane Johnson. Barb Shoup. Over the years I've heard stories about the ones who were chosen from that weekend workshop and who, because of that chosenness, gave up their lives—marriages, jobs, in one case a vocation at a seminary—to move to New York and study with the one who did the choosing. All of these stories ended up badly. Cautionary tales.

Ragdale Artist's Colony is located in an old mansion along Green Bay Drive in Lake Forest. It was only a ten-minute walk from the Inn, but no one at the Inn had ever heard of Ragdale, so I had to find my way there on my own. The gas station was equally unhelpful.

The workshop started promptly at nine o'clock. Thirty-five of us sat on hard metal folding chairs, and we would sit there for most of twelve hours. The chairs were in a line facing the front of the room, and the room was beautiful. At the front of the room, Gordon Lish stood encircled by paned ceiling-to-floor windows, and the light shifted color around him as the day went on. He seemed to be aware of the shifting light, and he played to it, changing his voice when the room went gold at sunset—from the almost W. C. Fields quality he had when the day began (the clipped ends of sentences, the long tie and tweed coat) to a more resonant sermonic voice as he took off the coat, revealing khaki.

Like any group of pilgrims, we were there for different reasons. Some were groupies who followed him from town to town. Lishheads. Some of us who taught were there out of curiosity, or to learn something about teaching writing from this famous teacher of writing. Some were there like dancers at a casting call, hoping to be discovered. This had happened, in fact, to a friend of mine when Lish had visited his graduate school. My friend had been the chosen one: lifted up, published by Knopf in a fit of Lishian mania, then dumped, just as quickly. A temporary infatuation.

I came from curiosity, I meant the "from" rather than "out of," like curiosity is a homeland. It's a blessing, a curse, turns you into a snoop, lands you in places you never thought you'd be and are later oddly ashamed to admit you've been. Yes, I was there, I'd say to friends, fellow writers, a bit awkwardly, the way it might feel to one of my indy label neo-'60s musician friends who admits that he, yes, showed up to an American Idol audition. Not there, he might say, to be part of all that stuff. I come from curiosity, he might say. Even if he (Lish or Cowell) *discovered* me, lifted me up, I'd shrug in irony and go back to my happy but pure obscurity. I expected, perhaps, that kind of bluntness that helps you grow more than praise. I was in the mood for bluntness, in a bit of a writing funk at the time, though hoping to

be ignored more than anything. So I was surprised by his initial kindness and generosity, his initial persona, and at the same time knew that when the day was over I would leave feeling uncomfortable, even angry at the power his charisma gave him. At the time he was the only truly charismatic person I'd ever been in the presence of in my life, with all the potential for good and for evil that personal power embodies. Since then I've been in the presence of others, and I'm a sucker for it.

We had all paid too much money to be there. That article "Captain Fiction" had appeared in *Vanity Fair*. We knew his reputation, the years as editor at *Esquire*, his teaching record at Columbia and Yale with waiting lists 400 students long. And finally, most importantly, the years at Knopf where he published almost every young short story writer who was anybody in a given year, writers who began in his classes often, and who ended up being reviewed in the *New York Times*, who had an instant reputation by virtue of being his protégé. There was not, at the time, a more powerful living editor of American fiction. I was very young when I went there. I was very young when I wrote the first draft of this in fact. I look back now and recognize the awe I see in my own students when in the presence of some writers or editors. Don't sleep with him, I want to say to them, no matter what a brave act they may try to convince you you'll be committing, and I mean that literally but primarily metaphorically. It just isn't worth it.

Even now, when so many people have written about his workshops, when I mention that I was there at one of them, there are questions. What was it like? Was it good for you? It's true that at the time there was not a more quoted teacher of fiction writing. Those of us who were teachers had been using his quotes for years, even when we weren't aware of it.

So here's what it was like.

He began quietly. The chairs were hard. He stood stiffly. It would, I thought, be a long day. A twelve-hour workshop, and he told us that we were probably people who lacked the stamina and would never make it in the world, *his* world, if we got up from our chairs even once during those twelve hours. In the end he let us break for a short lunch and then a short dinner, and we knew he would, but he had to begin with that threat. That's the way he was and is.

"You'll never," he said, "be in the presence of anybody who knows more about the composition of prose fiction than am I." The inversion of "I am," an odd inversion.

"I'm asking you to be prepared to let go of a great deal of learned behavior. You can go away from this room today transformed, if you allow yourself to be. You can leave here not only a changed person, but a writer."

I thought we were there because we were writers and thought we could be better ones.

Though, I'll have to admit, I was questioning it at the time. It's odd, now, looking back on it. Ten years after college, I published my first book, and the same year, I had my first child, and the writing, which had been fueled by mid-twenties angst until that point, lost its fuel completely. I told myself I would publish five or six stories a year, and I did, but looking back at those stories now I see how bad they were. My real passion at the time was my son, soon to be joined, in the same year I attended this Ragdale conference, by my daughter. It's not until now, in fact, looking back, that I realize I was probably pregnant while I listened to him speak. And what he said had no connection to the person who was emerging in me, though I wanted to believe. And did. I'll admit it now, I did for a while believe so fervently that I thought the only possibility was failure. I'd read Tillie Olsen's *Silences*. I knew how few women, historically, had been writers with children. I had no idea how skewed those statistics were, though, or how many women there were like me struggling with the same issues, how they were the same issues all writers struggled with, but magnified—how to keep going, how to be honest, how to combine your work and your life. All I knew at the time was how many of us in that room, listening, were women, worried that everything he said was true.

Many of the people in the room were women in their forties and fifties. He told them they were old. Any of us over thirty, in fact, had an immense handicap. "Young writers," he said, "have less to unlearn." And they have less to lose. It's easier to be honest, to speak truly, he said, out of innocence. Once you have a family, a career, a life you feel you need to hold on to, it becomes more difficult to face yourself honestly, and facing yourself honestly, speaking "true sentences" is the only way you'll be great. He said this many times to this group full of people over thirty. You may have more wisdom, he said. But 23-year-old writers can hide their lack of wisdom, they can sound very wise, and they have the energy and the honesty. You have a handicap, he said.

All the time he talked, he brought up the name of a writer in her twenties, someone none of us had ever heard of. You're competing with her, he said. This is your competition.

Through the years, we would see her name here and there. A story in a small magazine. Then she disappeared. I would find out from a friend of mine that both Lish and Rust Hills would go to workshops like Iowa and pick one writer out of the crowd and ruin that writer's life. It was a competition between them. "You want to be hated, and quickly?" one of those young women said to me just this past year. "Have one of those two

anoint you as the chosen one. People hated me for years, and they'd never even met me. It took me forever to get over it." One of the other reasons for silence, according to Olsen, was success before you're ready.

So. Lish didn't allow us to use tape recorders, but I wrote quickly. And this is what he said:

- There must be in sentences a dramatic necessity. There must be conveyed to the heart of the reader some reason for the speaker to speak, so the reader will go to his death less hysterically.
- Never write a sentence unless you can convince yourself that there is that dramatic necessity. The world is shrieking all around you. If you want to be heard, you have to make a strong noise and a unique one. I'm not going to tell you how to get into print, but how to enter history.
- If you want to insert yourself among the world of 10,000 things, you have to make a mighty noise and a unique noise. To be the 10,001st thing is never to have existed at all. The extent to which you displace the other is the extent to which you enter the world.
- The life of an artist is not the life of a social being. It is often done in opposition to the world. I hear about a writer no longer writing, or selling out, and I think yet another person has elected to take a life of less consequence in the face of fear and anxiety. To write requires absolute heroism. The greatest prose fiction writers of this century have been models of absolute heroism.[1]
- The prose fiction you produce must give you a changed vision of who you are. Can you write, if you're a homosexual, a story about a homosexual who is less than sensitive, who is the villain in the piece? Stories are a witnessing of the possibilities of the heart. They are not there to prove a moral point or assertion, only to witness the complexity of life. You don't need to add to the complexity; you only need to be a recording angel of what is there. Really see and smell the object. Render the object as it is right in front of you. The world isn't going to listen to you if you convey what is already known, predicted, felt.
- If you begin to write true sentences, you will outstrip 99 percent of the people writing. Ninety-nine percent of the persons writing will not dare writing true sentences. Why? Like you, they have too much to lose.

1. He tells the story of a 50-year-old woman who opts for safety and a 27-year-old quadriplegic who doesn't. He tells stories of the most talented writers in his classes who gave up, of one or two of the very worst writers he had in classes who stuck to it and cared and learned and who were now nationally recognized writers. Over and over again, he says that writing is not talent but character, and in that, I believe he is partially right.

- What does the short story consist of? Authority. A sense of your being absolutely in possession of what you are talking about, of your being possessed by the story absolutely. Authority is pressure, the sense of there being a force pushing from underneath, the heart saying to the reader *"I've got to tell you this and you've got to listen. If you do, it will ease something in both of us. This sentence can save us both if I utter it for us."* That pressure has to be there from the very first sentence, and as you go on you run an increasing risk of diminishing your authority through inattention, fraudulence, lassitude, and fear.
- The story also consists of stance, the general notion of a positioning of a VOICE that's addressing the page. Before you begin speaking, you have to position yourself at the edge. Because everyone's shrieking, and to be noticed you have to be either terribly formal or terribly informal, terribly shrieking or terribly silent, terribly knowing or terribly unknowing. You can't be in the middle.
- Become increasingly aware of your body. Apprehend your body as it is, how it does the work. How does your physical body produce sound? Updike's fiction is the way it is partly because of that severe psoriasis. The page should be the extension of your body.

 Or better yet, the page should be the body of a lover. Voice. What has doomed a lot of writers is the inability to reinvent themselves, to find a new voice.
- The story also consists of news, of information, of story and plot. But stories will not get you into the world of 10,000 things. ALL THE STORIES HAVE BEEN TOLD. The task is to make yourself into a storyteller.
- So think of a story in this way. You have three bags of beads: a white, a blue, and a red. The reader has the string, and he strings the beads as you lay them out. At the end the beads are inextricably bound, and you've got a symbol at the end. Meaning is generated. Why? The body wants to put like with like. The mind insists on making order. I will pay out from these bags as I go through the story. The mind of the reader will smooth them out. If I let something out of the bag that is even close to a bead that came before, the reader will make order from them, will make one thing of them. To the extent to which I exceed three bags though, I hurt the story. You don't want to add another bag of beads. You want to deepen. You have to be a genius to manage more than three bags of beads.
- I may also call the beads horses.
- A story runs like this. There is an attack. There is only one good way into a story. The way out is the same way. Then the story is diagrammed as a

circle. There is torque, an arc. Your horses turn around, come back in upon themselves. If you begin at "1," you end at "-1." If there is "x" a quarter of the way through, there is "not x" three quarters through. You bring the story back to zero because you are God. The god of the page.

- You do not take sides. You don't care who wins. You're there to witness the complexity of being. If you open up saying "indifference is a bad way to be," you end up saying "indifference is the only way to stay alive." You keep changing what is asserted. You have got to keep turning and torquing. You've got to keep surprising. There is the speech of the speaker between the lines, the author. It's got to be done, it's got to be said, what you're saying. It's the conversation between author and reader. Your job is to throw a lasso around the reader and bring him into the material. Most writers throw a lasso around the material and ignore the reader.
- Sentences. Begin with sentences and work up to paragraphs and stories. Sentences must achieve an absolute integrity. Are they true?
- Trust your tropes. If you say something in a sentence, then unravel it, write it out, see what you're saying, don't just leave it. If a sentence can be opened up, then open it up. Then you will begin to get poetry.
- Sentences must be linked. Render the object. Don't just say "the worn spot." Begin to render the object. "The place in the linoleum where her feet had worn the spot with the constant washing of dishes . . ." and on, and you have a story. See what the phrase is trying to tell you.
- One way to develop exceptional statements is to reach for a transformation.
- Rosenberg said that "an artist is a person who invented an artist." Anybody can become the greatest writer of his time. It's entirely a matter of character and will, of wanting this thing. You have to be willing to pay the price.
- A human being is making this thing, this story. Is making this up. Ink. That's all any novel is. Ink. Don't conceal your markers and reference points. Great literary art is the positioning on the page of a specific persona.
- I'll say this once: Flinch at nothing. Run from nothing.
- What will do you in? How will you do yourself in? Most of you will talk yourself out of being a great writer. I'm tired, you'll say. I have domestic circumstances, you'll say. I'm not talented enough, you'll say. Some of you will not have the stamina. I write seven days a week, every day of the year, nine at night until three. Most of you will fail because you won't have the dedication to labor. Whatever else they do, the writers you are competing with work all the time.

[78]

- Most persons will fail because they are unwilling or unable to so revise their hearts to express that relationship to work.
- What else will do you in? The hidden enemy. The habitude for not telling the truth. You will edit yourselves out, deny the truth. You are so used to being inhibited speakers. Most of you will come to the page silencing yourself, not saying what the heart knows. If you resolve to speak with perfect innocence and absolute newness to the page as if you were speaking to God, you will be heard by God. If you lie, God will know. If you are afraid of the truth, you won't compete. Period.
- Your job, then, is to be subversive. You get up in church and say what nobody would dare say. Everybody in the world knows the same things. No one is fooled. We all know what the truth is, but who would dare say it. Your job is to say it. In so doing, you take on a priestly role. You offer the blessed sacrament to those who would not say it. You resurrect those who don't say it. You are bestowing a blessed sacrament. Thank God someone has said this! We all know it's true. All the talents and the smarts won't give you anything. The only writers who are remembered are those who uttered their own truth with the loudest voice they could summon.
- You must go down to the bone, the very bone, where it hurts. Take a few little things and go down. You write your first sentence and then if you deconstruct it and look at what it's really saying, you go on, writing by where you've been. You see what the sentence is telling you. You ask yourself what am I really saying here. Doing art is being alive to yourself as a sensate being. Don't begin by simply reporting. Notice that the news does nothing but distance you. I'm asking you to start speaking the sentences that are in your heart. If you don't care, why should your reader.
- The job of writing is to move the reader through your sentences to the end of the story. Never deliver yourself as one who knows more than anyone else. Come to the page ignorant, in search of knowledge. Acknowledge your own weakness and fear and anxiety and insufficiency. If you're making it up, the only person you can say is lowest is yourself. If you're the god of the page, lift them up. What's it going to cost you? You are the god of the page and to that extent you must not judge.
- When I came before you I said I was the greatest teacher of these materials going, and now I'm proving it.
- Never write about teachers or about writers.

IMAGINATION

A rainy Saturday morning. The "rehab girl," a student EMT, fills the water jug for a group of cadet firefighters at the Wayne Township Fire Department's training site. You may have seen it on your way to the airport: a large windowless cement-block tower, like something from a dreamscape or De Chirico painting, with WTFD painted on the side in pink and green.

Inside the cement tower there are, as you'd expect in a tower from your dreams, many false rooms. And each room has a similar décor. Soot on the walls, drains on the floor, glass-less windows. And inside each room there are metal pipes in the shape of furniture, each pipe filled with the hiss of propane.

There's a room with an object built of pipes in the shape of a double bed, complete with headboard, so that, when lit, you see what seems to be a bed on fire. There's a propane sofa, a propane kitchen sink, a propane industrial spill. When the fires are lit, the temperature in each room rises to seven hundred degrees or above. And that's when the chief turns on the smoke machine.

For emergency workers and soldiers, training and then "scenarios" or games to test the training, are the only ways to prepare for the thing that

can't really be foreseen. The fifteen or so 20-year-old boys (they were all boys to me) helped each other with their gear. Nylon covering every wisp of hair, suits with their fluorescent striping zipped and fastened, masks flush against the faces, oxygen tanks working, batteries in the flashlights. The students buttoned one another up, checked each others' gear, like parents fastening khaki snowsuits. Their faces covered, the Darth Vader sound of the oxygen, the way they move in their heavy moonsuits: you can see why a child would be frightened of this apparition appearing through the heat and smoke of their nightmares.

When the smoke starts roiling out the glass-less windows, one team makes its first trip inside. They crawl up a ladder toward a second story door, the lead carrying the nozzle end of the hose, boys on the ground feeding the hose to those going inside. The hose is incredibly heavy, even when unfilled, and the suits are awkward. They need help, this time, to get over the railing and onto the balcony.

Once on the balcony, one of the boys forgets to stamp his feet to see if the floor is solid. You're dead! The chief yells. And the boy lies down.

The rest crawl through the door.

When the boys are inside, the fire hose becomes their only path out. If they feel a body lying on the floor (a mannequin, life size and weighted) they crawl behind the false sofa in the false room, pretend to check the body for injuries in the heat—neck or head? Weigh the risks of moving now against waiting to strap him to a board. It's dark, seven hundred degrees, they're sweating in the suits, and thirsty, and now there's this body and they've got to keep checking the floor for stability as propane flames shoot down from the ceiling and comrades are dousing the flames that don't, of course, go out, like one of those trick birthday candles. And the comrades will drag the body through the dark smoke—there's no way to see at all now. Where's the hose? Panic! This mannequin is dying. The hose, dammit! The hose!

And they find it, finally, like a scuba diver connected now to the only way up out of the dark.

Most of them make it through the exercise. Some of them suffer from panic: "My arm!" they'll say, "my leg! It's numb!" Sometimes they fall from heat exhaustion.

Like now. A boy comes out of the fire. He's used up all his air. Does it matter that it's not a real fire? No, it doesn't. He's used up all his air. His face is blue and his airline beeping. His friends pull off the mask. They're all sucking air today. It's their first time in the imaginary house. They go through air fast. You take your air with you when you go inside, and when you run out of it, you have to leave.

The boy bends over. His face is red. The rehab girl is suddenly a real EMT. She checks the pulse, blood pressure, puts ice packs at the groin, gives the boy a cup of water, calms him. All the while the real medics watch over both of them. You can see an angel in every picture of a fire, the boy says. He's delirious. No, it's true, the rehab girl says.

Real firefighters who are keeping an eye on them call a real ambulance. A friend of the boy with heat exhaustion says he doesn't care if he flunks the course. His responsibility is to his friend. When the ambulance comes, he'll take off all his gear and go with him.

The house is burning down, and all of it feels real.

ON BEING FIERCE

Last summer my daughter brought home a dog that weighed two pounds and still weighs less than five, and as I'm writing this she (the dog) is playing with a cat toy, a red felt mouse with chewed up ears that holds a plastic ball filled with beads between its two front fake fur paws. The beads rattle as the dog holds the toy in her teeth and shakes it hard from side to side and growls. To her it's not a cat toy; it's the primordial mouse her DNA taught her to catch and kill, the plastic smiling red felt mouse with its death rattle, and she hardly ever lets it go. All day long this dog is fierce.

When I thought about what I might tell my writing students in a last lecture, I decided I wanted to tell them to stay as fierce as this less-than-five-pound dog. And so some rules:

1

Whether it was a photograph in a shop-window that had first prompted me, or a chance remark negligently dropped in my hearing, I do not now remember nor does it much signify. I know only that some time before that spring day the word Eskimo had rung inside me and that the sound

had begun to swell like the vibrations of a great bell and had eventually filled the whole of my subconscious being. I had not been possessed instantly by a conscious and urgent need to go into the Arctic and live with a primitive people. These things operate slowly, like the germ of a cancer. They brood within, they send out tentacles and grow. Their first effect is not decision but restlessness. You find yourself feeling that something is obscurely yet radically wrong with your life. You fidget. Your world becomes progressively more stuffy, less tolerable. Probably you show it, and show it unpleasantly; for your friends seem to you more and more to be talking nonsense, leading a meaningless existence, content with a frivolity and a mediocrity to which you find yourself superior. In their eyes, very likely, unbearably superior. But no matter. The thing is at work in you. Finally, there comes a moment when you waken in the middle of the night and lie still, eyes wide open in the dark. Life, you sense, is about to change. Something is about to happen. And it happens. You have made your decision.

—De Poncin, *Kabloona*

I've always loved this opening to De Poncin's book *Kabloona* because it describes the way a subject takes hold of a writer, how something as simple as a word will for some unknown reason begin to resonate inside you, and suddenly everything but that idea, that word, seems meaningless, and even if in your daily life you have difficulties with decisions, you have no difficulty with this one. Why Eskimo? Any reasonable person would ask himself that and do his best to ignore it. De Poncin didn't. And so there he was, a French aristocrat in the 1930s, and he had to present himself before some priests to ask for a ride. They said all right, but treated the whole thing as a joke, he writes, like a Sunday picnic. The bishop took him along as a lark and spent the whole plane ride absorbed in a book while De Poncin, alert to the mystery of the word that brought him here, looked below and saw "a wide land of forest sown with thousands and thousands of shining pools, an unfinished world from which the waters had still to recede and where you would have said that no man lived." But "the airplane is radioactive," he wrote "and itself a creator of life." You "did not drop down from time to time because life suddenly appeared below" you, for wherever you looked, no life was to be seen. Yet wherever "you" "stooped, life sprang up as if spontaneously generated by 'your' coming; and it died down again when 'you' rose as if 'you' were carrying off the seed of life."

And so, while the bishop read his breviary, expecting to see what he expected to see, De Poncin's attention was itself radioactive because he stayed that prayerfully alert throughout the writing of his as yet unwritten

book. He was open to mystery. If De Poncin was searching for a topic, as long as it was this or that, he wouldn't have ended up in the Canadian arctic, wouldn't have felt possessed, the subject wouldn't have caught him in its hooks. Or even if he'd been caught, if he'd been reasonable, he would have had a drink, dreamed a few minor dreams, talked it all out at a bar or two and let it pass.

But he was not in the least bit reasonable, and a hook is the metaphor I would use for the beginning of his obsession. Something in the universe is always trolling the waters for a curious mind, an open heart. There are an infinite number of hooks in the watery air at every moment, invisible glass ones that you can hear sometimes in the wind, and each one of those glass hooks is attached to an invisible string, and each string, if followed, is attached to all there is. It doesn't matter if the hook is the word Eskimo or factory or gingko trees or frogs or pine needles or spiral galaxies or Shakespeare or image restoration and calculus. All that matters is that in the moment when you feel that pull toward some subject, you've been caught. The hook is in you. You've fallen irrationally in love. The priests will laugh at you. You're dressed like a dandy. You couldn't possibly bear the cold. Your husband or wife, your children, mother, father, friends, and neighbors. All of them might laugh. It will seem absurd to anyone but you. But the fact is that you ignore it at your peril. It won't go away. The word will stay inside you, joining the other hooks you have ignored, creating a nest of them, a messy coffin of a tackle box that you can sometimes feel right before you go to sleep. When I become aware of that box, I'll untangle an old hook and try to follow it, but usually it's lost its hold on the invisible string. I'm left with nothing but the hook. The fisherman has shrugged off the loss, reset another hook. It's drifted back into the air. Little by little I'll feel the hook, my hook, dissolve. And then I'll look around and see it:

The damn book with someone else's name on it.

Because the obsession, the writing, or the research takes hours away from other things, things that a good person might do instead; it takes a certain faith, an irrational leap, and it takes, most of all, a gathering together of every bit of courage at your disposal to go ahead with it. Being caught is only the beginning of the struggle. You have to hold on and follow the thread, take risks.

Rule One? You may in fact be crazy. You may in fact be one of those people who spends his life building a replica of the Vatican out of popsicle sticks. It may be a good replica of the Vatican built of popsicle sticks. Someone may be deeply moved by that replica. Or not. Who knows? Rule one: Despite the risks, just let yourself be caught.

2

> Not long ago my sister Melinda shocked me by saying she had always
> assumed that the book on Mooreland Indiana had yet to be written
> because no one sane would be interested in reading it. "No no, wait," she
> said. "I know who might read such a book. A person lying in a hospital
> bed with no television and no roommate. Just lying there. Maybe waiting
> for a physical therapist. And then here comes a candy striper with a
> squeaky library cart and on that cart there is only one book—or maybe
> two books: yours, and Cooking with Pork. I can see how a person would
> be grateful for Mooreland then."
>
> —Haven Kimmel, *A Girl Named Zippy*

I lived for five years in New Castle, Indiana, a town whose primary
industry was a large Chrysler foundry. The town, coincidentally, was
about ten miles away from Mooreland. The foundry was so important to
the town that, when the high school built the world's largest high school
gymnasium, they named it Chrysler Fieldhouse and in fact renamed the
high school Chrysler without even thinking of asking the corporation for
any money. Why not make it a sponsorship deal? In New Castle, Indiana, it
would have been simply impolite to ask. They named the high school
Chrysler in gratitude. Chrysler wages paid for the evening meal, for the
kids' shoes, they paid the mortgage and made the car payments. Some-
times those wages sent the kids to college. Of course if some big shot in
Detroit *happened* to notice how much the town fathers loved their com-
pany and decided to keep the plant open, if there was a choice between
closing the one in New Castle and the one in, say, Richmond, it was
assumed that Chrysler would recognize this selfless gift, this true devotion,
and like the gods they were, they would be just.

Of course Chrysler didn't notice New Castle's devotion, didn't care,
closed down the plant, but oddly the high school still bears its name. One
hundred years from now, if the town still exists, the high school will no
doubt still be Chrysler High.

My students often remain in the Midwest, and in the provinces we
think in our heart of hearts that we're invisible but maintain the eternally
optimistic belief that someone somewhere will, despite all the odds against
it, see us. When the bad thing happens, as in your heart you knew it would,
when the powers that exist, always, someplace else, do the thing they were
bound to do you get over it, and your fatalism grows. Fatalism is our fatal
flaw in the Midwest, stoicism perhaps a virtue.

But fierceness? It's tough for us. We don't ask for what we want or
recognize what we have.

One of my students has a boyfriend who lives in Henry County. For years he's been thinking deep depressing thoughts, and he decided that meant he'd be a writer. Two weeks ago, we read Chekhov's *Ward No. 6* in my lit class and the girl said, "That's my boyfriend. Those are all his thoughts." Here's what Chekhov said and what some boy in New Castle, Indiana, is at this very moment thinking: "Oh why is not man immortal? What is the good of the brain centres and convolutions, what is the good of sight, speech, self-consciousness, genius, if it is all destined to depart into the soil, and in the end to grow cold together with the earth's crust and then for millions of years to fly with the earth round the sun with no meaning and no object? To do that there was no need at all to draw man with his lofty, almost godlike intellect out of non-existence and then, as though in mockery, to turn him into clay. . . . Only the coward who has more fear of death than dignity can comfort himself with the fact that his body will in time live again in the grass, in the stones, in the road. To find one's immortality in the transmutation of substances is as strange as to prophesy a brilliant future for the case after a precious violin has been broken and become useless."

My student sent a copy of the story to her boyfriend, and he wrote back on email: "So. I knew I was miserable, but I thought at least I was original. And here's some guy who said the same thing one hundred years ago and better. I give up. It's all I had. Who wants to read about Henry County?"

In *Ward No. 6* Chekhov is writing about a very specific hospital in a very specific time and place. He's in conversation with Tolstoy's theories of nonresistance to evil, with Marcus Auerlius and Schopenhauer and with his own demons. But most of all he knows the doctor's "coarse peasant like face" as he thinks these thoughts, he knows that this particular night is not broken by a single sound, that the room in which the doctor thinks is filled with books and a lamp with a green shade. And he knows, in particular, that the doctor thinking these morbid thoughts actually feels delight and enthusiasm over them, and at the same time he's thinking, he knows that his thoughts are "floating together with the cooling earth round the sun" while "in the main building beside his abode people were suffering in sickness and someone was making war upon the insects or moaning over too tight a bandage or playing cards with the nurses and drinking vodka."

The ideas are universal, but the particulars—the boy in Henry County, Indiana, with its particular light, the way the girl is sending him Chekhov's story in the mail even though he could get it on the internet because he needs mail, she says, the Xerox copy of Nicholas Chekhov's painting of Anton that she's sending her boyfriend to make him jealous (Chekhov

looks in that picture, she says, like Johnny Depp mixed with Leonardo DiCaprio)—remain particular. That will only happen once in space and time. It may very well remain invisible. There's much of the world that does, and much of literature that will in fact simply float with the cooling earth around the sun, that will grow cold with the earth's crust and exist with no meaning.

Chekhov believed this. He believed it throughout the four hundred some stories and the great plays, all written simultaneously with his dying from tuberculosis, taking care of his family, innumerable love affairs, the building of schools and libraries, and the planting of at least 1,000 trees. And he said it despite the fact that he lived in a still medieval Russia surrounded by the red and green candles of orthodoxy. The boy in New Castle may not write because he thinks it's all been said before. Of course it's been said before, but not by him. Second rule for the fierce writer: Know this—every place on earth is filled with stories, with layers of forgotten history. It's Chekhov's brilliance or Alice Munro's or Thomas Hardy's or Welty's or Kimmel's or Faulkner's or Flannery O'Connor's—regionalists all—to excavate those layers and include them in one human story. To deny invisibility. In the Midwest, we need to work at being fierce.

3

Which leads me to rule three.

In an essay titled "Writing in the Cold," the poet Ted Solataroff writes about researching O'Henry Award–winning writers who are still writing ten years later. He tracked all the writers down and discovered that the key to holding the course is your ability to handle rejection—which is relentless and never ends.

Flannery O'Connor was hooked early on by her particular vision. There was never any question of not following it. Her writing itself is fierce, but she was personally fierce as well. Right out of graduate school she received a letter from the publisher, Rinehart (who had given her an award to complete her first novel, *Wise Blood*), and this is part of the response she wrote to her agent: "The criticism is vague and really tells me nothing except that they don't like it. I feel the objections they raise are connected with its virtues, and the thought of working with them specifically to correct these lacks they mention is repulsive to me. The letter is addressed to a slightly dim-witted Camp Fire Girl, and I cannot look with composure on getting a lifetime of others like them."

In response to John Selby, the editor at Rinehart, she wrote: "I can only hope that in the finished novel the direction will be clearer, but I can

tell you that I would not like at all to work with you as do other writers on your list. . . . I do not think there is any lack of objectivity in the writing; however, if this is what your criticism implies; and also I do not feel that rewriting has obscured the direction. I feel it has given whatever direction is now present. In short, I am amenable to criticism but only within the sphere of what I am trying to do; I will not be persuaded to do otherwise. The finished book, though I hope less angular, will be just as odd if not odder than the nine chapters you have now. The question is: is Rinehart interested in publishing this kind of novel?

P.S. I thought a bloody semicolon was for a long pause. What is it for?"

And O'Connor's stories and characters are as fierce as her letters.

If you've been redeemed, Hazel Motes says to Mrs. Hitchcock on the train in the first chapter of O'Connor's novel *Wise Blood,* "I wouldn't want to be." Like a kid who says something you'd like to say but wouldn't have the courage to. That's O'Connor. After Hazel Motes says this, he turns his head to the window. "He saw his pale reflection with the dark empty space outside coming through it. A boxcar roared past, chopping the empty space in two, and one of the women laughed." That reflection with the dark empty space is both carefully observed and symbolic and bare. Every hook for O'Connor is in the shape of a cross.

Fiction, she said in *Mystery and Manners,* is an incarnational art. The artist seeks revelation, she explained, through sense perception

O'Connor was a Catholic writing in the south, but hers was a Catholicism influenced by twentieth-century existentialists, and so her characters learn that a human being needs "to live constantly in the face of death, in the awareness that here and now may be the last moment." And that's the way she wrote. She read and read and read while she wrote. And she kept the windows of perception clean. For O'Connor learning to write meant learning to see, and the fierceness required of a writer is the courage it takes to follow the thread of perception even if it means that, like the character of Motes, you might "come off into the dark where [you're] not sure of your footing, where you might be walking on the water and not know it and then suddenly [through self consciousness] know it and drown."

O'Connor says about the grandmother in "A Good Man is Hard to Find" that she would have been a good woman if there had been someone there to shoot her every day of her life. In this she echoes Chekhov, who says there should be someone standing next to every happy man with a hammer waiting to hit him in the head. Why? To keep him awake. Third rule? Great literature takes both the reader and the writer out of the comfort of illusion and into the real. Only fierce honestly will get you

there. Get yourself a hammer. Chekhov's a good hammer, as is O'Connor, as is any great art. Rule number three: Think of rejection as a hammer as well. Most people don't. And don't go back to sleep.

4

Rule four: You can whisper and still be fierce.

5

Or you can scream.

Recently I've rekindled my adolescent love for Sylvia Plath. I teach a madness and literature course, and of course she had to be in there, but I came away with an appreciation for how incredibly good her poetry is. It's not the romantic vision of her illness that attracts me; it's the fierceness of her struggle with it. As she said, when she was crazy she was too busy being crazy to write. Though what she does maintain from the illness is the thing that mental illness and creativity have in common—those enormous leaps against the tide of logic, an easy skimming from lamppost to redbird to St. Thomas Aquinas. Divergent thinking. But the other thing she has in her arsenal is her intelligence, her ability to draw the divergent ideas into something that makes sense. Convergent thinking.

Oddly, she was obsessed by hooks. The first stanza of her long poem "Tulips" reads:

The tulips are too excitable, it is winter here.

Look how white everything is, how quiet, how snowed-in
I am learning peacefulness, lying by myself quietly
As the light lies on these white walls, this bed, these hands.
I am nobody; I have nothing to do with explosions.
I have given my name and my day-clothes up to the nurses
And my history to the anaesthetist and my body to surgeons. . . .
They have propped my head between the pillow and the sheet-cuff. . . .[1]

This is a fierce courageous poem. The initial simple hook is tulips. They're too excitable. Follow them. Why? Because it's winter here. Why? It's white, which leads to snowed-in, which leads to absence, to being nobody, to giving away her name and clothes and history and body, to being propped

1. To see the entire poem, go online or to the *Collected Poems of Sylvia Plath,* edited by Ted Hughes.

between the pillow and sheet cup like what? Like an eye between two white lids that will not shut, will not die. Eye? And in the next stanza she's become a "stupid pupil" that sees. Sees what? Nurses that are like gulls, and that leads her to the image of caps, and that leads her to the image of water, and that leads to an image of the body lying in the hospital bed as a pebble being smoothed.

And the idea of being smoothed leads to the idea of numbness, which reminds her, since she's in the hospital, of needles and of letting things slip, and the word slip reminds her again, because she's been thinking of pebbles and whitecaps and gulls, of a boat hanging onto its associations because it's a cargo boat—and the cargo? The cargo is a teaset, linen, books, all sinking now, and suddenly in the poem she's become a nun—going back to the water in the third stanza and a reminder of the white caps and moving forward to the nothing that the dead close on "like a Communion tablet," she writes. Communion? You give gifts at communion, so her mind goes from communion to "gift paper" to "white swadlings" (white for communion), and then to "an awful baby," and then to the image of red (a baby's mouth and the tulips) that leads her to a wound, tongues, color, "a dozen red lead sinkers" around her neck. And we go on with the red and the water and the rust-red engine and the snags and eddies and back to the tulips again, which should, she writes, "be behind bars like dangerous animals." Which reminds her of the mouth of a great African cat, which reminds her of her heart that opens and closes like the mouth of that cat, opens and closes—what?—"its bowl of red" tulips, which, like the heart, "blooms out of sheer love of me." And all these associative images lead to the image of the ocean: "the water I taste is warm and salt, like the sea," the poem ends, "and comes from a country far away as health."

She follows the hook of the hated tulips, tacks through the water like a sailboat through all the ocean imagery, the religious imagery, the hooks, the lines and sinkers, and the hook of the tulip; her fierce wrestling with the red of the tulip leads her back to the tulips, to the surprising (to her and to us) image that her heart blooms out of "sheer love of me" and comes "from a country far away as health." Why follow the tulip? Why Eskimo? Because it leads to truth. Follow any thread, and it leads to truth, if you let it.

She is one writer who absolutely had no choice. The hook was in there early, and it was one quite deadly hook. This hook would not so easily let go as it would for most of us—no simple instrument played as a teenager resting in a closet and calling to you, no unfinished article or book, no half knitted sweater. This hook was firmly lodged within the heart, and it was

sharp, and the thread was strong, and to pull against it was impossible. To grab onto the string and pull was the only respite she had. It was a tug of war that finally exhausted her. But while it lasted, it was fierce.

A rule for the fierce writer who also happens to be crazy: Remember that you're a shark, and you cannot ever for one second stop swimming. Rules for the fierce writer who happens not to be crazy: Trust the thread. Say what you mean.

But here's where I've caught myself on my own hook. Why did the word "fierce" grab hold of me this week and not let go? Isn't there too much fierceness in the world already? Because the question remains: How do you know with the simple absolute knowledge that the word is one to follow or one to resist? When you're writing, you know it. That's all I can say. But I also know that there are those other hooks, other obsessions, the ones that lead toward destruction rather than creation, and they can feel the same. I'm thinking of Paul Tillich's phenomenology of the demonic in *The Interpretation of History*. The demonic wears the face of fascination, feels like an overwhelming power; we experience it as a seizure, as a revelation of meaning, as "depths that lead either to what is ultimately real or to utter annihilation." It's the kind of obsession that feels like an opening up of freedom but which is, finally, the taking away of it.

When I looked at Tillich's essay again this week I saw that there was something else he talks about. And that's inertia. Stasis. This is how the obsessions of art are different from the obsessions of power or the sudden rising up of whatever crazy illusion it is that leads to war. In O'Connor's stories violence leads the characters back out of illusion and into the real. It takes something that big, O'Connor said, to knock her blockheaded characters out of their self satisfied worlds. When the inertial character takes hold it tends to corrupt the spirit. We may simply resign ourselves to the inevitable, demonic power as takes hold, diverting the spirit from its sense of justice and destroying the courage to resist exploitation. Niebuhr said that human beings are by definition anxious because they're free. They have to die and along the way they have to make choices. Stasis seems to be one way of avoiding the knowledge of the one and the necessity of the other. The more I think about literature the more I think that narrative is an engine that brings characters our of stasis and into the real world of that anxiety, away from the illusory world they've created to avoid it, and the more I think about the creation of art the more I think it does the same. In our lives, as in our art, we must stay fierce.

MONOPOLY HOUSES

On John McPhee's
"The Search for Marvin Gardens"

Sunrise in New Harmony, Indiana. St. Francis stands on a brick pedestal by a blue-black/olive pond, and he flings his birds toward the sky in salutation. He's made of iron, but his robes seem to flow like water. And those birds! They're arranged in an arc above his head as though they're both separate and at the same time originating from the saint's loving hands, or rather, like the saint is a Samurai juggling two dozen miniature swords that have transformed and taken flight. The real geese along the pond, this day, have all gone mad.

Across the pond, St. Francis in another incarnation bends, one hand touching the earth and the other heavenward, the angel of the sixth seal resting on his back, again in blessing.

There are no cars on the streets behind the New Harmony Inn, and as the day progresses there will still be very few because it's hard, as it should be, to find your way to harmony, new or otherwise. I myself am here only to observe. In the afternoon an elderly woman will drive the leaf-shadowed street in a golf cart, her eyes shaded by a straw hat, her pale blue dress a chip of clouded sky. Mrs. Jane Owen. More than anything else, this place is a product of her imagination. Her masterpiece.

A Norfolk pine, a secret garden, a hidden chapel, a quote, a fountain, a pathway winding through the woods: Mrs. Owens' canvas is perhaps a mile in circumference, circumscribed by the Wabash. Fragile with age and beautiful, she closes her eyes when she speaks and the words have the cadence of music. Her subject matter ranges from Paul Tillich, whose ashes are buried behind the Inn and whose spirit she can feel here ("Man and nature belong together in their created glory," she says, quoting him, "in their tragedy and in their salvation") to Bush ("If I were a good Christian, I would pity him") to a play she saw a week ago, to the Muslims who will be visiting New Harmony to see what Americans can be when they're not at war, to the difficulty the delphiniums have growing in the southern Indiana heat, as though they were children, to the new paths and sculptures she's placed so exactly. "You look tired," she says to me. "You need to walk the labyrinth. You must be emptied in order to be filled." The early morning sunlight filtering through the hat onto her face, she seems, as the poet Matthew Graham says, to hover someplace between earth and heaven.

When you walk through New Harmony, you're aware that you're walking through this consciously created space, with "patches of sacred space" as Heather McHugh calls them. The Greek word for these patches is *temenos*. Unlike most sacred places—cathedrals or buildings near landscapes such as Sedona that were built or exist on a greater-than-human scale—there's nothing inherently transcendent about the landscape itself here, which is flat pocket country at the convergence of two rivers.

Though I say that, and last night, a night in June 2006, the Wabash was streaked with such bright silver that it looked like you could mine it. The silver was the real thing and went on, depths upon depths. If I had placed my hand in it, I truly believe it would have come out glazed. And to the north, by the Barn Abbey, it looked as though someone had placed a painted scrim of gold and fresh green fields along the edge of the river; it was that surreal in its perfection.

It's the light, I supposed. The light. But not just the light. It's the shaping of that light. Mrs. Owen did a "deep map" of the place-the layers of human and non-human history—restored the narrative, and made the connections between the layers and the evolving present. As opposed to a place like Williamsburg, Jane Owen sees New Harmony as a river, she explains, and not a lake. Meaning continues to accrue, to flow, a meaning so mysterious and rich that other artists bring their own work and add them to the gallery: the pure white chapel, large enough for one worshipper, that is placed so exactly along the bank of a moss green pond that at all times of the day it's reflected in the water, an impossibly white rectangular

Monopoly house in the green. There's a double, star-shaped cross sculpture in the grass in front of the house that becomes, in the reflection, a cross-shaped window and that, at night, when the floodlight shines toward it, turns into a shadow against the house, and the shadowed tips look like birds in flight in St. Francis' hands across the way. Perfectly echoed.

And little things: the scent of flowering tobacco and spikes of Russian sage in a master gardener's yard. The branches twisted into the shape of huts in the silent downtown echoing the Harmonist cabins, the crimson gothic door of the *roofed* church around the corner from the roofless one, the gothic arch of a kitchen curtain in a house across the street and the moody, spooky way those Bradford pear trees in the gated hosta garden, trees usually so flame-like, have been trimmed to form that same gothic arch, an explosion of arches that form paper-thin waxed blue cathedral windows out of the night sky. The garden is dedicated in memory of Mrs. Owens' daughter, and it rests against her home as the girl might have rested against her mother's arms.

Everything in New Harmony chimes like this, in pattern and a variation of that pattern, like all art. The screens in the doors to the New Harmony Inn are gold, and in the daylight they glow and harmonize with the golden gates of the Roofless Church, and the iron flock of birds around St. Francis's head chime with the flocks of very real birds, and at night they inscribe complicated figures of light in the air, like a figure skater on ice, and always, all around you, there's the sudden glimpse of a brooding monk or child or woman or fallen angel—the mind's first draft—that makes you look again to see that no, it's no monk, no crying child or grieving mother, but a piece of carved stone.

Why do I keep wanting to insist she is the artist? For the same reason, I suppose, that Virginia Woolf insisted on the artistry of her domestic women. Because it's true and because it's hidden. And because she will not get the credit, I'm afraid. Ah, Philip Johnson, history will say, what an amazing architect, and his conception for that Roofless Church: only the sky is large enough to contain the love of God! But it was Mrs. Owen's conception, and it was Mrs. Owen who brought Johnson and the sculptor Lipchitz together here with Merton and Tillich, and it was Mrs. Owen who restored the buildings, reminders of the two nineteenth century utopias. And it's that bringing together of disparate things that is also the very definition of art. But I'm afraid that history will say, if anything, *Mrs. Owen, how wonderful was your hospitality.*

But the thing that interests me about this place right now is the way that New Harmony is not experienced as a linear narrative: this happened in 1850 and then this in 1860, and so on. Everything is vertical, layered,

and the harmonic is created by the convergence of language (quotations on plaques and stones that take you by surprise: *Doubt is not the opposite of faith; it is one element of faith* or *As long as we are on earth, the love that unites us will bring suffering by our very contact with one another because this love is the resetting of a body of broken bones* or *A culture that has forgotten how to pray, goes mad with desire* engraved on a plaque or stone) and shaped space.

Most importantly, the place is *experienced* vertically, in clots and chunks of time.

Here, a summer afternoon by the pond—eastern, calming, the shadows of the leaves on your face, the silver grasses right there by your eye. There, communion with friends around a long table, the sun setting through glasses of wine—you could be in the middle of a childhood dream of your future or your fantasies of Greece—or there, dunes of sand in black and white, the bust of the beloved Tillich. Mrs. Owens' work is experienced as an assemblage. For an artist who sees the past as it percolates through the present, the alternative to the linear essay is Mrs. Owens' answer. It's the "deep map," the collage.

One of my best friends dreams of someday living in Monopoly houses. He wants them to be that red and green and yellow and blue, a living room in one house and a kitchen in another, and so on. He wants the roof of each house to be made of tin or aluminum or something metallic so its red or green or yellow or blue can be seen for miles, so that he can hear the rain, so it shines in the occasional sun.

The houses will be built of something that feels like plastic, and they will all be connected by glass walkways, and the great thing about them is that they will never have to move from one square on a board to another. They will never move at all, will remain always in the middle of a bean field in Indiana, and the beans themselves will change from green to yellow to red (though never blue), and he will always be happy. I think it would go well in New Harmony, that it would chime with the Harmonist cabins.

My friend writes essays and stories that are built like mosaics, like his dream house, and the white spaces between the chunks of words or houses are the glass corridors, and you can move around the pieces in any order that you choose, and they're concerned with vertical, not horizontal, time.

His favorite mosaic essay (other than his own, which are some of my favorites as well) is John McPhee's "The Search for Marvin Gardens." The essay is built around a brilliant conceit. A man (John McPhee) and one of *his* best friends in the world sit down to play a game of Monopoly, and in the process McPhee wonders what the real Atlantic City looks like now.

And so, as he travels through the game with his friend, which he describes, he moves in the mosaic between the places on the board (a map of an ideal Atlantic City) and the place represented by the map in much the same way my own friend moves between his real home and the ideal one that he will someday build in New Harmony.

McPhee never tells us directly that he's made the trip to Atlantic City, that he's made the trips to the library, that he's researched real places and interviewed real people. He doesn't say, "I'm sitting here playing Monopoly with my friend and I'm reminded of the day last week when I went. . . ." There are very few overt connections at all.

In the mosaic essay McPhee is doing what creative nonfiction writers often do—taking things that don't seem on the surface to go together, "following rabbits down holes," as Scott Russell Sanders calls it. He's completely associative in his thinking, trusting that he will be able to pull it all together in the end. And that's the key to successful pieces like this—the surprise that, after all the associative and seemingly random thought, the writer is able, finally, to make sense of the chaos. And sense does have to be made. That's one of the reasons we write. Because life does come at us in that chaotic way, and writing makes sense of it.

So, first, the chaos. The piece jumps from two guys playing Monopoly: "Go. I roll the dice a six and a two. Through the air I move my token to Vermont Avenue" ("where dog packs range"). And suddenly the words "Vermont Avenue," as they might in poetry, take on two meanings—the literal place and the place of the game—and serve as the hinge between the sections of the mosaic. They also connect two periods of time.

From this point on we're prepared for the essay to move back and forth between the game place and the real place, between history and play and observation. We're also prepared by that first piece of the mosaic for the essay to move not only between sections but *within* sections, from the place to the map of the place. "The sidewalks of St. Charles Place have been cracked to shards by through-growing weeds. There are no buildings. . . . Five plane trees are all that live on St. Charles Place. Block upon block, gradually we are canceling each other out," McPhee writes, and this hinge sentence that could work in either world leads him to state, "My opponent follows a plan of his own devising," a line that is true in the game but also has resonance in the social Darwinian world of capitalism.

I actually like the metaphor of hinge as a metaphor for metaphors. There are no shutters on Monopoly houses, but if there were, it's the hinge that makes them swing from the meaning that hugs the house to the meaning that swings out into the air.

Sometimes the associative leaps involved in the transitions are ob-

vious, for instance, when a section in the essay ends, McPhee's friend is "called into the Army . . . in game two I go immediately to jail . . . ," and in the next section of the essay McPhee leaves the game and begins, "Visiting hours are daily eleven to two," and you know the next setting is the literal jail. In other places the associations are less clear.

So what holds it together besides the metaphor of the game? How is the chaos transformed into sense?

First, the details. In each instance, what the writer chooses to report is an image of deep and complex decay. In the jail there's a "windowless interior," an 18-year-old "in steel cuffs." There are reports of overdoses, visions of liquor stores, roofs blown off, bricks scattered in the streets, unemployment lines, bad dogs, broken windows, abandoned windows, a mattress lying in the street soaking in a pool of water. The piece relies on its details to carry meaning: the many smashed windows, a white Ford station wagon stripped to the chassis, a plastic Clorox bottle sitting on the driver's seat, the wind that has pressed newspaper against a chain link fence.

All of this in implied contrast with the origin of Monopoly, which is about capitalism as a game, the accrual of wealth. Paper money, which is, in itself, a symbol.

The piece relies on irony: the Paradise Soul Saving Station on Virginia Avenue in pink, orange, and yellow and flanked by the Virginia Money Loan Office. And the irony is created by juxtaposition: the Soul Saving Station is right next to Singer sewing machines and pictures of Christ and a phrenologist.

But if it were only the details and the irony, it might begin to work, sort of work, but not hang together in a whole. The piece is about *the* Monopoly, *the game,* as a celebration of capitalism and the irony of the place itself—yes, yes—but what else? What's the question that's trying to be answered? What's the point of it all finally?

If an essay means "to try," and the writer senses in the first draft what he or she is after but isn't quite sure of yet, you sense in this essay the point at which McPhee wants to take it beyond the simple irony and asks himself the question, "Why?" or "So what?" These are the most important questions a writer can ask, and the answer is often the conclusion to the essay, or, if the "why" is a question that can't be answered, then the fact that it can't be answered is the conclusion but the "so what" should always be clearly answered.

And so, finally, McPhee asks the reader, but mostly asks himself, "How many years must a game be played to produce an Anthony J. Drexel Biddle and chestnut geldings on the beach?" In other words, how many

years will I live in this poverty before the real resembles the ideal, and when will justice be done? This is both the answer to "so what" as well as a statement of the "why."

And there is no answer, McPhee thinks. No answers. In the game, he has Atlantic and Ventnor, and we've seen that these places are not worth having. His only hope, he decides, is Marvin Gardens. The place he has not been able to find.

And so he goes, at the end, in search of it—the one place he hasn't seen. He returns to the real Atlantic City. The two parts of the essay are brought together when his opponent "accepts the trophy with his natural ease" and and McPhee makes, "from notes, remarks that are less graceful than his"—another hinge. And the ending is pure prose poetry. Unlike journalism, which has to mean the one thing that it means, and that we *want* to mean the one thing that it means, like poetry, each sentence in an essay often means two things, or three.

"Marvin Gardens is the one color-block Monopoly property that is not in Atlantic City. It is a suburb within a suburb, secluded. It is a planned compound of seventy-two handsome houses set on curvilinear private streets under yews and cedars, poplars and willows." Notice the details? They've changed.

"The compound was built around 1920 in Margate, New Jersey, and consists of solid buildings of stucco, brick, and wood, with slate roofs, tile roofs, multi-mullioned porches, Giraldic towers, and Spanish grilles. Marvin Gardens, the ultimate outwash of Monopoly, is a citadel and sanctuary of the middle class," McPhee writes, then goes on to quote from a resident. " 'We're heavily patrolled by police here. We don't take no chances. Me? I'm living here nine years. I paid 17,000 dollars and I've been offered 30. Number one, I don't want to move. Number two, I don't need the money. I have four bedrooms, two and a half baths, front den, back den. No basement. The Atlantic is down there. Six feet down and you float.' "

And that's an amazing found line, a piece of dialogue, a gift from the interviewing process. A living death, the suburbs, but you float.

" 'A lot of people have a hard time finding this place,' " the man goes on to say. " 'People that lived in Atlantic City all their life don't know how to find it. They don't know where the hell they're going. They just know it's south, down the Boardwalk.' " And in the word "Boardwalk" we're brought back to the game, in both dimensions.

In a traditional essay, one with an introduction, body, and conclusion, one that doesn't exist on the page as separate squares of text, the essayist would say what? The essayist would state his or her conclusion, thus: *Those who live in the streets of Monopoly don't reap the benefits of capitalism, they*

do not pass Go, they end up in jail. Why? Because the sources of capital were never in the game to begin with. They lived in the outskirts. They're gated, their homes patrolled by police. But in creative nonfiction, particularly one that's built as a mosaic, as in poetry, the meaning is in the concrete images and not the abstractions. But it's still there, the focus. Out of what seems like chaos, you can still find and state the thesis, even if the author doesn't. In an assemblage or a collage, the meaning comes together when you set fire to the last image, and a line leaning from that image burns quickly back through the essay and suddenly the whole thing explodes, like a firecracker, into meaning.

As a place, New Harmony is the opposite of Atlantic City, but as artists, John McPhee and Jane Owen have much in common. History percolates through the present in New Harmony and in McPhee's essay, but it's not the history that's interesting. It's the connections the artists make between the present and the past. Everything exists in this one instant. Yes, there were two nineteenth-century utopian communities in New Harmony, and the Harmonist cabins are a row of weathered Monopoly houses set neatly in a row, and the library from the second utopia still stands, but fling history in the air like St. Francis's birds, and discover its meaning in the present. In the assemblage, the montage of the place, in artistry, words are disconnected from advertising and commerce and every detail is a hinge into metaphor. It took a woman, or perhaps an artist, to see that utopia is not a political construction because utopias usually end, as Karl Popper pointed out, in violence, or as McPhee points out, in decay. Utopia can only exist on another realm, or perhaps, I'm beginning to believe, as a work of art or architecture that suggests, rather than coerces, echoing a part of yourself that you've forgotten, some future but as yet unreachable, perfection.

SAILING THE SEA IN NEW HARMONY, INDIANA

On Digression in Creative Nonfiction

Even though we're sitting in a pocket of land stitched on both sides by the water of the Ohio and the Wabash; even though we see water glinting just beyond the roofless church with its descending spirit, and beyond the garden of Tillich and the graves of native Americans and of crazed millennialists, and beyond the labyrinths and the shell-pink clock and the creepy twilit eclipse light of the hosta garden, and even right outside this window where I stand somewhat uncomfortably next to this cross with its crown of thorns; even though we know there are bodies of water edging, defining, creating the space we're in, I know from being here before that unless there's a flood, we tend to give the rivers very little thought. The Wabash is something that you walk up to the edge of now and then but is a thing that turns you back in toward the town and the layered history of this place, or, more frequently, in toward the self.

Despite the fact that this is an odd sort of semi-island, it never occurs to us to bring a canoe or raft or johnboat, and I doubt that we could do much sailing if we tried. So. While everything in me wants to think about the mystery of labyrinths and hostas, about roses and the smell of herbs,

or to take down all my books of Tillich and to meditate on those words you could swim in and to come out feeling baptized, instead I'm here to talk about writing nonfiction. I've vowed that I will hold the course, that I will resist the shoals of Tillich and sail, despite the odds, across the inland sea of language, and because so many of you are writing memoir, through the inland sea of the heart. I promise I will hold on to that metaphor, the metaphor of sailing, and I will not let go.

And if, despite my best intentions, I feel myself letting go for a while, I'll try to warn you all to duck so the boom won't knock you off your seats as it sweeps from one side of this room to the other. Or, if need be, in my tacking we need to shift our weight for balance, I'll let you know that as well: that is, if I see it coming.

This is, as I've said, a lecture about writing nonfiction and about how it is like sailing. That's all it is.

And so, to begin, from an introduction to sailing by Kathleen Mc-Coon Hennish, I will quote the following: "You can get where you want to go *in an essay* but almost never by going in a straight line, which is one of the most pleasurable features of sailing." ("In an essay" are words added by me, I will add, in the spirit of truthfulness, since this is an essay about writing nonfiction, not fiction). As every sailor knows, she explains, you need to tack, to zigzag back and forth across your desired course, shifting the sail and boom from one side of the boat to the other.

It's in tacking, I say, leaving Ms. Hennish behind in her website with way too many pop up ads, that you find the pleasure in creative nonfiction —seeing how far away from the center line that runs between you and your destination that you can veer and still make it back to that center line. That's where you find the pleasure both in the writing and in the reading (how will I get back, how will I have the strength to pull the sail, how will I do it; or in the case of reading, he's gone out too far, he'll never make it back to "x," never be able to connect this digression with the beginning). But it's also one of the surest ways to reach your destination, which, in the case of sailing, might be paradise, but in the essay is some undiscovered, perhaps until that moment unnameable truth, the thing that takes you by surprise and shakes your soul so hard you slap your head and say, My God, I thought I was lost, but there it is, it's the lostness itself that's led me to the place I wanted to go all along but wasn't aware of.

In fact, sometimes I think it may be the only way. As Ms. Hennish says, you can point a boat directly downwind and swing the boom out at a ninety-degree angle which will allow the sail to block the wind and propel the boat in the same direction as the wind blows, and that works very well,

she notes, but limits your choice of destination and—unless the wind changes—makes it impossible to sail home.

When I say the word "tacking" in this essay I could use the word digression, or a phrase like the odd and sudden leap. And, as some of you may know, there are two types of tacking: "coming about," where you zigzag into the wind and let the wind itself easily fill the sail and move you away from the center, and the other more dangerous "gibing," where you turn the sail completely against the wind, the tack that may cause you, if you're not careful, to turn your craft over and possibly to drown. The biggest danger in both tacks is that you'll either not go far enough out of fear, not "honor the object" enough, or that you'll honor the object so much and get so far out that you lack the strength or will to the pull the boat around toward center, at which point you'll cut the tack out in revision, the best move when that happens, or you'll leave it in and not make any sense.

Still, despite its dangers, there are two reasons why I think that tacking is necessary when you're writing nonfiction. I suppose, in thinking about it, that they're the same reason, depending on whether you look at it through the lens of psychology or the lens of metaphysics.

Through the lens of psychology. Jung said we have a self we think we know, the one we present to the world, the self that threatens to smugly take over in memoir because of fear or a deeper inability to see, no matter how honest we think we're being. Sometimes it's the self that sees itself as a victim or that's unable to get outside the wind of personal pain long enough to see that the little self, the little suffering boat, is floating in a *sea* of suffering and that by staying aloft and naming this one piece of suffering you might be able to save not only yourself but all of us from drowning. Tacking your boat away from your own story into, say, a digression on St. Augustine or on the color green might save your life, or at the very least trick yourself into reaching the undiscovered self, the one that hides, or that hasn't yet been born.

And through the lens of metaphysics. Sometimes the truth you're sailing toward is too bright to look at, like sailing directly into the sun or trying to see the face of God. You sense it's there, and you may think you know what it is it's saying, but if you did you'd be quite blind, so chances are, you're wrong. And if you go ahead and substitute the truth you think you know when you begin, it's the truth of someone masked and blinded or someone who, while thinking herself courageous, is in fact quite the opposite. Sometimes the choice of genre in itself—fiction or nonfiction, journalism or story—is the thing that gives you the most leeway to feel that

wind against your face, blind or no, that holy wind that makes you turn into a starboard tack but that draws you back once you've passed through its eye into a port tack and then back to starboard and so on until you see it from the corner of your own very human eye.

I'm going to start with Stephen Crane's "The Open Boat" and to call it, for the purposes of this piece, creative nonfiction, though you all probably know it as a story. I'm using it, one, because it has a boat in it, and two, because sometimes I think that "creative nonfiction" is, in the way we define it, a rediscovery of a few things that fiction lost when literary modernism made a fetish of the concrete and killed off the omniscient narrator around the same time that Nietzsche killed off God and journalism made a fetish of objectivity. Both genres lost something profoundly important, something that was submerged for a large part of the twentieth century. Creative nonfiction allows you to "essay," to try out ideas, and "The Open Boat" is filled with them:

"She did not seem cruel to him then, nor beneficent, nor treacherous, nor wise. But she was indifferent, flatly indifferent. It is, perhaps, plausible that a man in this situation, impressed with the unconcern of the universe, should see the innumerable flaws of his life and have them taste wickedly in his mind and wish for another chance. A distinction between right and wrong seems absurdly clear to him, then, in this new ignorance of the grave-edge, and he understands that if he were given another opportunity he would mend his conduct and his words, and be better and brighter during an introduction or at a tea." And in fact the elements of the narrative—the sea, the tower, the captain, the shore—are all objects that Crane tacks around to reach his final destination, which is an idea, a truth, a fairly new truth at the time, about the human condition.

"The Open Boat" appeared in its first incarnation as a piece of journalism titled "Stephen Crane's Own Story," his account of an incident that occurred when he was a reporter covering a gunrunning expedition to the Cuban rebels right before the Spanish-American War. In the newspaper version he has to follow certain conventions of Victorian yellow journalism. The headline reads "He tells how the commodore was wrecked / and how he escaped / fear-crazed Negro nearly swamps boat / young writer compelled to work in stifling atmosphere of the fire room / bravery of captain Murphy and Higgins / tried to tow their companions who were on the raft / last dash for the shore through the surf..."

He obviously doesn't care about the newspaper article. It's filled with clichés and awkward sentences: "somehow they sounded as wails" and "there were no hifalutin emotions visible upon any of the faces which

confronted the speeding shore." Now and then he includes some of the phrases that will stay in the story (essay): "the fine golden southern sunlight fell full upon the river," the boat's "white sides gleamed like pearl, and her rigging was spun into little threads of gold," and "as darkness came upon the waters, the commodore was a broad, flaming path of blue and silver phosphorescence." (In the essay he says "gleaming trail of phosphorescence, like blue flame" instead of "flaming path of blue and silver phosphorescence" and adds that "[i]t might have been made by a monstrous knife.")

It would be tempting to say that in the short story/essay he's more universal, that he writes solely in metaphor without extraneous detail, and that he maintains what's important from the original and cuts what's unimportant out.

But *in fact* the original includes things that are extraordinarily important that the short story/essay leaves out, events that become, when you know both versions, weird silences that underlie every sentence and that he probably couldn't have voiced or even been consciously aware of given the time in which he was writing. It's the undiscovered thing, the risky thing that can't be named, because there isn't yet a real name for it, but that's felt. The lacuna in the story, the silences, the hidden places you can only tack around. You choose one genre or another based on how far you feel you can go beyond your comfort zone into the things that you can't name.

You know the story and its meaning. Those men in the dinghy moving through the beautifully impressionistic ocean and coming face to face with the universal indifference of nature to the human condition began their sea voyage, in the journalistic version, on a larger boat called the Commodore. There's been a fire in the engine room, and the boat sank. Stephen Crane was one of the men who made it onto the lifeboat. There are seven men still left on board.

The men in the dinghy know they can't get too close to the Commodore, because they'd be swamped and they'd all die. Crane watches the first mate leap off the ship to his death, and it was "rage, rage, rage unspeakable that was in his heart at the time," he says in the journalism, a phrase that reappears in the more famous piece.

Four of the lost seven end up on a raft, and the men in Crane's lifeboat throw a lifeline. "Suddenly," Crane writes in the newspaper article, "our boat began to go backward and then we saw this Negro on the first raft pulling, on the line hand over hand and drawing us to him. . . . [H]e had turned into a demon. He was wild—wild as a tiger. He was crouched on this raft and ready to spring. . . . [H]is face was the face of a lost man

reaching upward, and we knew that the weight of his hand on our gunwale doomed us. . . . The cook let go of the line. We rowed around to see if we could not get a line from the chief engineer, and all this time, mind you, there were no shrieks, no groans, but silence, silence and silence, and then the Commodore sank."

The cook cut the lifeline and no one argued, including Crane.

None of this is in the later version. The racism in the original is faced, in the story version, in a metaphorical tacking because that's the only way it could be—"the faces of the men must have been gray, and the gulls that come close to the men and stare with black bead-like eyes" are described using much of the same language as that used for the black man on the raft as is the darkness of the sea and the land that "seemed but a long black shadow." All questions of race are projected onto nature.

"The Open Boat" is a confession: a confessional memoir without mention of the event being confessed (which is also true, actually, of St. Augustine's confessions), a moving toward the undiscovered truths. Crane as correspondent is tacking when he remembers a poem about a dying soldier in Algiers, which he had not regarded as important. Why take this starboard tack, this digression toward some poem? In this case, it's obvious. His dying was "less to him than the breaking of a pencil's point." Now, however, it quaintly came to him as a human, living thing. . . . [T]he correspondent, plying the oars and dreaming of the slow and slower movements of the lips of the soldier, was moved by a profound and perfectly impersonal comprehension."

His own perfectly understandable and justifiable collusion in evil is projected onto the gods. It's not nature or the gods that were indifferent; it was also Crane.

"During this dismal night," Crane writes in the story, "it may be remarked that a man would conclude that it was really the intention of the seven mad gods to drown him, despite the abominable injustice of it. For it was certainly an abominable injustice to drown a man who had worked so hard, so hard. The man felt it would be a crime most unnatural. Other people had drowned at sea since galleys swarmed with painted sails, but still—

"When it occurs to a man that nature does not regard him as important, and that she feels she would not maim the universe by disposing of him, he at first wishes to throw bricks at the temple, and he hates deeply the fact that there are no bricks and no temples. Any visible expression of nature would surely be pelleted with his jeers.

"Then, if there be no tangible thing to hoot, he feels, perhaps, the

desire to confront a personification and indulge in pleas, bowed to one knee, and with hands supplicant, saying, yes, but I love myself."

Let's look at the opening chapter to *Pilgrim at Tinker Creek,* another body of water, and at Annie Dillard, another master of the tack. Dillard's memoir begins "I used to have a cat, an old fighting tom, who would jump through the open window by my bed in the middle of the night and land on my chest. . . . And some mornings I'd wake in daylight to find my body covered with paw prints in blood; I looked as though I'd been painted with roses.

"It was hot, so hot the mirror felt warm. I washed before the mirror in a daze, my twisted summer sleep still hung about me like sea kelp."

Remember the sea kelp.

Does she stay with the cat? No, the cat has led her to the roses and in particular to images of the sea and toward the spiritual. She tacks toward the roses and the blood, "the rose of beauty bare and the blood of some unspeakable sacrifice or birth. The sign on my body could have been an emblem or a stain. . . ."

Page break. Starboard tack. "These are morning matters, pictures you dream as the final wave heaves you up on the sand to the bright light and drying air. You remember pressure, and a curved sleep you rested against, soft, like a scallop in its shell. But the air hardens your skin; you stand; you leave the lighted shore to explore some dim headland, and soon you're lost in the leafy interior, intent, remembering nothing."

From cat to blood to sacrifice to sea scallops.

The cat! Remember the cat, a port tack back toward the wind. "I still think of that old tomcat, mornings, when I wake. . . ." The wind. "The memory remains of something powerful playing over me," she writes. "I wake expectant, hoping to see a new thing. . . ."

And the boat drifts out of the wind (What is that something powerful? What is that unspeakable sacrifice? Too soon to get there), and the port tack takes her to a birdcall to a flamingo to a duck that flew away and then a starboard tack into the house as an anchorite's because the words "sacrifice" and "blood" have led her toward the spiritual and the metaphor of anchors and anchor holds and anchors at the bottom of the creek and mystery, mystery—what is it? You can't get there directly, so we're back to the duck and then a tack to Kazantzakis and the globe and a description of the creek and a tack then into black steers—a human product, she says, like rayon, which makes her think of a field of shoes. A tack into snakes, a page break, a tack into frogs: "frogs have an inelegant way of taking off from

invisible positions on the bank just ahead of your feet," "Frogs eat every-thing whole, stuffing prey into their mouths with their thumbs. People have seen frogs with their wide jaws so full of live dragonflies they couldn't close them. Ants don't even have to catch their prey; in the spring they swarm over newly hatched, featherless birds in the nest and eat them tiny bite by bite."

Why go off onto the eating habits of frogs? Because the tack takes her closer to meaning. It's followed directly by the phrases 'it's rough out there' and 'chance is no surprise.' Every live thing is a survivor on a kind of extended emergency bivouac. . . ." and by Allah's question "The heaven and the earth and all in between, thinkest thou I made them in jest?" And ahh, that's the question the wind is blowing toward her—is there meaning in nature, has it all been made in jest? It's the same wind that blows Stephen Crane, but she will eventually reach a different conclusion, and she could only reach it by following the cat to the blood to the bird to the frog.

And for the rest of the opening chapter she takes any digression, trusting that it will keep her heading into the wind of her central question, and it does, and she sails through the rest of the book; in fact the first chapter ends "the breeze is the merest puff, but you yourself sail headlong and breathless under the gale force of the spirit." She sails through geology, theology, astronomy, literature, tacks through meditations on words like seeing and winter and spring and intricacy and fecundity and stalking and nothing, until she sails back home at the end of the book, ending of course with "I used to have a cat, an old fighting tom, who sprang through the open window by my bed and pummeled my chest, barely sheathing his claws. I've been bloodied and mauled, wrung, dazzled, drawn. I taste salt on my lips in the early morning; I surprise my eyes in the mirror and they are ashes, or fiery sprouts, and I gape appalled or full of breath. The planet whirls alone and dreaming. Power broods, spins, and lurches down. The planet and the power meet with a shock. They fuse and tumble, lightning, ground fire; they part, mute, submitting, and touch again with hiss and cry. The tree with the lights in it buzzes into flame and the cast-rock mountains ring."

Every image in this paragraph is something she gathered from a di-gression. And she ends "The giant water bug ate the world. And like Billy Bray I go my way, and my left foot says 'Glory,' and my right foot says 'Amen' in and out of Shadow Creek, upstream and down, exultant, in a daze, dancing, to the twin silver trumpets of praise."

She's made it through, weaving directly across the wind. I'd say she was a sailor who comes about. You may think she's gone so far into frogs or legend that she'll never make it back to the question you want to know the

answer to, having lived through a hundred years of Stephen Crane's conclusion that nature is indifferent, so it matters to you that she stays on course, and she does, she swings back. One thing leads to the next and each move is woven tightly into the one direction.

Earlier this week I told my workshop about a man I met when I was walking once on the Monon Trail in Indianapolis. He was balancing rocks on a large rock by the White River. I was with my daughter and her friend, and we stopped to watch him. All these awkwardly shaped rocks were perfectly and impossibly balanced by his hands that patiently held them, nudging one side and then the other, focusing so completely on the heft and shape and feel of rock—no matter whether it was a river rock or piece of leftover highway dreck—he would find the center of gravity, the place it was perfectly balanced until it stood on its own on some tiny corner.

This is a tack, I'm warning you, that I feel like taking for God knows what reason. I may end up cutting it, or I may end up bringing it back with me in the boat of this essay by patterns of cellular growth that can be described mathematically for different trees in the same way that crystals can be described mathematically, and that. . . .

At any rate (there are a lot of "at any rate's" and "so's" in tacks), we watched him for a while, and he said to me, So you're a writer? I'll tell you what you do. Every day when you go out in the world, you take a walk, and as you walk you count a hundred things. Let your eye go where it will and rest for a moment and go to the next thing and the next until you've reached one hundred, and you'll be a better writer.

Sure, I thought. This guy can balance river rocks, but other than that, he's fairly full of himself. But I tried it and in class earlier this week tried it again, and one thing I noticed that I didn't notice before was the wood grain in the door of the conference room, the way it swoops down in an inverted tornado-shaped funnel that looks exactly like the shape on the wood in the descending spirit mushroom in the roofless church, and so I started looking at wood grain and wondering what it was and what caused it and noticed that the grain in the door to my room has pieces the shape of oars and that the cabinet that houses the television is pine and that there are also shapes of oars in addition to the knots and that the grain around the knots is sometimes in that oar shape and at other times surrounded by a whiter circle like an eye, and so I wonder about the grain and find out that it's a pattern caused by cellular growth that can be described mathematically in the way that crystals can be described, but that the pattern of an individual tree is formed in part by tacking through the yearly cycles of rain and drought, the sugars in the sap, the movement around insects and

the uncontrolled cancerous growth of cells that results in what to us are gorgeous burls. I discover that truth and pattern are reached, even in the wood that makes the boat of thought, by a spiraling labyrinthine tacking around the things that threaten to turn you back, by a following of fascination into the wind of our ultimate concern, as Tillich would remind us, of the spirit of truth.

DRIVING FAMOUS WRITERS
AROUND I-465

Nick Hornby is standing in the Butler University Writers' Studio waiting to talk about how to write a novel, and a student comes up to ask him the *real* question, the one you can't ask in class, which is, of course, Did you meet Hugh Grant? Followed by, What was he really like?

I know this is the real question because it's the same one a student asked Salmon Rushdie, in almost the same spot, about five years ago.

Hornby is the author of the books that became the movies *High Fidelity, Fever Pitch,* and the one with Hugh Grant, *About a Boy.* And despite the fatwah against Rushdie, the Islamic threat against his life that kept him in hiding for over a decade, the Booker Prize–winning author of *The Satanic Verses* biggest claim to fame, for some of my students, is that he had a cameo appearance in the movie version of *Bridget Jones's Diary,* which also starred Hugh Grant. Hugh Grant is, according to both writers, as nice as a spoiled film actor could be and not at all like the characters he plays, which means, according to Rushdie, that he's a pretty good actor.

Both Rushdie and Hornby are, according to me, as nice as most writers are when visiting a new place, which is to say extraordinarily so, because they're curious people. The first thing Rushdie wanted to do when

he got off the plane in Indianapolis was to go to the Speedway. We got tickets for the van that takes tourists on a lap of the track. I have an Indy 500 van ticket stub signed by Salman Rushdie. Hornby was interested in everything he'd overheard in the airport. He'd heard, he said, someone say that she was majoring in hospitality. "Is that a major?" he asked. At some schools, I said.

Hornby talked about the life of a novelist. "My theory of writing in part is that it is a personality disorder. Anyone who is mature wouldn't write. There was a point," he says "when Saul Bellow wasn't Saul Bellow and he still said 'Look at me! Look at me!' The heart of writing is a kind of childishness. Maybe that's why writers are as a whole more badly behaved than doctors. There's a kind of temper tantrum at the heart of what we do."

Maybe so, but he seemed awfully nice.

In case you were wondering what he was really like.

For most of my working life I've co-directed a writers' series. Every two weeks during the school year I drive to the airport, pick up a writer, and spend a day or two driving him or her around. It's a great job, and though my job title says Professor, in fact I'm at times a chauffeur. I have special insurance, and I've even rented a special car for people with long legs—i.e., Maya Angelou.

Most of the writers I've driven around Indianapolis are novelists, including Margaret Drabble, Carlos Fuentes, Ray Bradbury, Douglas Adams, Toni Morrison, Larry Brown, Dave Eggers, Nadine Gordimer, Kurt Vonnegut, Lorrie Moore, John Updike, Joyce Carol Oates, Richard Ford, Tim O'Brien, Tom Keneally—a long list of writers who have won Nobel Prizes, Pulitzer Prizes, National Book Awards, cult acclaim, or are first-time emerging novelists. It is an amazing privilege and pleasure. On the way back to the airport people often start telling me things I don't necessarily want to know, so that at times in addition to a chauffeur I feel like a bartender or hairdresser or terrorist. And so I've taken a private vow of confidentiality, like a therapist or taxicab driver, and I won't tell any of the good stories.

Actually, my favorite non-private story has to do with Tim O'Brien. I take that back. My *two* favorite non-private stories have to do with Tim O'Brien.

The first is when my daughter was about three and I took her to hear him read because I couldn't find a babysitter. He came up to where she was sitting on the front row and said, "You make a sound, and you're dead meat." He thought he was being funny. My daughter thought he was serious, and I didn't realize it. She hasn't been to another reading.

The second is when O'Brien read from *The Things They Carried*, a chapter that reads "This is a true story." At the end of the reading a student came up and said, "Oh my God, that was a true story," and O'Brien said it wasn't true. As the student walked away, O'Brien turned to another student and said, "I was lying just then. It was true." And when another student, who'd overheard that conversation, asked him if it was true, he said no, that he'd been lying to the second student, and so on and so forth up to the third floor of Jordan Hall.

And then there was the time, and this is true, when John Updike pointed out that I had a toothbrush on the dashboard of my car, and I realized I was like one of the messy women in his novels that the protagonists always leave for someone else.

But this isn't meant to be an essay about gossip. Because in between the initial "please excuse my messy car" and the final confidences, whenever I was anywhere near a novelist I'd listen and ask questions along the line of How in the world did you do this? Because writing a novel, it seems to me, is a little bit like blowing up a giant kids' swimming pool. If you stop for a second, the air begins to leak right back out. The novel requires that you keep blowing to keep that structure, like a giant balloon, floating in the air. "Novelists make very bad mates," Kurt Vonnegut said during an interview, "because the novel requires such intense and constant concentration that during the time you're working on it, you live completely in that world. At one time, Reynolds Price didn't write on weekends, but he discovered that in missing one day he would actually be missing three—because of that fracturing of concentration."

Though a novel feels more like building a house than like anything that floats. You'll get the frame up and then create sections of drywall, or you'll have the sections of drywall built, i.e., written, and realize there is no frame. I only know that eventually you finish with hanging the drywall, and you put up tape and spackling, and you sand, and get ready to paint, which means making sure that a character named Jim in chapter three is still named Jim in chapter five.

Every novelist has a different metaphor for the process, and every process is different. Maya Angelou said that you have to have a structure in place, that you have to know where you're going before you begin. Nick Hornby finds out where he's going by getting there.

"Is the second novel easier than the first?" I would ask and invariably get the answer—not at all. Every book presents its own problems. Lorrie Moore said that writing a novel felt like directing a symphony orchestra that's playing inland when you're twenty miles out to sea and underwater. You can't see or hear the orchestra or have any real idea what they're

doing, but still you're wildly directing and hoping it will work out right. John Dufresne says he never knows what a novel is about even after he's written it; it's too large, from the inside, to contain it in one mind. Only the reader can do that.

When I started on my "How in the world did you do that?" quest, one of the first people I talked to was the late Michael Dorris. He had collaborated in the past with his wife, Louise Erdrich, but his own first novel, *A Yellow Raft in Blue Water*, had just been published.

Dorris talked about the structuring of his novel in terms of islands. When you're writing a novel, he explained, you have ideas for scenes, things you're excited about at the beginning, or that come up as you're writing. The normal tendency is to think you have to start at the beginning of the story and work your way to those scenes, but what happens is that you either never get to those scenes because you quit first, or, when you get to them, you've lost the initial excitement.

"What I found," he said, "is that it's best to write them when the initial excitement is generated." So instead of going from beginning to end, starting at page 1 and thinking, "My God I've got to get to page 400!" he would create these rafts of scenes and then order them. Ordering the islands created the plot. Then he wrote the connecting chapters. The bridges between the rafts or islands, the connecting chapters, were often the most powerful scenes in the book.

The danger with this method, again to completely change the construction metaphor while still locating it firmly in architecture, is that you will end up with something that closely resembles an unfinished interstate: all these exit and entrance ramps like that ramp that goes off into nothing in the movie *Speed*, or like a train set before it's put together.

The challenge becomes "How the hell do I find the connecting piece of highway that will have the right curve and connect this twisting bridge over here with that exit ramp over there and still end up with something where the ending refers back to the beginning, and cars can run around it without crashing into mountains?"

The answer, said Dorris, is that you move the sections around, you worry over it, and one night in the middle of the night the problems solve themselves: oh, I get it, that's his *sister*, not his wife. And the sections begin to connect themselves.

The second piece of advice is connected to the first one, and it's from the British novelist Margaret Drabble, the sister of novelist A. S. Byatt. It's a tough little nut of advice.

When you start a book, she said, you finish it.

She's written over twenty novels and in every single one, she said, she hit—at around page 150—a complete and utter wall. Every writer has his or her own point at which the wall will come. It might be page 10. There might be more than one wall. But there will always be a wall, and for her it always comes around page 150.

At that point she says to herself, "This is a mess, it's a complete failure, I can't go on, it will never work, whatever made me think I was a writer anyway, I quit."

She knows writers, she says, with drawers full of unfinished novels, and the problem is always the same one. The key, she says—this woman whose subject matter is adultery—is fidelity. Even if it's true that it's a complete failure, you have to finish it before you go on to the next one. Going through that wall, she said, is part of the process. It makes the book a better one. And even if you quit and start another one, she said, you will without fail hit that wall in the next novel at exactly the same point.

So Margaret Drabble's advice is this: maybe that other idea you just had is younger, more attractive, more exciting, but you'll never finish that book either unless you finish this one, because writing is a discipline. And part of the discipline is generating three hundred or so pages and being willing to throw things out if need be, to restructure, to move things, to be faithful to the original idea.

Harriette Arnow, author of *The Dollmaker,* wrote the first five hundred pages of that novel before she got to page 1. This is an even more amazing story when you realize that Arnow had two children and a husband and got up every morning at five to write the novel before her children went to school. Discipline.

"From the sketch to the work," Vladimir Holub wrote, "one travels on one's knees."

Don Kurtz is the author of an Indiana novel that should be a classic: *South of the Big Four.* Indiana, he said, is the moon to most of the rest of the world. It has its own quirkiness and wonder and is terrific subject matter. *South of the Big Four* was published by Chronicle Books in San Francisco, and at the time they published the novel they were known for publishing only avant-garde work. Indiana can seem more avant-garde than a novel disguised as a postage stamp, Kurtz said, even though the novel is, on the surface, realistic. While Kurtz currently lives in New Mexico, rural Indiana was the place he knew best, and that sense of place took him through the process.

The novelist Isabel Allende's place is Chile. "If I were to write about

mangos," she said to me, "I'd have to go to the market and buy a mango and taste the mango. But a Chilean apricot of my youth? I don't have to do that. I have it inside." That's the way Kurtz feels about Indiana and Hornby about London. "I can't see myself writing a book outside of London," Hornby says. "I write about cities, and to write about a city I don't know is to lose something valuable from my locker."

Don Kurtz's second piece of advice had to do with structure. As he was writing, he said, he thought of each chapter in terms of oppositions. Here are two characters. One wants one thing and one wants another. In *South of the Big Four* there's a man who comes back to a small farming community in Indiana. He wants to move back in with his brother. His brother doesn't want him to. The resolution is finding an abandoned house across the way. The resolution to that first chapter, he said, became quite consciously the beginning arrow for the next chapter. He would look for the arrow that was in opposition to that, and he made his way through the book. Whenever he was stuck, he'd look for the opposing arrows.

Tim O'Brien constantly asked students, "Where's the story? Find the story." He sees beginning novelists as becoming mired in the background of the characters, or in language. He referred to John Gardner's book *On Becoming a Novelist*. "In the end," Gardner says, "what counts is not the philosophy of the writer but the fortunes of the characters, how their principles of generosity or stubborn honesty or stinginess or cowardice help them or hurt them in specific situations." What counts is the character's story.

Several writers emphasize the importance of history and interviewing, of research, to the novel. "What interests me," Carlos Fuentes said, "is what happens to men and women when their lives intersect with history. In fact," he said, "the precise mission of the novel *is* to fill in the holes of history. What history forgot to tell, it is up to the novelist to tell. No one knows what Napoleon's dreams were, but the novelist does.

"And the novel introduces doubt, reflection, imagination. It makes us understand that we count for something in history."

Fuentes's advice was to look for enigmas and mysteries in history, for lacunae, and to give the mystery flesh. He told the story of Ambrose Bierce's disappearance in Mexico after his wife left him at the age of seventy-two. This is the note the wife left: "For years I've tiptoed around this apartment, feeding your genius." What did that mean? What happened to Bierce? The novel of what happened in Mexico is the novel that

Bierce himself never wrote. Fuentes knew Mexico, and so he asked himself if he could write the novel for Bierce. And he did.

Those enigmas exist everywhere, he said.

When he was speaking at a conference once in Bloomington, Indiana, he and Gabriel Garcia Marquez were given the choice of touring the Indiana University music school or going to Nashville to see the John Dillinger Museum. Fuentes chose the Dillinger Museum, which was, he said, "America's Lenin's Tomb."

Thomas Keneally, author of *Schindler's List,* gave similar advice. Look for the paradoxes in character, those bits of local history that have resonance as parables. When talking about the writing of *Schindler's List* (which, by the way, is primarily a montage of quotations and interviews, and though it's classified as a novel, he himself doesn't call it one) he was fascinated by the paradox in Oscar Schindler's character. He was also fascinated by the way Schindler's small factory served as a lens through which you could view the Holocaust without flinching.

The commandant of Auschwitz, Keneally said, was a better Catholic. A good and faithful husband. The contradictions in Schindler: the fact that he was a horrendous husband and a ruthless businessman, the fact that virtue could arise in a man like this, is what fascinated Keneally.

Susan Fromberg Schaeffer said that all novels are a means of preservation, a point echoed by Nobel Prize Winner Nadine Gordimer, who talked about the "journalistic function" of the novel, how it serves to define how things were at a given time in a given place. Schaeffer interviewed hundreds of Vietnam veterans for her novel *Buffalo Afternoon* and hundreds of holocaust survivors for her novel *Anya.* She said that there is "a stupidity that envelopes me" when she begins working on a book. The pitfalls of the writing, the difficulties of working with veterans and survivors, didn't occur to her. If they could write their own stories, she said, it would be wonderful. But most of the survivors can't bear to write about it.

During interviews, she explained, you knew you were getting a strongly censored version. So she had to *imagine* the rest. That's the function of the novel. "In extreme trauma," she said, "it's very difficult for the people involved to get an objective distance. There are personal fault lines, something literally shattering happened, and you can't put too much pressure on it, or it will crack. So it's up to the novelist to tell the story. The novelist is the only one who can."

Schaeffer spent months interviewing different people before a character would emerge, a character that would absorb as many of the experiences as possible. Her process was different from almost everyone else's.

After months of interviews, she will walk around with the book in her head until she knows the entire thing, almost word for word. And then she gets it down on paper.

I've heard it said that every novel has at least one huge flaw, that there is no such thing as a perfect novel. Every novel, John Barth said, is a controlled crash. And one after another, the writers I've talked with mention that sense of failure. The material just will not fit into any preconceived form.

But it's out of that sense of failure that new forms are born. Kurt Vonnegut mentioned the sense of failure both when he talked about, and in the text of, *Slaughterhouse Five.* He struggled with his sense that the book was a failure because of its fragmentation, little knowing that the fragmentation itself would influence a generation of writers.

Marianne Wiggins said that her first novel was not a novel at all. It was a story collection. But no one wanted it, so she called it a novel and named it *Separate Checks.* She made the characters in all the separate stories sisters, and at one point a waitress asks them, "Do you want this all on one bill?" and one of the sisters says no, they prefer separate checks, and suddenly the fragmented nature of the collection is drawn together and becomes a novel.

And what else? Richard Ford keeps folders for each character and each possible setting. He drives around for a year or two, taking notes, and then he begins writing. Eudora Welty revised by cutting her books into pieces and then pinning the pieces together with dressmaker's pins.

All novelists are curious about everything. Almost every one of them is a good listener. Some will give you their life stories, but almost every one will try to get yours.

Nick Hornby had advice for readers when they approach a novel. "There is a sense," he said, "that books have to be hard work to read and if not, they're not going to do you any good. I don't think it makes you a better person if you read Flaubert instead of Dan Brown.

"I have friends who have children, who come home from work and are tired. They don't turn on the TV because it's easier. The reason they're watching TV and not picking up a book is because some of the serious books are dour and long. So if you're bored by a book," he says, "put it down and read something else. Don't beat yourself up over it."

Most readers want a book that will wake them up, make them laugh, make them think, or break their hearts.

Most of this I learned while driving people around I-465.

LEAPING ACROSS THE CANYON

On Writing

My next door neighbor owns seven white dogs. They're all outside this morning, all quiet, all running gracefully through the grass like the ghosts of deer. The dogs are small, rare, well-behaved and odd-looking breeds. The two largest dogs are whippets, English greyhounds, spooky and muscular. They fly back and forth across the six-foot fence between our houses, and it's utterly soundless, just a smudge of white one way and then the other. Their job is to be mysterious, weird, earthbound angelic birds in the form of dogs. Sometimes they seem like that, and sometimes they seem too thin and crouching, sneaky and rabid, all toothy smile.

Every day begins like this for a writer: with the vain attempt to try to get to, in words, something that's just beyond where words stop. This is your job—to throw the rope of words out and try to catch it, then to walk across the rope until the air gets tired of pretending to hold you up, and the imaginary rope dissolves, and you're plunged into a canyon.

Though sometimes you take a leap across the canyon without a rope at all, a blind leap that doesn't involve faith, just the hope that there will in fact be a way to return to where you started. Either way, you often fall. Then you climb back up the rock face, skin your knees and hands, and

throw the rope again. This is your trade, your work, what you do every day of your life.

And so: I still don't have those whippets right, how dream-like strange they are to me. I could throw words at them for the rest of my life and not quite get at the mystery. I wish that I could be a whippet, an earthbound mammal that gives the illusion of flight. Why do the dogs fly over the fence and back? Maybe they sense something in the air and think they can catch it in their teeth.

What I love in this world is both the whippet and the rope of words.

My neighbors have giant gumball machines and neon-striped juke-boxes and antique rose-colored lamps and antique sinks and a stained-glass fox in the kitchen window and glass green walls. Two weeks ago they built a playhouse by the drainage creek. There are green lawn chairs for the children on the playhouse porch. The chairs are an intense green, not an indigenous color.

My neighbors create their home at every moment, which involves both making things and tearing things down. Last week the husband was up in a sweet gum tree with a chain saw, balancing on a heavy branch and sawing off the limbs at the tip. Whack! Thud! The screech of the chainsaw coming so close to his own powerful leg, and his three children squealing, and the seven white dogs and the wind and the pile of leaves and bark! Whack! Thud! And a gathering of boys around the basketball hoop to play and to watch, and the sun setting all orange and green and shining on the chainsaw's metal teeth. And when he got the thing de-limbed it was right through the trunk until the whole tree fell, and then two seconds through the trunk of a dogwood and it was down too, and my neighbor standing there like Paul Bunyan getting all the kids to carry limbs taller than they were out to the street to be carted away with the next day's trash.

And within two minutes he and his wife decided not to have the stump ground all to hell, as they'd originally planned to do, and instead to build an octagonal bench around it and scoop out the center to grow geraniums.

The whippet's job is to jump; my neighbors' job is to build a life interesting enough to hold seven dogs, two cats, and three children. And my job is to make things up, which has nothing to do, often, with invent-ing something new. I just sit here patiently picking up each object on the assembly line of perceptions and then picking up the word that goes with that perception and placing it back down on the belt. Whippet. Wind. Paint-green chair on the playhouse porch, that kind of satiny sheen that candy takes on when it cools. Pick up the image. Package it in words. Inspect the sound. Pass it down the line. Next sentence. Next image:

Whippet. Wind. Ghost. Sweet gum tree. The light hits the top branch of the white pine, the metal perch on the bird feeder, the intricate mesh of the porch screen, one white rock. One red-haired neighbor checks the chlorine level in her children's above-ground pool. Two fat red cardinals pick up sunflower kernels and fly to a branch of the black walnut tree.

Those are the things I can see. There are other things I take on faith. At every moment neutrinos pass back and forth through all these things that seem so solid and impenetrable—the bodies of the walnut tree, the cardinal, these fingers—as though we're not even here. They're invisible but apparently have mass. Where are they going? Flying through our bodies and the bodies of whippets and chainsaws and boys playing basketball and the insubstantial wind like that. This is the neutrino's work.

Pick up the image. Wrap it up. Lay it back down. Pick up another, do the same, lay it down. Now and then there's one that feels like the canyon's edge, a simple image on an assembly line that opens somehow magically into a vast landscape, and I leap off or toward it. The difference between a detail and a metaphor. Transubstantiation. You begin with one and end up with both. Sometimes the wine stays wine. Sometimes it's both wine and spirit. You always start with wine. The first miracle.

So drink this down: inside the white dog's and my neighbor's bodies and my body and your own there are, in addition to neutrinos, viruses. The virus's work, it seems, is to get its DNA into the host cell's RNA. According to a new study from Purdue University, the virus does this the same way you insert a part into a car, by creating its own simple machine. Think about this. The virus makes an octagonal hole in the RNA and shapes the DNA into the same octagon, and the whole thing works like a bolt in a pair of human pliers, and it looks exactly like the bench my neighbors want to build around the sweet gum's remaining stump.

To say that the universe tends toward disorder seems counterintuitive. Things seem, instead, to tend, through labor, toward further complexity and to follow some sense of aesthetics and shape, some pattern, and it's all more mysterious and awful and lovely than we can even begin to fathom.

In January scientists announced they had discovered eternity. The universe doesn't have an end, a canyon drop. It keeps expanding. It's at the edge that the universe makes itself up as it goes along. It's here in the center or the edge of center or wherever it is we are that we do the same. So that every cell, every massive and invisible neutrino, every virus, every particle and wave, every boy playing basketball, every neighbor building a playhouse, every whippet flying over a fence, every single living thing that does its work each day helps to make the universe.

WHERE'S IAGO?

The day of the winter solstice, the day the spaceship Mir would fly directly over Indianapolis so that astronaut David Wolf could talk to his mother, we held our department end-of-first-semester lunch. My friend Aron knew I was thinking about this topic and anything that had to do with misfortune, calamity, evil—for days he'd brought them up. You know, Aron said, last night I discovered the origin of the word "disaster."

It's dis-aster, he said, astral, a mis-alignment of the stars.

And religion, he said, means to bind back, to heal. The Hebrew word is *Tikkun.*

A colleague named Larry sat across from us, but we didn't talk to him. We talked about Iago and the origin of words.

For several years now Larry has been studying labyrinths, and he is in fact the kindest, most introverted person any of us knows. This day he was wearing a new sweater, a reddish brown with other colors and textures woven through in no discernible pattern. You could lose yourself trying to trace the threads, so we didn't try, just as we always take his introversion at face value and smile and say pleasantries but make no real attempt to knock at the door and enter.

But that night, before I went outside to look for Mir, I got a phone call from Aron. He'd been driving away from the restaurant and turned the corner into a cluster of police cars, he said, directing traffic away from an accident. He was about to turn into the line of diverted cars, but he saw the shoes of the victim and then, as more cars turned, the pants, little by little unmasked, until finally there was the sweater.

I recognized him then, Aron told me. It was Larry. Like a lamb there in the road, he said, blood all over his face and only me left there to help get him in the ambulance and go with him to the hospital and to call his wife.

It was so intimate, Aron said, that I realized I had no idea before this moment who he was. Everyday it's all "ha ha happy happy." Something like this happens to one of us, and we don't know who it was it happened to. We hide from one another, he said, all the time, as though there's something we're ashamed of.

I talked to Larry, Aron said, on the way to the hospital, in between the doctors and the nurses, until his wife came.

You know, he said, all of our literary tradition sees evil as having something to do with the inability to see outside ourselves, to see another human being as real.

And by the way, he said, you want to know where Iago is? I'll tell you where Iago is. He's here, he said, and even over the phone I knew he was pointing to himself.

A year ago, about this same time, I received one of Kurt Vonnegut's famous late night phone calls. Susan, he said, with no hi or how's the weather there or how have you been; it was just Susan, is it "breath of newmown hay" or "scent of newmown hay?"

I think it's breath, I said, but I told him I'd look it up and call him right back if it wasn't. The line he was fact-checking was from the Indiana state song "On the Banks of the Wabash Far Away." For some reason, writers who were born in Indiana and move away often think I'll know the answer to questions like this. What town were Duesenbergs built in? I can't re-member, but it was up near Fort Wayne. Where was the Conn trombone factory? In Elkhart. What was the name of D. C. Stephenson's secretary? Madge Oberholtzer. What color are the soybean fields in mid-November? I haven't a clue.

The song Vonnegut was referring to was written by Paul Dresser, Theodore Dreiser's brother. They were both—Paul and Theodore—from Terre Haute, Indiana, as was Eugene Debs, as is Larry Bird, in case you're wondering. Every one of them, until he was conveniently dead and iconic,

was a source of embarrassment to Terre Hauteans, with the exception of course of Larry Bird.

My great grandfather was a carpenter and stonemason; he did all of the woodwork for several of the Indianapolis buildings that Vonnegut's grandfather designed, so this whole exchange felt like some sort of weirdly historical déjà vu thing. I was so eager to be helpful that I heard myself doing that ladadada fast singing you do when you're trying to get to the lyrics in the song you want to remember. La da dream about the moonlight on the Wabash, la da da there comes the what of newmoon hay. Ta da la da da da. A ha! Here's the oak you need for that doorframe: Breath. It's breath of newmown hay, not scent.

He was working on the galleys for *Timequake*, and the line comes up on page 166. I say this because I will probably always think of it as my most important contribution to American literature, and it will go unfootnoted.

At any rate, he said thank you then, and in order to say something kind, he asked how my novel was going.

It's a mess, I said, truly awful, and I tried to think of some way to change the subject.

I can tell you what's wrong with it without seeing it, he said. You're missing Iago.

Iago?

The character that bounces all the other characters around. I wasted twenty years figuring that out. Look for Iago.

Let me say here that Vonnegut has been, my entire conscious life, my hero; if this weren't true, I wouldn't have wanted to think about this topic for longer than two minutes. Even when I was a child, if something broke in our house, my parents would go to Vonnegut's Hardware Store to get the tools to fix it. Which shows you in part that it's more lucrative to be an architect than a carpenter. But more importantly, any child growing up in Indiana, when she feels that sense that it's an impossible place to be from, remembers Kurt Vonnegut with relief and gratitude. It's a feeling both irrational and deep, and I would gladly cover an island in flowers, or write a lecture over Christmas break, to express it. And I felt that he was probably right but had no idea how and wasn't going to ask. I was too overwhelmed at the time with the sense of God speaking to me from the whirlwind to follow up with, Huh? The blueprint's beautiful, the math is elegant, I might have said if I'd thought of it, but I'm a poor architect myself, better with the materials than the design, and I don't quite get it, Mr. Vonnegut, I don't quite get how this window should be placed. Whatever do you mean, Where's Iago?

And it occurs to me now that I didn't ask questions because I wanted to hold on as long as possible to the mystery of it, which has happened. I've thought a lot about Iago, about how and why Iago might be a tool that helps create structures that are level and true, buildings strong enough to hold imaginary lives.

Iago is the image of evil in the way that Romeo and Juliet are forever the image of romantic love, so I have to talk about evil here, but I also have to say that I'm slightly embarrassed by the idea of talking about it. I think that even thinking about it made my computer's hard drive crash. While there is of course such a thing as catastrophe, I wouldn't before writing this essay have called anything evil, which seems to imply a conscious malevolence in human beings, in the case of "moral evil," or the universe, in the case of "natural evil." There is no such thing as evil, I've always assumed; it's all simply a matter of tracing things back far enough until you can determine some completely understandable cause in biology or chemistry or physics. If you want to call it the force of entropy or chaos as opposed to the force of order, I'm fine with it. Call it the shadow, and I'm sort of okay with it. Call it evil, and my brain goes dim.

But I think that Vonnegut was talking about Iago in two ways: both Iago as a certain type of character—not a villain necessarily but a catalyst, the part of this essay I'm the most comfortable with—and as evil in the way it's usually understood, as part of the very structure of the world. I think he was implying a kind of seriousness that he shares in fact with Debs and Dreiser, all three of whom end up saying something like what Vonnegut says in *Timequake:* "For God's sakes can't we just help as many people as possible get through this thing, whatever it is." (And for this, if nothing else, Terre Hauteans should be proud.)

I'm not going to talk about whether a writer has some sort of moral imperative or responsibility to name evil, though I'm certainly not averse to thinking about it. I am going to talk about how Iago creates dramatic tension and to say that there are aesthetic consequences of moral evasiveness or flinching away from evil in fiction—in addition to a lack of seriousness, a kind of muddiness, characters with a static sensitivity, a case of viral ennui that is never realized in dramatic action.

But I have to say that what probably interests me about the subject, honestly, has nothing at all to do with making fiction work and everything to do with the hope that fiction matters.

And, too, many writers have written and spoken about the question of the responsibility of the artist eloquently: Czeslaw Milosz, Toni Morrison, Wole Soyinka, Flannery O'Connor, Eli Wiesel, William Faulkner. I love

their essays about literature and am haunted by them. I'm also haunted by a question and answer session I attended where a student was obviously deeply moved by Thomas Keneally's talk about the interviews he did with Holocaust survivors while writing *Schindler's List*, and who asked what was the one thing he should do if he wanted to be an artist. And Keneally said, not at all glibly, that the student should try if at all possible to see the evil that no one sees and that will be, in fifty years, the thing that no one can believe we did nothing about. I've been haunted by that statement as well.

Although it is of course an incredibly dangerous thing to say to any human being, maybe in particular to a writer. There's the risk of projection, of intellectual arrogance, of blindness, of over-simplification, or the possibility of falling unwittingly, like Oedipus, into an even greater evil. "I think of myself," Keneally said earlier on the same day, when asked why he wrote, "as a horrendous human being." Probably the best we can do is describe what we see and, when we're conscious of evil, to locate it in the characters with whom we most closely identify. Within ourselves. I'll come back to this.

My first thought is to think of Iago as a catalyst character. Iago slithers through the Garden of Eden because without him it's a dull stagnant story; nothing would ever change. Human history in time begins with Iago. In fact, the first Iago begins the action all the way through the Old Testament. Evil or misfortune has a similar function in the story as it does in life. For the Gnostics and for the fiction writer, evil is the source of all moral understanding; the function of evil, in the best of conditions, is tension and imbalance, the eventual creation, through suffering and misfortune, of wisdom. Suffering, misfortune, and, I should add, honesty, are Job's (and Vonnegut's and any good fiction writer's) great attributes. "God damn the day I was born," Job says in Stephen Mitchell's translation, in the face of his neighbor's easy platitudes. With honesty, and not one whit of patience. It's that honesty that allows him to hear, finally, the voice of God, a voice he wouldn't have heard if it weren't for Iago.

The "knowledge of good and evil," Martin Buber writes, "means an adequate awareness of the opposites latent in creation," the yes and the no. He says that the cause of all moral evil is the lie, the particularly human evil that creates illusion—"inauthenticity" is Sartre's word—in the liar and in those around him. We create illusion because we choose to maintain order. Often we create illusion because we need, as did Dr. Jekyll, at least the appearance of goodness. Over and over in the literature of evil the word "illusion" appears, not because it is an evil in itself, but because it is

the Petri dish that allows evil to mutate and to grow. It was "illusion that ruled," Eli Wiesel says in his great holocaust memoir *Night,* "not the Germans."

Of course this assumes a world in which we can know what illusion is. It may be our particular evil, at times, to operate as though we can't hope to know. I guess we'll find out.

But for now, let's think about Othello. His love for Desdemona and hers for him is a structure created out of opposites—passion and jealousy, trust and distrust (if Desdemona went against her father's wishes, might she go against his?)—and illusion. The destabilizing half of each equation is repressed in favor of the half that tends toward order. Passion is foregrounded and jealousy repressed, etc. Othello was a braggart in love with the heroic story of himself, and he loved Desdemona, he acknowledges to Iago, for loving that story. "She loved me," he says "for the dangers I had passed, / And I loved her that she did pity them."

Othello's happiness was constructed with a crack, but it was a happiness which could have gone on and on, as fairly uninteresting but nonetheless subtle tensions forever and ever Amen, the couple safely ensconced in Eden, blissfully unaware of how little they really knew one another, if it weren't for Iago. He brings Othello out of his illusion and into the real (and I'm thinking of the play as O'Connor might think of it, where the violence brings a form of cleansing grace, though not in enough time for poor Desdemona), a necessary move for Shakespeare's play, where the latent or potential opposites are finally actualized in a scene because of Iago. He makes the conflict real and therefore dramatic.

Iago's particular evil manifests itself as a conscious, Nietzschian will-to-freedom, though he rationalizes it plenty and, if pressed, would probably say he was a pretty good guy though misunderstood; he had his reasons. But he woke up one morning and realized that human freedom is limitless once you realize that what "seems to be" isn't true at all, that any ordered world is all a brave construction, a building of fragile material, a place enclosing light within darkness, and that this fragile building can be reconstructed as he wishes it to be by someone like—himself. What power! Anyone can do it! Richard Niebuhr said that "[e]vil is always the assertion of some self interest without regard to the whole," and Iago asserts his self interest with a vengeance. He could consciously construct his identity as a mask and then set out to deconstruct other masks. He will *seem* to have Othello's best interests at heart. In that way, in part, he protects his own illusions: "Heaven is my judge," he says, "not I for love and duty / But seeming so, for my peculiar end; / For when my outward action doth demonstrate / The native act and figure of my heart / In compliment

extern, 'tis not long after / But I will wear my heart upon my sleeve / For daws to peck at; I am not what I am."

Othello's ordered world is vulnerable to Iago because, within his world, chaos and order are separated by the most fragile of tissues. He's extraordinarily passionate, with opposites very close to the surface. The line that always seemed to me to be at the center of Othello's character is this one: "Perdition take my soul, but I do love thee. And if I love thee not, chaos is come again." A character who says that is in a particularly vulnerable position. There's love or there's chaos, no in-between. (Though this is perhaps always true of love, which is a fulcrum balancing joy and despair, yes and no, and it's this balancing, more than anything else that places it at the center of so many of the world's stories.)

And here comes Iago: the deconstructor, the unsettler, the emperor of ice cream.

I think that Vonnegut is saying that Iago is inevitable because every human system contains the roots of its disorder, every order contains the seeds of its disintegration. Every last by-definition-contingent one. No exceptions. If it didn't, it would be perfect. If it didn't, it wouldn't be human.

There should be a law of thermodynamics, and perhaps there is, that says for every human structure there's a hairline crack, a fault line, and Iago is the character or force whose function in the plot is to see, or at least to sense, that fault line, to insert himself within it, flattened like a mouse under a door or, more accurately, to become like water finding a fissure in stone and settling in, causing the stone to crack.

And what happens as the rock is breaking, until the new order is restored as two rocks, or as one, or as unrecognizable rubble: that's where the story is located. Without Iago the wedge, there wouldn't be this story. There would only be the story that existed before the story began; there would only be the baseline story, which can go on and on interminably, all of its illusions intact, with its minor daily tensions and conflicts.

It's easy to begin a work of fiction with the sense that here's the way it is, it always was, will always be. That "always is" seems filled with so much conflict, day to day; isn't that the story? Isn't it enough? *I've written six hundred pages.* Isn't this it? Not until Iago finds the opposite lurking in what "always is." Something needs to cause those tensions to erupt into time. This day, this story.

Using this definition, Iago is a tool. When his work is done, he's silent, as much a victim, often, of his own evil as anyone. (Think of Sir Lancelot in Arthurian legends.) Shakespeare's Iago operates out of a self-delusion: he convinces himself that Othello has slept with his wife, that Othello has

received honors that he himself should have received. The first illusion he creates is one of his own making; the first recipient of his lies is himself. It's perhaps the self-delusion that causes the crack in Iago that allows evil to seep, smoke-like, in. "Demand that demi-devil," Othello says after he's killed poor Desdemona as the result of Iago's conscious lies. "Why he hath thus ensnared my soul and body?" And Iago says, "Demand me nothing. What you know, you know. From this time forth I never will speak a word." The stone has broken in two, the illusion is exposed, and silence takes over. To live in the lie that was the world of the story at the beginning of Othello is to live nowhere at all: in nothingness. Like the Misfit in O'Connor's "A Good Man is Hard to Find," Iago has been the tool of a kind of grace, and I'm using grace right now in a particular secular sense as a knowledge of the real.

Martin Buber in *Good and Evil* explains that we experience evil when the lie exists so long that the "nothingness of the illusion has become reality," and lives are "set in slippery places: so arranged as to slide into the knowledge of their own nothingness; and when this finally happens 'in a moment' the great terror falls upon them and they are consumed with terror. Their life has been a shadow structure in a dream of God's. God awakes, shakes off the dream, and disdainfully watches the dissolving shadow image."

When I say six hundred pages, I don't say it lightly. Harriet Arnow in fact wrote six hundred pages of *The Dollmaker*, six hundred pages before she got to page one, six hundred beautifully crafted pages worth of sentences written early in the morning before she had to get the children up for school, to make the breakfasts and the lunches and find the homework accidentally kicked under the couch or thrown away and put the clean clothes in the dryer. These early pages described the family's rural Kentucky life with its daily conflicts, each character locked in place. And she threw them away.

Because on page 601 the war, Iago, enters in, and the father's restlessness and wanderlust and the mother's physical strength and love for her children and obedience to her husband reveal themselves as the hairline potentially destabilizing tensions that could have remained, and the family is thrown from the flawed but unchanging Eden of Kentucky to the wartime hell of Detroit. Iago is a force in this story: World War II. But it's primarily the mother's story, and as the father is infected by the war, Iago very quickly takes on flesh and blood. The father becomes the unsettler, different from the first Iago in that he's not conscious of his role, which is to uncover the existential situation for the mother. Previous to this, in the

long-running back-story, her loyalty to her husband has been without choice, but it contained the seeds of its destruction. Her illusion was the hope that her husband shared, or would come to share, the same agrarian worldview, the one she's based her family's happiness on: self reliance, a life within nature, the cycle of the seasons. When in fact her husband is restless. He wants technological solutions, loves machinery, loves cars, is a hunter not a farmer.

They could have gone on with these differences forever because they could live within the tension; there was no reason not to. But World War II gives the husband a release for the authentic, not the seeming self: a patriotic move to Detroit with its burning steel mills and trains. Now the mother has to choose between loyalty to the family or the place, which had been up to this point only the potential conflict. By remaining obedient she has made a choice that will affect her children and their lives and will result in the death of a child. The mother has now entered the world of her own illusion, her own lie. The world turns upside down and the new status quo will only be accepted after the death of the daughter, that cleansing restoring violence, the end to this story. Of course from there we get a new status quo, and a new crack, but for a while everyone holds on to the way things are, boxing themselves in with hastily built walls that were never really meant to last.

I'd like to give one more example of Iago, both as a character and as a force, from Sudanese novelist Tayeb Salih's *Season of Migration to the North*. This novel is divided into two distinct parts, and one of the interesting things about its structure is the way Salih consciously plays with the Othello/Iago narrative.

In the first part of the novel the narrator meets and then tells the story of Mustafa, a man who, like Othello, moves from Africa to England and not only murders one Desdemona but causes two others to commit suicide, though he insists that "I am not Othello. Othello is a lie."

In this astonishingly beautiful short novel, there is more than one Iago, and Mustafa himself is an Iago who plays out the Othello role for one lover's Iago and then in turn functions once again as Iago. The novel seesaws back and forth between these poles: the community, the crack, the splitting apart, the new community, the new flaw, the new destruction. The crack that allows evil to enter this world (and I'm thinking of evil here in several ways—as negation, as violence, and as the force that leads to the destruction of a human community that has integrity, beauty, and history) occurs in part because of the illusory identities one culture creates for another. Mustafa is educated in "a language not my language" and leaves

the Sudan for London, which was "emerging from the war and the oppressive atmosphere of the Victorian era." Like Iago, Mustafa has a mind "like a keen knife" and, like Iago, he becomes conscious of his ability to create alternative illusions, an ability made even easier because of his essential invisibility. Evil enters in, as Aron said, and as much of the world's literature suggests, through solipsism: one human being unable to see another human being as real.

In London Mustafa becomes a master of seduction. "My store of hackneyed phrases," he says, "is inexhaustible. I feel the flow of conversation firmly in my hands, like the reins of an obedient mare: I pull at them and she stops, I shake them and she advances; I move them and she moves subject to my will, to left or to right." All Mustafa has to say is that he grew up along the Nile, that he could reach outside his bedroom window as a child and dip in his hand, and the illusion of wildness and exoticism, of everything both glamorous and repressed, becomes an aid to seduction. Mustafa in his Iago-mode is conscious of the illusions in the women he seduces, and he inserts himself, so to speak, within that flaw.

"Poor Isabella Seymour," the narrator says of one of Mustafa's seductees. "She had eleven years of happy married life, regularly going to church every Sunday morning and participating in charitable organizations. Then she met him and discovered deep within herself dark areas that had previously been closed." Mustafa becomes an imperialist of love. Isabella's illusions, as is true of all of Mustafa's lovers, rest along essential fault lines in Victorian morality, hidden fault lines of repression and romanticism that sex brings to the surface and which becomes intolerable. Two of Mustafa's lovers commit suicide. "You, my lady," Mustafa says, "have been infected with a deadly disease which has come from you know not where and which will bring about your destruction, be it sooner or later."

"I came as an invader into your very homes," Mustafa says, "a drop of the poison which you have injected into the veins of history . . . , the germ of the greatest European violence, as seen on the Somme and at Verdun, the like of which the world has never previously known."

All through the novel, illusions lead to violence, and the first half of the book ends when he meets a woman, a passionate nihilist, whom he loves with the same either/or love/chaos intensity of Othello:

> She was my destiny and in her lay my destruction, yet for me the whole world was not worth a mustard seed in comparison. . . . The smell of smoke was in my nostrils as I said to her "I love you my darling," and the universe, with its past, present and future, was gathered together into a single point before and after which nothing existed.

This woman plays Iago to Mustafa's now Othello—since every system, including Iago's, contains a crack—and she manipulates him into murdering her, a history which he has to hide upon his return to Africa in the second half of the novel, where he brings the violence with him. In part because his past remains hidden, he functions as Iago once again for the Sudanese woman he marries and finally for the narrator. Evil is a virus in this novel, with its source in unreality, and it infects characters one by one.

When Mustafa returns to the village, the narrator is sometimes seized by the feeling, as he sees him—"a drink in his hand, his body buried deep in his chair . . . , abstractedly wandering towards the horizon deep within himself, and with darkness all around us outside as though satanic forces were combining to strangle the lamplight"—that "Mustafa Sa'eed never happened, that he was in fact a lie, a phantom, a dream or a nightmare that had come to the people of that village one suffocatingly dark night, and when they opened their eyes to the sunlight he was nowhere to be seen."

Because Mustafa is a lie, everything begins to seem like an illusion or mirage to the narrator. At the point where the narrator can act to save the woman he loves, he is overcome with the awareness of evil, which seems so large that it prevents action. "The darkness," he explains, "was thick, deep and basic—not a condition in which light was merely absent; the darkness was now constant, as though light had never existed and the stars in the sky were nothing but rents in an old and tattered garment." At his darkest point, the "no" takes over and he imagines that underneath everything is finally nothing at all, an empty room, and he participates in an impromptu boom-boxed "festival to nothingness in the heart of the desert." The only act that can break apart the illusion and sense of nothingness—without violence—is truth telling, which has become impossible. Once again it's illusion that creates the fertile ground for evil to enter in, and Mustafa is both a victim and a perpetrator of illusion.

In part this novel's power comes from the catalyst characters. But part of its power lies in the fact that the novel has more seriousness and weight than many contemporaneous American novels, a weight which seems to come from the feeling that the story rests within something outside itself, within a power with its own mysterious order. This is a novel in which tragedy is still possible.

The Iago story is often a story of a fall from innocence, and this novel is no exception. The fall is abrupt, and at the end the narrator almost drowns, both literally and metaphorically, in the "no." He is conscious of the river's destructive forces "pulling me downwards . . . ; sooner or later the river's forces would pull me down into its depths." But in the end he

chooses to fight against the current "because there are a few people I want to stay with for the longest possible time and because I have duties to discharge. It is not my concern whether or not life has meaning."

In the river, Salih gives us evil with presence, the universe as a vast and brooding thing that threatens to overwhelm with the awareness of our condition in it, the condition we build these grand illusions in order to avoid.

So maybe Vonnegut wasn't talking about catalyst characters at all. When I think about the most beautiful and powerful novels I think of ones where the evil in the world itself is clearly drawn. It's easy to be blind to it. If we're in a position of power, it's easier to be blind to it. Anthropologist Lionel Tiger said that the industrial system itself provides "a uniquely efficient lubricant for moral evasiveness." Maybe what Vonnegut means is the acknowledgement of evil, the naming of it. That's what he finally discovers in *Slaughterhouse Five*, a kind of seriousness and honesty.

"The essential modern evasion," critic Andrew Delbanco writes in his book *The Death of Satan: How Americans Have Lost the Sense of Evil*, "was the failure to acknowledge evil, name it, and accept its irreducibility in the self. The repertoire of evil," he writes, "has never been richer. Yet never have our responses been so weak. . . . We certainly no longer have a conception of evil as a distributed entity with an ontological essence of its own. . . . Yet something that feels like this force still invades our experience, and we still discover in ourselves the capacity to inflict it on others. Since this is true, we have an inescapable problem: we feel something that our culture no longer give us the vocabulary to express." So "evil is returned as the blamable other, and we ourselves are seen as victim of it."

The power of *Season of Migration to the North* rests in part in its recognition of the way imperialism requires both arrogance and illusion and so, as a human system beginning in illusion, is a medium for evil and, therefore, for violence.

I think that whatever evil we're living in the midst of we find particularly difficult to name. Of all our contemporary novelists, Don Delillo perhaps comes close to naming it, because his world is so unflinchingly and unsentimentally observed. "You're worried and scared," Don Delillo writes in his novel *Underworld*. "The world somewhere took an unreal turn."

You find Iago in *Underworld* not in a character but in a milieu: where cultural construction of identity is assumed, where our deepest wish is the flying carpet, the creation of an island floating in midair that will actually hold us, a perpetual motion machine disconnected from any source of

power but its own, an eternity created entirely in culture, a world where Disneyland exists, as critic Baudrillard has written, in order to give everything around it the illusion of the real. "All these people formed by language and climate," Delillo writes in *Underworld*, "and popular songs and breakfast foods and the jokes they tell and the car they drive have never had anything in common so much as this, that they are sitting in the furrows of destruction." His characters experience a "moral wane," an ennui that needs the balance of an enemy. The biggest problem for the characters in this novel, in fact their Iago, is the absence of Iago. They "need the leaders of both sides to keep the cold war going."

If evil slips in when illusion is created, as our literature suggests, or if evil is the elevation of self-interest over the whole, or if it is the inability to see anyone outside ourselves, if human culture is only a system of signs referring to one another with nothing at the ground of things, not even an identity to mask, then we may be living in a particularly dangerous time. If signs are all there is, in Delillo the signs are nothing but post-apocalyptic waste, the accumulation of temporary stuff that we call home. Where's Iago? his characters seem to ask over and over again. Out with the trash, gone with the wind; he's history.

The night of the winter solstice, everyone in Indianapolis leaves their houses. We've been told to turn on all our holiday lights at 6:14 p.m., and to go outside and wave at the dark sky. The spaceship Mir is passing over, with David Wolf inside. His mother lives in this city, which is, tonight, glittering with crayon-colored incandescent glass. He will have nine minutes to talk to her and we will have nine minutes to light every light and wave our hands, which are, in the dark, invisible even to us.

We can hear radios through the night. We've been listening to radios communally every May of our lives. Though it's always been the whine of racecars, this sound of disembodied voices and technology is nothing new to us. We laugh as we listen to the radio and will wait to turn off the lights until he passes over. Of course he will recognize his old neighborhood, this particular electricity pulsing through these particular wires, this brave sharp scattering of jewel-toned light.

And now David Wolf's mother, in the nine-minute window of communication open to her, speaks to the son spinning above her head exactly like you would speak to a son who had gone too high in the neighbor's tree: "You look good, David, but I'm not going to let you stay up there much longer," and the son says, "Too late, Mom, you already signed the permission slip." And then we hear some empty static, and we laugh and turn off the radios and lights after he passes over.

It was sweet really, so human, but the night was cloudy, and we feel vaguely unsatisfied. A consciousness cast out beyond the campfire's light, some communication from all that brooding silence, but the night was cloudy and the sound was bad, and we couldn't really see each other. Was he really there? We wanted a frisson, a chill, some recognition of the increasing distance between us.

This fog, these clouds, this dark night. What's beyond it? We've spent this entire year staring at the sky.

There were those pictures of galaxies colliding to form new stars, the swirling blood and amniotic fluid and coldness of it. One night the planets were aligned in such a way that they were strung in a row like science fair Styrofoam models. And in the summer, Mars was hanging right above the moon, the whole planet burning intense as cigarette ash, the pinkish orange of iodine.

Styrofoam, ash, and iodine: Delillo's trash and drek.

In the summer there was that robot thing that walked around the surface of the red planet. We waited for it to confirm our fears: that at one time there were sentient beings living there, that Iago slithered through its texts, that it used to be a garden. But every message was contestable, filtered through something human-made with room for so much slippage between what seems to be and what is. In that slippage there is a great but illusory and temporary freedom. We need Iago. Because every story is a fall from innocence: from seeming grace into the hard truths of what is.

SATURATION

On Climate, Politics, and Sex
(or, The Ballad of the S.A.D. Café)

Part I

The absence of struggle is often the case of the winter houses in literature. The dialectics of the house and the universe are too simple, and snow, especially, reduces the exterior world to nothing rather too easily. It gives a single color to the entire universe which, with the one word, snow, is both expressed and nullified for those who have found shelter.

—Gaston Bachelard, *The Poetics of Space*

I'm walking along the sidewalk to my car, away from work, toward my home. I've made this trip several times a week for more years than I'd care to mention. I've been down this road with my windows open, with windows shut, in minivans and cars, on bicycle, on foot. I've been on it pregnant, been on it joyful, been on it broken-hearted, been on it scared, been on it alone and in company, been on it fully aware and half asleep, in the daytime and at night, at times of reverie and focused concentration.

The trees that line the road are Bradford pear. They bloom white, gather leaves, the leaves fall, they bloom again. Never once have they asked my advice or waited for my permission, and when our moods, the Brad-

ford pears' and mine, have coalesced, as they do once or twice a year, it's pure accident. No matter how beautifully flame-like they may seem in the spring, if I'm distracted or unhappy, I just won't see them. Though that's their only chance at being seen by me, if I'm being honest. In the winter, they're part of the pattern of midwestern gray.

Like now. It's mid-December, and the sky, of course, is gray. What kind of gray in particular? It's well known that midwesterners have over one hundred words for gray. In the cities, even the bluest summer sky has a grayish film, like a cataract-clouded eye, and the winter gray is associated with things mineral and heavy—concrete, steel, and stone—and today I feel a steely chunk of it next to my heart. As William Gass writes, "In the Midwest, around the lower lakes, it's a rare day, a day to remark on, when the sky lifts and lets the heart up."

I've been reading about perception, and so today I try to look at the trees, the gray-green grass, the library that looks like a pathetic wedding cake, the parking lot with its salt-smeared cars, the road itself, and let my eyes unfocus and my brain unlearn everything it thinks it knows about the way that objects look. I gaze blankly, trying to avoid fixing space with objects and spaces between objects, trying to undo the perceptual constancy that allows the brain to see the tiny students coming out of their dorms as full-sized, or even as figures at all. I forget about proximity, similarity, continuity of contours, the favoring of closed systems, the privileging of smallness, the preference for symmetry and movement—all that overtime work that bossy over-achiever, the brain, does constantly with its preconceptions and its fear of chaos as we so-called *see*—and the world flattens, and objects turn into simple shapes, and hard-edged things begin to rise like bubbles in a glass of New Year's champagne. Do try this at home. Unfocus your eyes, and watch all the objects on the table in front of you begin to rise.

It's not easy. I do it for as long as I can, which isn't long because—snap, something moves. Is it a danger? Is it food? Is it something beautiful or terrifying? Snap, snap, and once again the brain forces the eyes to do their work of creating illusions.

I always believed Flannery O'Connor when she said that learning to write is learning to see. I've believed it for years, and I still believe it, though I believe it differently than I used to. I used to give my students objects and tell them to focus. See the flame of the pear tree in the center of the cut strawberry, the glossy bulges around the black seeds. See that particular leaf you're holding in your hand. See your hand. Not any hand. See yours.

But now I also think that what she meant was that learning to write is

learning to see through, to see confounded, to blur, to see with old eyes, to see with young ones, to close your eyes and see with the eyes of the blind.

And so for this moment of unfocused attention the gray Indiana sky becomes what William James calls "a great blooming and buzzing confusion" and beautiful, full of light and movement, full of blue and lilac shadows, despite its predictable gray skin.

And so. I've been thinking a lot about climate in fiction.

I'm not sure why the idea of climate seemed like something important to think about this year, other than the idea that barometric pressure, the pressure of the atmosphere on a unit of the earth's surface—in this case the unit being a character, those human beings who rise up out of the fog of ink or screen—seemed like a thought for a project in thought, which the essay always is. And of course it's been a year of hurricanes, tsunamis, fire, and just south of where I live, tornados. The tsunami was so violent, in fact, that the friction affected the earth's rotation. We lost something like a third of a millionth of a second this year from our one and only lives.

But tsunamis, hurricanes, and floods are the emergencies, the weather, the moods that break up the regularity of the seasons. And weather is not what has concerned me. Weather is different from climate. Climate is the thing that persists, the thing that gives a place its tone over time, the thing that when it changes, if it changes, changes slowly and imperceptibly, not in the span of a human life.

I've always thought of a story's climate as something that reflects character or that stands in contrast to character: the storm that builds, like movie music, with the climax. But I'm not interested in a universe that serves as nothing but a mirror for human drama, not interested today in a fiction of narcissism because it's so obviously not true. Nature doesn't mirror my moods; it invades, it saturates, it sometimes seems to rule them.

The climate of Indiana, for instance, is a large part of who I am. The shape of my body, my choice of clothes, the way I feel in different months, the texture of my skin: all of that I'm sure is partly fashion, partly hereditary. But then again, there are so many women who look like me in the Midwest. I know that. I've been told that. And I know it's in part because so many people from northern Europe—Germany, Poland, Switzerland—migrated here in the mid 1800s. So it's heredity, right? But what were they looking for? The forests, the shape of the land, the climate that best suited them, the one that built the structure of their midland bodies, the protection against the winter cold, the summer humidity. We're made of climate, we experience internal weather, and when, because of life events, our mood doesn't lift with spring sun or dampen with the heavy felt of winter,

climate reminds us that it remains the uncanny mysterious "other," larger than ourselves.

Climate reveals itself as "IT," the thing we refer to when we say "it rains, it's snowing, it's warm, what's it like it outside." IT is perhaps like the existentialist's God, something that affects us and that we pay profound attention to but which pays us no mind. It does as it wants, no matter what our expectations.

And so, while a flood or hurricane or tornado may serve as a catalyst—the "one day" of a story, since a story starts when the problem starts, and sometimes, granted, the problem is the weather—there are other stories in which the climate puts a constant pressure on characters, like the lower lakes midwestern gray, the IT that affects *my* mood today, the thing that affects the sense of myself in space (shorter, somehow, wider, as though I'm being pressed, enclosed, different from those taller, richer days of sun). Climate is something writers often take for granted, but it is an element that permeates the very cells of the best fiction of writers such as Sherwood Anderson and William Gass. Or maybe, simply, the best fiction.

You can think about whether specific climates give rise to specific types of narratives: rain to repressed sexuality as in Somerset Maugham's short story by that name, or New Orlean's subtropical swampiness and Anne Rice's vampires, again, repressed sexuality and the never-ending longing of the earth, or God, for blood. Rice wrote *Interview with the Vampire* after the death of her child, and the cry of a mother questioning why the earth requires that sacrifice underlies every word in that amazing novel, and the climate is stitched to every word as well.

You can think about whether the dry heat of the Santa Ana wind really does cause women to run their fingers along the blades of their kitchen knives and eye the back of their husband's necks (Raymond Chandler), or whether the intense dark of nineteenth-century winters gives a mystical intensity to the rare green light from the ikon lamp or the flash from a sunset in the stories of Chekhov. And all these things lead to musings on climate and national character and individual fate. Like a Quaker meeting, this essay will give you time to muse and to imagine. To unfocus your eyes and refocus them.

But come back to me.

Because wherever your musings take you, here's the thing:

Whatever the climate is, if climate is to exert its pressure, fiction must be *saturated* with it. The climate must be more than simply landscape, more than setting. It must be remembered by the writer, inserted again and again, or rather, not inserted; it must become perhaps, in the writing,

the meditation point, the knot, the thing that one spirals back to again and again in the writing of the story because it saturates not only the story, but the characters.

IT, that mysterious other, moves into the spaces, the alveoli of the lungs that speak the story—those clouds, that sky, the sea, that snow. We shouldn't, as readers, forget about it for many pages or it will disappear, and the character's actions will become meaningless.

If these are snow characters, or swamp characters, and they're taken from that snow or swamp, then where do they get their power? What now will feed them? In those spaces, those beats between dialogue, between gesture, between, even, other elements of setting—the climate reasserts itself. The vampire in the swamp of New Orleans or the rain of Paris is a much more sensual vampire than the one in the snowy caves of eastern Europe—and it's the moisture that feeds his sensual blood lust in one and more violent bone breaking in the other.

Let's take, for instance, snow.

Part II

The sun abruptly hid itself, ugly peat-brown clouds moved in from over the ridges to the southeast, and a wind bearing cold, alien air that went to your bones and seemed to have come from unknown regions of ice suddenly swept down through the valley, setting the temperature plunging and inaugurating a whole new regimen. . . . "[S]now" Joachim's voice said. . . . [E]verything seemed veiled in white mist and both town and valley were lost to sight. . . .

—Thomas Mann, *The Magic Mountain*

A climate built of snow has certain qualities, and those qualities are built into the nature of the substance itself. Snow is a connected system of delicate cloud forms consisting of ice crystals: polyhedra, tubes, spheres, needles, dendrites, and shells. The single flake in the system is always a hexagonal crystal, six-sided symmetry, molecules attracting to the points and cusps, a fractal growing and splitting. They're symmetrical, mathematically explicable things. Beautiful, yes. But terrifying in that symmetry.

Water and ice are clear, and a snowflake on your hand turns clear quickly, but snow in the air or on the ground *looks* white because of all the light-reflecting surfaces that scatter that light into all its colors. Two meters into a glacier of ice, and most of the long waves of red photons are dead, and we see only blue. Dig into snow and squint your eyes; you'll see the

glacial blue, the liquid eye of movie screen color that does not, like water, reflect, but only intensifies, draws you in, a smoky eternal blue.

For an example, take Thomas Mann's novel of the stupor preceding the Great War, *The Magic Mountain*. In this novel, the protagonist Hans Castorp leaves the world of the flatlands, leaves the hardwood forests and songbirds, crosses the sea in the height of summer, ascends the Alps to the tuberculosis sanitarium where he plans to spend three weeks and ends up spending seven years. "Time," Mann writes "is water from the river Lethe, but alien air is a similar drink." This alien air is the climate of the novel, a climate that lacks "odor, content, moisture," a climate that goes "easily into the lungs and [says] nothing to the soul." It's Hans Castorp's job, he's told by the sanitarium's doctors, to acclimatize himself to this emptiness, and so climate appears in one guise or another: as air, as temperature, as blossoming, but particularly as snow, on every single page.

As soon as Hans arrives, the climate begins its pressure on his character. His body feels freezing while his face feels flushed. The weather in the sanitarium is contrasted with the weather in the flatlands, which is associated immediately, in Hans's reveries, with his grandfather's death. In the "intoxicatingly damp meteorology" down below, in the wind and fog, the physical stuff that makes a body appears in his memory as "waxy, yellow, smooth stuff with the consistency of cheese." The mountain climate, in contrast, is pleasantly numbing, doze-inducing, white, and its particular light saturates even the objects in the novel, from the shimmering white milk on the tables in the dining room to the glaring of the sun through the white clouds that cause the inhabitants to screen their faces with a white canvas sunshade. It's the type of climate where, unlike the climate Hans has left behind, "if someone dies right next door you don't even notice it. The coffin is brought in early in the morning while you're still sleeping."

Little by little, as he adjusts to the climate, he adjusts to timelessness, one consistent feature of a snow-filled text. Writers who meditate on snow seem inevitably to meditate on time. True time began, according to Aristotle, when beings were created, and it persists only where and when things change. Frozen things don't change. They're preserved, botoxed. A winter setting serves as a form of cryonics for imagined beings. On Magic Mountain, these beings come as close as possible to living in the eternal present, which is, for Mann, not a place where human beings should live. It's where they die without any awareness of their death. In the eternal present, meals are sumptuously served followed by rest cures where each body wraps itself in its casket of blankets, on its special lounge chair, in the freezing air, living life on "the horizontal" without work, without news-

papers, with the small hidden-away dramas of love that take place primarily in daydream. Sex anticipated and sex remembered take up far more space than sex in actuality.

The only work required on Magic Mountain is the taking of one's temperature, the charting of the rise and fall of internal climate while viewing the "hard barren landscape" that lay "under the bright sun like a framed painting."

Hans, who is not sick but is convinced quite shortly that he is, buys a blanket, soon can't remember his age, and by page 83 of a 704-page novel, the climate has done its work on him. He's gone from health to sickness, from energy to lethargy, and has become "very tired," so tired that "tired isn't the word for it. You know what it's like when you're dreaming and know that you're dreaming and try to wake up, but can't?" And he will remain in this stupor until page 699.

So, it's early twentieth-century Germany, you're Thomas Mann and you believe that the cause of war is ordinary well meaning citizens who are seduced by illusions, such as:

1. Perhaps the discussion of bad ideas is something that can take the place of work
2. Perhaps ideas are without consequence
3. Perhaps rich food, sexual intrigue, naps, bad novels, and other cheap entertainments can take the place of both work and ideas
4. Perhaps it's possible to live without pain
5. Perhaps if you run from evil it does not exist
6. Perhaps it's possible to live in isolation
7. Perhaps if death can be ignored it will also not exist

Your metaphor is that of a snowed-in tuberculosis clinic where, because among the few truly moribund patients, who are hidden from sight, there are far more who are hiding in plain sight.

You want the sense of time passing in the novel to feel like real time, to have the reader in her recliner as she reads begin to feel her cheek, to take her temperature. How many hours have I been reading this book, she asks? How many days? Have I myself been here seven years? The afghan wrapped around my feet, the blood slowing down. Am I sick? When I stand up, will my legs still hold me? Should I get a sounding of my lungs? Am I reading this in twenty-first-century Indiana, or have I gone back in time to the home of my ancestors?

You're Thomas Mann, and you want your fiction to be a virtual reality chamber, for it to be felt in the reader's bones because you know you're right about this thing, civilians and war, and although you don't know that

twenty-first-century reader, you know that what you have to say will be important for her to hear. Don't buy it, that illusion! he shouts across the centuries. When you're done reading this book, get off that couch and go into the world, you ordinary citizen, and feel consequences of your sleep-walking. Don't allow evil, once again, to do its work.

But that's 616 pages of virtual stupor, and you want your reclining reader to feel time passing, and you want her to feel cold. And so you saturate your book with the climate. It appears on every single page.

Hans arrives in winter, buys his first thermometer on page 91, his third day, when summer is over. By page 115 it's a cool cloudy morning that "evokes no memories;" by page 138 the weather is vile again, and in that vile weather, Hans falls in love and first wraps himself completely, like a mummy, so he can think about that love, keeping it separate from the body. Instead of declaring his love, which he won't do for pages and pages, he lives within the love as in a dream. More time is spent on the description of real time—the seven minutes it takes while he takes his temperature, watching "the sheen of mercury blended with the refraction of the light in the elliptical glass tube"—than on any action.

After that, on page 100, the weather changes again, signaling to the reader and to Hans's cousin Joachim but not to Hans the tick of the eternally spiraling clock, the seasons that come around and around and that affect your mood, your actions, but in reality only bring you closer to death.

A third of the way through the book the weather turns foggy and cold again, and Hans is taken to look into the inner climate. There's a wonderful x-ray scene from that era when x-rays were moving pictures, like television screens. He sees his own foggy interior, and his cousin's, appear through the darkest night as "a milky glow of a slowly brightening window, the pale rectangle of the fluorescent screen." In that screen he sees something expanding and contracting like a flapping jellyfish—his cousin's heart—and he sees "what he should have expected to see, but which no man was ever intended to see and which he himself had never presumed he would be able to see: he saw his own grave . . . , saw the flesh in which he moved decomposed, expunged, dissolved into airy nothingness."

It's this flesh that the frozen air is meant to render into stillness so that time stops and the progression into decomposition becomes impossible, or if not impossible, at least invisible, or if not invisible, geometric and rational as a snowflake.

On page 223 he experiences mercury's moods, his inner weather, a "blazing heat with icy frost hidden within and beneath it," experiences love as "a fusion of frost and heat." By page 229 the beautiful weather

comes and holds, on page 230 there's a splendid autumn day, on page 231 he sees his love dressed in white and his temperature climbs and he asks, on page 261, what the body, this flesh that longs for the woman—Frau Chauchat—is made of and is told by his doctor that it's made of water, that "the dry stuff is a mere twenty-five percent, twenty percent being ordinary egg white to which just a little fat and salt is then added." After death, the body evaporates, and Hans is told that life "means that the form is retained even though matter is being transformed." Nothing frightening, nothing wet and swampy. Dry stuff and water. Stay up here in isolation and you can convince yourself that's all life is.

And so forth. By page 263 winter arrives again, and both the snow and the temperature fall, the days become dim, the snow providing indirect light, "a milky luster that suit[s] this world and its people." Once this winter begins, Hans fever chart curves upward and everyone in the sanitarium begins reading a pulp book called *The Art of Seduction*. Fearful of the flesh, Hans spends this winter of rising internal heat meditating on life, deciding that matter was "sensual to the point of lust . . . , a secret, sensate stirring in the chaste chill of space. It was furtive, lascivious, sordid . . . , derived from and perfected by substances awakened to lust via means unknown, by decomposing and composing organic matter itself, by reeking flesh. . . . This was the image of life revealed to young Hans Castorp as he lay there preserving his body warmth in furs and woolens, looking down on the valley glistening in the frosty night, bright beneath the luster of a dead star. . . ." Even the atom, he decides, was "an energy-laden cosmic system, in which planets rotated frantically around a sunlike center, while comets raced through its ether at the speed of light. . . . And in the same way, the innermost recesses of nature were repeated, mirrored on a vast scale, in the macrocosmic world of stars, whose swarms, clusters, groupings and constellations, pale against the moon, hovered above the valley glistening with frost. . . ." Hans Castorp, wrapped up in the chill like a mummy, studying life and deciding, in the chill and cold of the Alps that warmth and moisture, life itself, is nothing more than the spirit turning disreputable. And so he will remain, as the climate bids him to do, wrapped in an icy non-being, hovering in the mysterious space between the carnality, the magic, and the terror of love and death.

And so the seasons turn.

Page 356. It's April, and a series of "gloomy, chilly, damp days set in, with steady showers that turned to snow. . . . Water seeped, trickled, dribbled everywhere—it dripped, then gushed in the forests." On page 356 it pours for an entire week. On page 362 spring arrives, but no, on page 364 we learn that all this change is nothing more than smoke and mirrors.

"The days get longer during winter, and when we get to the longest one, the twenty-first of June, the beginning of summer, they start getting shorter again and it all heads right back downhill toward winter. You call it obvious, but once you disregard the obvious part, it can momentarily set you into a panic, make you want to grab something to hold on to. It's really like some great practical joke, so that the beginning of winter is actually spring, and the beginning of summer is actually autumn. . . . For a circle consists of nothing but elastic turning points, and so its curvature is immeasurable, with no steady, definite direction, and so eternity is not 'straight ahead, straight ahead,' but rather 'merry go round.' " By page 406 it's July with bad weather, a mixture of snow and rain with an occasional burst of summer, and the new winter comes on page 407, and we realize, as Hans has, that the climate creates "always the same day" that:

> . . . just keeps repeating itself. . . . One should speak of monotony, of an abiding snow, of eternalness. Someone brings you your midday soup, the same soup they brought you yesterday and will bring again tomorrow. And in that moment it comes over you—you don't know why or how, but you feel dizzy watching them bring in the soup. The tenses of verbs become confused, they blend and what is now revealed to you as the true tense of all existence is the inelastic present, the tense in which they bring you soup for all eternity. But one can't speak of boredom, because boredom comes with the passing of time—and that would be a paradox in relation to eternity.

The pressure the climate puts on the character of Hans is deadening. But it's this deadness, the new winter coming on, that finally leads Joachim, his cousin and a real tubercular, to act. Under the pressure of this eternal monotony of snow, Joachim, who remembers the flatlands and understands the world is gearing up for war, understands that eternity in life is not a possibility (or rather, since the dichotomy between eastern and western philosophies is part of the novel, not desirable for western man, according to Mann), and Joachim changes.

He decides to leave the sanatorium, to go back down to the valley where he may well die but where he will know solid time again. It is the climate, his response to it, that brings about Joachim's action.

By page 416 it's a splendid morning and Joachim's leaving. By page 417 the clock hand has jerked, the flowers have ceased blooming, Hans has ceased grieving over Joachim's departure, which happens during the autumn equinox when Hans's uncle visits to try to bring Hans back to the flatlands and out of his stupor. Joachim's departure, brought on by the pressure of weather, has caused a consultation with the flatlands uncle

who comes to bring his own pressure on Hans, the non-tubercular tuberculosis patient who does not want to leave his non-life among the shades. The uncle feels cold, yet, as with Hans, strangely feverish. Happily married, he falls in love (the fever in this place coming from the terrifying mixture of sex and death within the physical body), and by page 417 the uncle feels the "spirit of the place joining forces with his own good breeding in a dangerous alliance" guaranteed to make him one of the horizontals, but by page 427 he escapes in the middle of the night, the climate having done its work. The uncle refuses the timeless life, the light air like the "pure ether of the spheres."

In the narrative arc of the novel, the uncle was Hans's last chance to change, to come down from the mountaintop, and the rhythm of eternally returning weather turns its wheel toward a fierce snow:

> . . . in monstrous, reckless qualities . . . , in light flurries . . . , in heavy squalls. . . . [T]he few paths still passable were like tunnels, with snow piled man-high on both sides, forming walls like slabs of alabaster, grainy with beautiful sparkling crystals. . . . Down in town, street level had shifted oddly until shops had become cellars you entered by descending stairways of snow. . . . And more snow kept falling . . . outside was gloomy nothing . . . , foggy vapors and whirling snow. . . . The mountains were invisible. . . . Around ten o'clock the sun would appear like a wisp of softly illumined vapor . . . , nothing the eye could follow with certainty. . . . , a chaos of white darkness, a beast.

Suddenly the climate does what we usually think of it as doing in naturalistic fiction. It becomes animate, a fierce god incarnate, insisting on its dominance over human beings. Hans loves it, loves the monotony, but *one day* he acts as well. Over 400 pages, and he does something. He buys skis and attempts to make his way through the powers of nature.

At this point, around page 466, snow becomes what it often is in literature. It is Lacan's "Thing," the uncanny something that falls from who knows where, the non-I, human yet not human, the deadly silence of the void that somehow brings relief from the gaze, the stare into the emptiness of the void. It becomes animate. As Chekhov said, weather becomes animated if you are not squeamish about employing comparisons of her phenomena with ordinary human activities.

Hans embraces the forces. At one point he thrusts the end of his ski pole into the snow and watches "blue light jump from the deep hole as he pulled it out. . . . [I]t was a peculiar delicate greenish-blue light, icy clear and yet dusky, from the heights and from the depths. It reminded him of the light and color of a certain pair of eyes."

The snow is uncanny and yet intelligent, rational; it's the water droplets that make up the human body suddenly and violently gathered up and "frozen into manifold, symmetrical crystals, little pieces of an inorganic substance" that is still "the wellspring of protoplasm" and beyond that absolutely symmetrical, with an "icy regularity" that "characterized each item of cold inventory." It is both organic and anti-organic, the terrifying mystery of consciousness, so that "life shuddered at such perfect precision, regarded it as something deadly, as the secret of death itself." In the snowstorm Hans pictures himself being covered with "hexagonal symmetry," and his human heart pounds "stormily," the outside having come inside, and he refuses to "be covered by stupid, precise crystallometry." The pressure of the snowstorm, his focus on the texture and the color, and his reverie in the storm lead to Hans's mystical experience. He dreams of green and blue, of the great soul that "dreams through us," of the "icy horror of the bloody feast existing alongside joy," and finally something in this numbingly sleepwalking man says, "Awake, awake! Open your eyes. Those are your limbs, your legs there in the snow. Pull yourself together and stand up! Look—good weather!" The dream takes him back to the sanitarium and like most dreams, by bedtime "he was no longer exactly sure what his thoughts had been."

Joachim comes back to Neverland, the sanitarium, in April; he is truly dying now, and the doctors attempt to save his life by making him weatherproof, stiff and cold, turned into pure symmetry and form. Human beings can't preserve themselves in snow, as much as Disney and Michael Jackson might like to believe they can. Frau Chauchat, the beloved, returns with Advent and the beginning of winter, a winter that had been interrupted by summer days with a blue sky so intense it was almost black. Hans is unable now to differentiate between "still" and "again." It's spring on page 590, snowing by page 604, the woods are ill with lichen by page 610, and in a chapter called "The Great Stupor" the spring weather has caused, as it does, a suicide among a waterfall, the motion of which reminds Hans of the pandemonium of hell.

Hans will remain in this climate, wrapping himself up in a blanket and letting the snow fall on him in his lounge chair, taking his temperature for seven minutes several times a day, longing for a woman he only touches once, for seven years. In *The Magic Mountain* the climate has been, all along, an insistent metaphor, a metaphor that is broken finally by the thunderbolt of war, the thunderbolt which was "the deafening detonation of great destructive masses of accumulated stupor and petulance . . . , the thunderbolt that bursts open the magic mountain and rudely sets its entranced sleeper outside the gates."

The climate-induced stupor was, finally, demonic, and it is broken only when the political climate breaks open the heavens. Still speaking in terms of climate, Mann writes at the end:

> Where has our dream brought us? Dusk, rain, and mud, fire reddening a murky sky that bellows incessantly with dull thunder. . . . Around us is rolling farmland, gouged and battered to sludge. And there is a road covered with muck and splintered branches. . . . It is the flatlands—this is war. And we are reluctant shades by the roadside, ashamed of our own shadowy security . . . , and the spirit of our story has led us here to watch these gray, running, stumbling troops. . . . They are a single body, so constructed that even after great losses it can act and triumph, even greet its victory with a thousand-voiced hurrah—despite those who are severed from it and fall away.

Part III

> The sound of the freezing of snow over the land seemed to roar deep into the earth.
>
> —Yasunari Kawabata, *Snow Country*

How can you explain the strange beauty of Japanese Nobel laureate Yasunari Kawabata's *Snow Country*. As in *The Magic Mountain*, the prose is saturated by climate. It's never left behind, not even for a page. If you were writing a similar book and knew you wanted to get this feel, one thing to do might be to simply take a magic marker and highlight everything that is *not* climate to see if the prose is saturated enough so that the page, once highlighted, has small blocks of color, those blocks being the alveoli of human speech, of action, the unhighlighted areas denoting the world outside the human.

In *Snow Country* the characters are bits of heat, or rather cold that is *lesser than,* actors that move fairly silently through the snow-drenched climate, a climate that is loud in its silence.

What snow does, in particular, is to change so completely the visual landscape that inner and outer become erased. Fiction that takes place in snowy climates often focuses, paradoxically, on heat: political (think *Doctor Zhivago*), sexual (think Chekhov's story "Witch," or Hoeg's *Smilla's Sense of Snow*), literal such as fevers (*The Magic Mountain*), or flaming, as in *Snow Country*. Sex is compressed to a flame beneath the skin; death is dream-like, quick, held in suspension until the summer thaw and ooze.

The very atoms slow down, freeze, appear before your eyes as a confu-

sion of stars and planets, the symmetry of ice: beauty, as Rilke said, is the last veil covering the terrible.

In *Snow Country* the climate of outer and inner space are constantly inverted or mirrored in one another. Climate, in particular snow, is the center of a flower, a white peony, let's say, that Kawabata touches, spirals out from and back to constantly, like an elderly relative watching the weather channel, asking, always, each hour, What is the weather? What is it doing outside? How is it where you are? And because the novel is told from Shimamura's, the protagonist's, point of view, it's Shimamura who does the spiraling.

Like the climate in *The Magic Mountain*, the air of *Snow Country* is colorless and cold, and the pressure it puts on Shimamura is a sense of unreality. If this were a film, it would be white with touches of black and a blazing red from sunlight, a kimono, frozen skin, a red that deepens the sense that the uncanny is rushing in.

As with *The Magic Mountain*, this novel begins with a train, in this case coming out of a long tunnel into the snow country, and the snowy cold pouring *in*. Into the train, into Shimamura. It begins with a misted-over window that serves as a mirror in the depths of which the landscape outside the train moves, reflecting figures within the train, "a light in the mountains" shining "in the center of the girl's face" so that the landscape seems to flow over her face and the face seems to flow out of the mountains. The ray of light then comes through the pupil of the girl's eye so the eye becomes "a weirdly beautiful bit of phosphorescence on the sea of evening mountains." Later, as Komoko, the geisha who loves Shimamura, looks in the mirror, the snow from outside is reflected and in the middle of the snow her red cheeks, skin that causes Shimamura to wonder if the sun is up, to reflect, while looking at the reflection, that the intensity of the snow seems to burn icily.

Throughout the novel Kawabata plays with the opposites of fire and ice—the sparkle of ice flying off into bits against the faded ashen line of yarn that, even in its ashen dullness, seems "warmly aglow" and reminds him that his cheeks "too, were aflame." Skin burns, light passes through people, everything human is part of nature, and everything in nature is cold. The sky is cold, the woman's hair is cold, Shimamura is numb with the cold, and the moon shines over it all like "a blade frozen in blue ice." Everything is connected perceptually because it seems that Kawabata sees without the interference of that logic machine, thought. Perception is not mediated. It's pure, and so nothing gets in the way and says "No! Not

possible!" when Kawabata has Shimamura see the mirror he knows full well is on the wall float over the evening scenery and become one with the snowy mirror, the lake, that it reflects. He cannot believe that the works of man are works of man at all. In fact, every object is so saturated with the climate of this mountainous country that everything seems "part of nature, and part of some distant world."

Again, on every page the climate is the weather of dreams where the void, instead of being still, roars. How can any character operate outside of this? Impossible. Again, Kawabata is amazingly good at learning to see by turning off the rationality that defines realism.

This is a silent world where every *thing* screams and human beings are intensely silent, one in which the climate is folded seamlessly into every scene and where every human action is precipitated by perception of climate. For instance, in a tense but frozen scene between Shimamura and Komoko, Kawabata writes that the black mountains are "brilliant with the color of the snow. They seemed to him somehow transparent, somehow lonely. The harmony between sky and mountains was lost."

Short paragraph. Shimamura is married. Shimamura is stalled in his career. Shimamura is a cold yet passionate man. He notices the snow and Kawabata tells us nothing, absolutely nothing, of what he feels, just that Shimamura sees the snow and immediately he "put his hand to the woman's throat." To establish harmony? Connection? Out of fear? A sense of beauty? "You'll catch cold," is all he says. "See how cold it is."

The geisha is clinging to a railing. Suicidal? Overcome with love? A small gesture except for that word translated as "cling." She's much smaller in relation to the enormity of the roaring streaming universe than is, say, Kate Winslet in relation to the sea in the movie *Titanic*. Kawabata "keeps it cold," as Chekhov would say, and when Shimamura attempts to bring her back inside, she says simply, "I'm going home." Kawabata says only that "her voice was choked." That's our only indication of how she feels.

And Shimamura? He says, "Go home, then." Again, the roar of the external climate both precedes and follows this tiny human exchange, fraught with so much inner climate. He notices that "[t]he woman's hair, the glass of the window, the sleeve of his kimono—everything was cold in a way Shimamura had never known before. Even the straw mats under his feet seemed cold." We're told this, and then, without transition, only that insertion of cold, that needle in the heart, "He started down to the bath." But the woman! She's clinging to the railing; we know she loves him, but there's this wind tunnel of snow and cold and sky, and we can barely hear because of it. What is it she will say, that woman hanging on the railing

and insisting that she's going home in that choked voice. The next line is "Wait. I'll go with you."

The entire love triangle of *Snow Country*, its steaming subtext, all of Shimamura's coldness, and his need, is told in this dreamy cold, slowed down iciness.

Like a snowflake, this is a novel with a crystalline architecture.

The novel cracks open in two equal parts. It's the shape, in some ways, of a moth. There are the two love triangles with Yoko in the center. Part one begins and ends in snow. Part two begins in autumn and ends in fire and ice.

In part two Shimamura has returned to the snow country in autumn. The colors are at first the brown of cedar bark, the green of moth wings, the mountain ranges turning autumn-red. It's the first color, other than red, black, and white that the novel contains. Because this is a novel of snow, it is also a novel of color and the lack of it. But the green of the moth wings, rather than being the color of life, strikes him as the color of death because, of course, it is the color of movement and change rather than of icy stillness.

Again, Kawabata's brilliant imagery foregrounds nothing; the river flows from the tips of the cedar branches exactly as it would look without the interference of the brain, and the beans jump "from their dry pods like little drops of light." Komoko comes to Shimamura in his chest, "like snow piling up . . . , an echo beating against empty walls." The teakettle contains "the sound of wind in the pines," and Komoko's feet are like bells, and the mountains roar like the sea, and everything begins and ends, when the snow comes, in terror.

Part two begins in death, the novel insisting, while the autumn turns to winter, on the beautiful death of the moths, and on the increasing chill—of the floor mats, of the stone mountains—until, finally, winter begins with the snow, like white peonies, framed by the inside window, and "[t]here was something quietly unreal about it."

This sense of unreality is associated with gazing into the universe that contains, terrifyingly, an unexpected something rather than the expected nothing. Whether that something is a projection, as Lacan would have it, of the Id-Machine, the Real, the undesired fulfillment of desires, or whether it is Other doesn't concern me. All that concerns me here is that it is insisted upon, and that it is embodied in the symmetry of stars, of ice, of snow.

When Shimamura looks up at the sky he sees himself floating off into the Milky Way, and "there was a terrible voluptuousness about it. Shima-

mura fancied his own small shadow was being cast up against it from the earth. . . . The limitless depth of the Milky Way pulled his gaze up into it. . . . He blinked and the Milky Way came to fill them, . . . And the Milky Way came down to wrap itself around the earth. . . And the Milky Way, like a great aurora, flowed through his body to stand at the edges of the earth. There was a quiet, chilly loneliness in it, and a sort of voluptuous astonishment." Kawabata writes this and immediately has Komoko say, "If you leave, I'll lead an honest life," as she walks on.

Huge line, but so small in comparison to IT.

The last section of the book insists on IT, in the guise of snow. Shimamura leaves, briefly, to the village where cloth is woven from silk made by the dying moths, and the cloth's pure white is formed by weaving in the deep snow, the houses underneath tunnels in the snow. He goes to the heart of snow country in order to avoid those two love triangles of the novel, with the woman Yoko in the middle, love triangles you could *miss* if you weren't careful, as lost as they are in the roar of that silent snow.

But he comes back to the metaphor of fire in the midst of snow, and the last few pages of the novel fuse the fire and the ice and the final burning away of all the love in Yoko's death in the silk factory. Again, inner and outer are reversed, and everything is unfocused and blurred and does what it does when the eyes unfocus, what snow helps the eyes to do. The world floats as it does when you unfocus your eyes.

That's what Kawabata does in his writing; that unfocusing is how he learned to see. And so: "The low, dark houses along the street seemed to be breathing as they floated up in the light of the fire and faded away again." The world floats toward the stars and the stars come down to earth in the amazing imagery of the Milky Way, that white snowy haze of a galaxy.

"The sparks spread off into the Milky Way," Kawabata writes,

> and Shimamura was pulled up with them. As the smoke drifted away, the Milky Way seemed to dip and flow in the opposite direction. . . . He did not know why he should feel that a separation was forcing itself upon them. . . . A woman's body had fallen through the flames. . . . Perhaps the strange, puppet-like deadness of the fall was what made that fraction of a second seem so long. . . . He saw the figure as a phantasm from an unreal world. That stiff figure, flung out into the air, became soft and pliant. With a doll-like passiveness, and the freedom of the lifeless, it seemed to hold both life and death in abeyance. If Shimamura felt even a flicker of uneasiness, it was lest the head drop, or a knee or a hip bend to disturb that perfectly horizontal line. Something of the sort must surely happen; but the body was still horizontal when it struck the ground.

Komoko screamed and brought her hands to her eyes. Shimamura gazed at the still form.

When did he realize that it was Yoko?

Shimamura did not see death in the still form. He felt rather that Yoko had undergone some shift, some metamorphosis. In the frozen country, nothing dies; the atoms simply slow. The snow that saturates each page puts a particular type of pressure on the characters. Sometimes climate represents the ticking of the game clock, the sense of time passing or running out, the changing of the seasons, say, signaling a character's meeting with a predetermined fate. There are novels saturated with summer, saturated by the climate of the sea or mountain, novels of spring when Guinevere and Lancelot loosen the ties that bind them. There are climates and novels of extroversion and action. And climates of introversion. My winter gray is a climate of introversion, but snow creates a particularly blocked-off world. What will be left when the snow melts, when all that crystalline beauty disappears? The brown grass, black slush from car exhaust, discarded trash, the frozen dead. At the end of *Snow Country*, Yoko, the other woman in the love triangle, falls, in her death, like the moth at the beginning of part two. She falls like the persistently falling and rising snow. And as Shimamura moves toward and away from her, "[a]s he caught his footing, his head fell back, and the Milky Way flowed down inside him with a roar."

TIME CAPSULES

On Time in Willa Cather's
Death Comes for the Archbishop

If no one asks me, I know what time is, but if I am asked then I am at a loss what to say.

—St. Augustine

I'm watching a documentary on television. This woman with a British accent is accompanied by her director and a cameraman, and the three of them are trying to smuggle themselves into Afghanistan to determine the fate of three little girls. We see the three little girls' eyes from an earlier trip. Their mother has recently been shot to death in front of these same girls, and they've lived for days in a house with the men who have shot her. The men admit they've shot the mother, but they won't say, the journalist says,

what was done to the girls. In order to get to them, the journalists will have to go over the mountains in the bitter cold in the dark.

At every moment something is at stake. Those little girls! We saw them in the first frame of the documentary. The cameraman focused on their beautiful eyes and the fabric draped across their lower faces and pulled around their shoulders, fabric that draws the attention to those eyes and to the very real tears.

We look for the bridge, the journalist says, and we can't find it. We have to reach those girls! The only thing to do is to wade through the water. In this cold, there's the danger of frostbite, she says.

The whole scene is filmed in an eerie night-vision blue, the color of the room you're sitting in as you watch it if you were able to step outside your window and look in.

They wade across as she says, "We wade across." In minutes their socks have frozen and she says, "In minutes our socks are frozen." We see the guide rub her feet and she says, "The guide rubs my feet." The cameraman gets close to her face and she tries to talk but her cheek muscles are frozen and she has difficulty talking. She says, "I try to talk but my cheek muscles are frozen and I have difficulty talking."

"We've heard there are checkpoints along here," she says, "and so we have to sneak around them." We hear the sound of her newly thawed feet on the rocks. "This is a smuggler's route," she whispers, and the only people the camera shows, aside from the journalist, are up to no good—guns, drugs.

"We hear something," she says, and soon she's standing in a flock of smuggled sheep. "If we make it to sunrise," she says, "we'll know that we survived."

More walking and then the sun comes up, accompanied by music and a gold filter.

At every moment she's in danger of not making it to the next moment. She's narrating in present tense to underscore that danger. We know that the point of view is actually the editor's, that this has already happened and the narrator has survived it. If this were a feature film, there would be no question of language, no need for a narrative stance, but this is a documentary and part of its power comes from the fact that the camera is handheld, and that it's told in present tense, and that we believe it's real.

The journalist is likeable and brave and sincere, and what's interesting as I'm taking a break from writing this essay is the way in which it's the cameraman and the director who go into the moment, and the narrator is there only to attempt to construct the bones of time into an order with

some coherence and pattern, some connection between the present and the past, and some hook into the future. It's not language that looks through God's windows in the documentary, this alternative story-telling device; it's the insect eye of the camera, and there are places it can't go.

The documentary gives the illusion that time works like that, that we experience it in a narrative, while in fact we just experience it in eternal capsules of approximately three seconds, it's said, and each capsule contains whatever obsessions and memories happen to enter in.[1] It's when we have to tell it, when we go into the therapist's office and try to get from "my life is a mess" and find that we have to fight to slow down and say okay, well, this happened and then this and then this and then this in order to communicate the sense.

When I first started to write stories I was taught or read that every story has an arc, that the arc centers around a character who changes or has his last chance to change, that unless that happens the story is a static one. Even in a story that is put together in an episodic fashion, this particular form persists. At some point I decided the reason for this is that human beings, in part because of our need to make sense out of chaos, are particularly good illusion builders, that the purpose of a story is to bring a character out of illusion and into the real, which is something we usually protect ourselves from quite nicely thank you.

The movement in a story, I was taught, is internal, which means psychological. It takes place in perceived time, and stories are about how people feel and change *through* time. Someone was one way in the past, and that past affects the present, and the change will affect the future. Which may well be, that causality and the possibility of change, are a necessary illusion in themselves. Stories rely quite a bit on the fact that we all believe time is linear and moves in one direction, that a narrative, like life, has a clear beginning and an end.

History seems to have an order, its own arc. We teach it to our children and we number and date the years and keep very careful tabs on them.

In the Western calendar, for instance, Easter is tied quite clearly to the

1. Interestingly, consciousness and understanding are always tied to a short time span, which was called the "specious present" by William James. The specious present is closely related to the phenomenon of short-term memory and our ability to grasp and understand sentences, lines of poems, and snatches of melody. It has a duration of up to about three seconds.

seasons. We have a lunar calendar, and leap year was begun to keep the Christian holidays fixed within the seasons where they belong, which is to say the resonant ones. Easter occurs the day of the first full moon after the vernal equinox, the day the sun crosses the equator, dividing the days into equal parts darkness and light. From this point on in the northern hemisphere the days will get longer. Easter is the first Sunday after the paschal full moon, which may be quite different from the actual full moon.

And what's the paschal moon? It's the lunar month whose 214th day falls on or next to March 21, which is a rule that follows the golden number that is the number of a particular year, a numbering which started in 432 BC and goes up to nineteen and then rotates through again. So the golden number of the year 2000 is six, and the year 2001 is seven, and the year 2002 is eight, and so on up to nineteen when it begins again with one.

So in the year 432 BC someone started counting at one, and the counting hasn't ended, one year leading to the next, all of them connected together almost arbitrarily, by the passing on of a story. The golden number of 2000 is six, and its dominical letter is BA, which has to do with a lettering of months that goes back eons of human time as well.

It's all both arbitrary and careful, both scientific and superstitious. Whatever it is, it shows how much human beings have believed that there is some order to the universe, that it can be apprehended and understood. And how odd that in the first years of a new century in a city in the American Middle West we should wake up one morning and, looking at the calendar, know that it's time to put on our Easter clothes. We knew nothing about the paschal moon, but still the story of it bleeds up through the centuries, and little girls spin in their new dresses in the living room. On holidays in particular the internal change in one person is much more textured and alive.

And so, time in fiction (fiction which is life made metaphorical, life condensed, life put into a book-shaped box so that we can comprehend what it is, life, how it works, how we should act, believe, think, that kind of fiction) would seem to be one of its most necessary elements, as an ordering device if nothing else.

And there are the obvious things. The amount of time it takes to read, that we allow ourselves to linger, sometimes becomes a subliminal music. There are the number of pages in a book, all representing the passage of time, though the real time it may take you to read a novel that covers 1,000 years may in fact be less than two hours. The number of pages per chapter or chapters per book all set up a rhythm for that book, like poetry, and rhythm is one way of representing time. A novel takes on a music in that way just like the music of a line in poetry. Take Ishiguro's novel *Remains of*

the Day. There are eight sections to the novel, and the number of pages per section go like this: 18, 22, 64, 14, 13, 57. . . . Do you see a pattern? Dot, dot, dash. Dot, dot, dash. Short, short, long, short short, long. Anapests, the controlled sound of a minuet, the controlled music of the repressed protagonist.

That music is there in any book, and you can usually find the pattern of it visually. A novel is like a short-lined poem or a long-lined poem: the chapters are similar in length, or they have a pattern.

Also, we manipulate time most obviously by our choice of tense.

Present, past, future, conditional. This affects the music because it affects the verbs, causing them to add or drop sibilance (she walks, she thinks, she spits) or the drum of the hard consonants (she walked, she thought, she spat) or to become twisted in the rhythm she would, she had walked, she had often thought or spat. Sometimes revision is a matter of changing tense, of changing the "had" to simple past.

Once we choose a tense, we're often tense about the choice and we know that we can't tell something in the present (even in the past tense) without something erupting into the present from the past as in she had remembered, she often remembers, she doesn't remember, she couldn't remember. This is the fuzzy non-cinematic way we introduce back-story.

But still, there's that arc, that sense that one moment causes something to happen in the next, infinitely, and so moments are knotted together into a story, a story that contains suspense when read forward but, when read backward, is seen as inevitable. (A visual: if you draw a tree from the trunk out, the branches divide into other branches, the branches divide into twigs, and in your drawing there's no obvious path to a particular blossom, or ending, at the end of a particular twig. But if you start with that particular blossom, and move back toward the trunk, there were never any choices. It was always inevitable.)

But another possible way of looking at human stories is through the lens of timelessness, which is also stillness, where the writer's purpose is to slide down into the richness of many nows, to move around them in any order, to pick them up and look at them through the light. One way of bringing depth to fiction is to become more conscious of the many layers of history—of instants—in one instant in one place.

According to the philosopher of science Simon Saunders in his *New York Times* review of a book called *The End of Time* by Julian Barbour, to Einstein, time was "spatial." Time "relates events to one another; it is an arena like space," Saunders writes. There isn't such a thing as past and future.

"But Barbour denies that time is like space," he writes. "Events aren't situated in any fourth dimension and they are not related to one another by time. So time does not exist. But then how are we to think of change, of all the things we ordinarily think of as happening in time?" For Barbour," Saunders explains "spatial things are the primary reality. We must begin in fact with shapes. Imagine collections of triangles, cubes and other geometrical shapes. Think of an entire three-dimensional universe as built up of them and all their spatial relationships."

Think of this when writing fiction, that "neither Newton's theory nor Einstein's is what we use when it comes to our knowledge of the past. . . . With the exceptions of eclipses and the like, what we know of history comes almost entirely from records and memories. This . . . is the truer understanding of the past. Certain configurations contain with them copies of others; just as in a geologist's specimen there are shells, bones and spores, there is the past in petrified form. Each point . . . is unimaginably vast—a possible way in which all particles in the universe may be related to one another—and the history it encodes may be vast as well."

Some points in the universe are time capsules. Most points in the universe perhaps are not. But our world is highly structured and contains both living and non-living things, and so "it is a time capsule par excellence," according to Barbour. "If this is how we really know about time in practice, perhaps that is all there is to it. There are only time capsules; you and I are in a single configuration, inside an instant. An instant is not in time, time is in the instant."

"By a time capsule," he goes on, "I mean any fixed pattern that creates or encodes—the appearance of motion, change or history. . . . Although they are all static in themselves, pictures often suggest that something has happened or is happening. . . . But in reality it simply is."

What is especially striking about the Earth, Barbour explains, is the way in which it contains time capsules nested within time capsules, like a Russian doll. Individual biological cells are time capsules from which biologists read genetic time. The body itself is a time capsule. History is written in a face that contains a date. Time is nature's way of preventing everything from happening all at once. Yesterday seems to come before today because today contains records or memories of this thing we call yesterday. Through memories we are present simultaneously in many nows.

Should I be here? Should I be doing this? And perhaps that's what we're here to do, to collect these observations and tie them together in narratives as real and essential to the universe as DNA and supernovas.

And that is the thing that fiction does particularly well; it serves as a

capsule of moments. It's just that there are very few works of fiction that are able to show the spatial nature of time or timelessness.

In a story written with this vision, the fiction writer moves around a story which occurs to him usually as an impulse or a feeling which contains, he trusts, the whole, and then it becomes a matter of plucking points out of the chaos and stringing them together like Christmas lights and knowing when to stop at a particular light and to slide down into the center of it like one of those moments in a children's story where they show thousands of snowflakes and say that on each one exists a world and the camera angle slides down into that world and we see the Grinch and the Whos opening up in all their glory. It's knowing when to stop and let the moment open out in all its luminosity and detail. It's knowing that choosing to crack open the geode of a particular now, a geode which contains reflections of many different times, is to make a choice that effects the rhythm of the piece and the morality. Do you choose to open every moment? None at all? Is everything given the same weight or are some things emphasized? Is your tempo slow? Is your metaphysics one in which events take place along a string which is so eternal that everything is known, is equal, is forgiven, *is*. There often is a sense of God in timeless fiction, but not morality. *The Odyssey* is a good example. Things happen. Odysseus does not feel guilt. Penelope does not feel jealousy. Things just happen and the gods are behind all of it. When Odysseus comes to life, the gods are breathing through him.

In Willa Cather's great novel *Death Comes for the Archbishop* things that are highlighted are the landscape and the light, points in space and time that the archbishops move through on eternal horseback. The rise and fall of action has nothing to do with a drama that takes place in a small slice of time, one that, like a love story, focuses on all the ups and downs of one single human (Madame Bovary, for instance) as though it were everything. Human dramas happen—the story of Magdalena and her husband is one of them—but they're seen from the long perspective as stories that almost run themselves once certain things are set in place (the violent husband, the suffering wife), little clocks of human stories that keep predictable time because every human story is the replaying of myth, stories that have a predictable arc without the intervention of grace. Time in the novel isn't measured by the tension and release of human emotion. If anything, it's measured by the intensity of light. It's spatial and sun-lit, and even the rocks are alive, the literalization of myths, in the beautiful time capsule that is this particular place and time when cracked open. Drama is muffled, heard from afar in the middle of a seashell, in the roar of now.

Everything in the novel suggests motion, but it suggests motion in the way that a painting suggests motion. In fact everything is quite eternally still. It is as though Cather touches a spot in the landscape and it comes alive for one moment like those maps in museums. And the way it comes alive, as a painting comes alive, is through light. For example:

> It was early when the Spanish Cardinal and his guests sat down to dinner. The sun was still good for an hour of supreme splendour and across the shining folds of country the low profile of the city barely fretted the sky-line—indistinct except for the dome of St. Peters, bluish grey like the flattened top of a great balloon, just a flash of copper light on the soft metallic surface. The Cardinal had an eccentric practice for beginning his dinner at this time in the late afternoon when the vehemence of the sky suggested motion. The light was full of action and had a peculiar quality of climax—of splendid finish. It was both intense and soft, with a ruddiness as of much-multiplied candlelight, an aura of red in its flames. It bored into the ilex trees, illuminating their mahogany trunks and blurring their dark foliage; it warmed the bright green of the orange trees and the rose of the oleander blooms to gold; sent congested spiral patterns quivering over the damask and plastic and crystal. The churchmen kept their rectangular clerical caps on their heads to protect them from the sun. The three Cardinals wore black cassocks with crimson pipings and crimson buttons, the Bishop a long black coat over his violet vest.

They were talking business; had met, indeed, to discuss an anticipated appeal. But the discussion is not important. Only the moment and the light are important. Notice the use of "had," the static description that gives the illusion of motion. And notice the light: the flash of copper, the light that suggests motion, both "intense and soft," light that "bored into the ilex trees."

The vision of the book is similar to that of orthodox Christianity, described by theologian Timothy Ware as a vision "where all creation is a gigantic Burning Bush, permeated but not consumed by the ineffable and wondrous fire of God's energies." Orthodoxy, not unlike Jewish mysticism, confronts the seeming impossibility of created beings being able to know God while knowing that God is by nature a mystery, unknowable. The solution to the paradox in both cases is a distinction between God's energies, usually described as light, and God's essence. "For his energies," St. Basil writes, "come down to us but his essence remains unapproachable."

The monk Nicolas Motovilov writes of walking with the Russian saint Father Seraphim, who turned, during their walk, into light: "After these words I glanced at his face, and there came over me an even greater

reverent awe. Imagine in the centre of the sun, in the dazzling light of its midday rays, the face of a man talking to you. You see the movement of his lips and the changing expression of his eyes, you hear his voice, you feel someone holding your shoulders; yet you do not see his hands, you do not even see yourself or his body, but only a blinding light spreading far around for several yards and lighting up with its brilliance the snow-blanket which covers the forest glade and the snow-flakes which continue to fall unceasingly. . . ."

In physics and in the vision of the mystics, there is no time, only eternity, an eternity that reveals itself within creation as light. And every instant contains, as Barbour describes in *The End of Time,* every other instant. Take this example from Cather's novel:

> On the morning after the Bishop's return from Durango, after his first night in his Episcopal residence, he had a pleasant awakening from sleep. He had ridden into the courtyard after nightfall, having changed horses at a rancho and pushed on nearly sixty miles in order to reach home. Consequently he slept late the next morning—did not awaken until six o'clock when he heard the Angelus ringing. He recovered consciousness slowly, unwilling to let go of a pleasant delusion that he was in Rome. Still half believing that he was lodged near St. John Lateran, he yet heard every stroke of the Ave Maria bell, marveling to hear it rung correctly (nine quick strokes in all, divided into threes, with an interval between); and from a bell with beautiful tone. Full, clear, with something bland and suave, each note floated through the air like a globe of silver. Before the nine strokes were done Rome faded, and behind it he sensed something Eastern, with palm trees—Jerusalem, perhaps, though he had never been there. Keeping his eyes closed, he cherished for a moment this sudden, pervasive sense of the East. Once before he had been carried out of the body thus to a place far away. It had happened in a street in New Orleans. He had turned a corner and come upon an old woman with a basket of yellow flowers; sprays of yellow sending out a honey-sweet perfume, Mimosa—but before he could think of the name he was overcome by a feeling of place, was dropped, cassock and all, into a garden in the south of France where he had been sent one winter in his childhood to recover from an illness. And now this silvery bell note had carried him farther and faster than sound could travel.

The Bishop is in the American West, in Rome, in Jerusalem (though he's never been there), in New Orleans, in the south of France. Nothing happens in this scene because nothing happens when time does not exist.

In this, as in every other scene throughout the novel, Cather illumines rather than narrates:

She came for the Bishop's apple blossoms and daffodils. She advanced in a whirlwind of gleaming wings, and Tranquilino dropped his spade and stood watching her. At one moment the whole flock of doves caught the light in such a way that they all became invisible at once, dissolved in light and disappeared as salt dissolves in water. The next moment they flashed around, black and silver against the sun. They settled upon Magdalena's arms and shoulders, ate from her hand. When she put a crust of bread between her lips, two doves hung in the air before her face, stirring their wings and pecking at the morsel.

Each scene is a revelation of timelessness, a revelation of the light of God. Even death is not a dramatic moment, because nothing ends. Death is the "moment when the soul made its entrance into the next world, passing in full consciousness through a lowly door to an unimaginable scene." An unimaginable scene that has its counterpart in this world when fiction cuts itself adrift from drama, and throws in its lot with moving air, with dust and light. An unimaginable scene that has no past, no future. "During the last weeks of the Bishop's life," Cather writes, "he thought very little about death; it was the Past he was leaving." The human sense of time. But the Bishop had "an intellectual curiosity about dying; about the changes that took place in a man's beliefs and scale of values.

"More and more," Cather writes, "life seemed to him an experience of the Ego, in no sense the Ego itself. This conviction, he believed, was something apart from his religious life; it was an enlightenment that came to him as a man, a human creature. And he noticed that he judged conduct differently now; his own and that of others. The mistakes of his life seemed unimportant, accidents that had occurred en route, like the shipwreck in Galveston harbour, or the runaway in which he was hurt when he was first on his way to New Mexico in search of his bishopric.

"He observed also that there was no longer any perspective in his memories. He remembered his winters with his cousins on the Mediterranean when he was a little boy, his student days in the Holy City, as clearly as he remembered the arrival of M. Molny and the building of the Cathedral. He was soon to have done with calendared time, and it had already ceased to count for him. He sat in the middle of his own consciousness; none of his former states of mind were lost or outgrown. They were all within reach of the hand, and all comprehensible."

You want wildness in your stories? You want miracles?

"Where there is great love there are always miracles," Cather has her Archbishop say to his friend Joseph. "One might almost say that an apparition is human vision corrected by divine love. I do not see you as you

really are, Joseph; I see you through my affection for you. The Miracles of the Church seem to me to rest not so much upon faces or voices or healing power coming suddenly near to us from afar off, but upon our perceptions being made finer so that for a moment our eyes can see and our ears can hear what is there about us always."

I saw the comet Hale-Bopp with my own eyes for an entire summer just two or three years ago—this truly amazing marquee of light which even now feels like something I might have seen on television but without the force of a good soundtrack that would have imprinted into my memory the unbelievable reality and once-in-an-eternity presence of what I saw. When it was gone from the night sky, it was absolutely and utterly gone, and when I think of it now I wonder why I didn't spend that entire summer living outside, saying this is amazing, look at this because you know it is amazing. And even now as I'm remembering this and working my way through this essay, the journalist is still, eternally, narrating her story as she makes her way into Kabul in an armored car.

THE APPRENTICESHIP OF
FLANNERY O'CONNOR

While I am a woman I am also a freak. The work I do is not suitable for a woman. It is unsexing. I speak with real conviction here. I don't write "the womanly" novel. I write the same kind of novel a man would write, only it is ten times harder for me to write it than it would be for a man who had the same degree of talent. Dr. Johnson was right: a woman at intellectual labour is always a dog walking on its hind legs. When you add to that the task of running a house, serving dinner that seems to have been prepared by an excellent cook, and all the while trying to be a good hostess—which means trying to make every man in the room have a good time—oh well, I am inclined to self-pity now and I don't deserve any pity at all, for I have a good time in this life. But I do have a lot on my hands. I bite off more than I can chew all the time.

—from a letter by Caroline Gordon

The function of the artist is to penetrate the concrete world in order to find at its depths the image of its source, the image of its ultimate reality.
—Flannery O'Connor, *Mystery and Manners*

An iconographer learns to draw the Virgin Mary through a long apprenticeship. You can sweep the studio for ten years before being allowed to mix paints and then finally another ten before taking up a brush. If you do it correctly, it can take years to complete one image.

The preparation of the board alone can take months. The wood has to be sanded smooth and prepared with coats of gesso—rabbit hide glue and chalk—and the gesso has to be dried and sanded between each coat until it feels as smooth and cool as fine china. Then the image is copied from a prototype that undoubtedly had a miraculous story as part of its origin—it flew with white wings, say, down from heaven and landed in a lake in Archangel Russia and stayed there until some iconographer made a copy, and then it flew away and landed in St. Petersburg, and so forth, hatching cathedrals and copies of itself wherever it landed. A copy of this original image is etched with a sharp blade into your own small square gesso before you begin to paint. If your hand cuts too sharp you have to begin again from the beginning. If you think too much rather than paying attention to the prototype, if you insert your own ego in any way, you have to begin again.

Every painting session begins with prayer and the preparation of an egg wash (run the yoke under water carefully so it doesn't break, transfer it from your left hand to your right, breaking the skin finally with a pinch of the fingers and letting the yellow goo run into a cup, to which you then add an equal part of water and some vinegar). You brush the egg wash over last week's work and begin. The paint is egg tempera made with tints found in clay and plants and blood; the colors are proscribed—an ochre for Mary's face, a rusty red for the robe, a vermillion tinge for the shadows —and they're applied in multiple layers, from dark to light, and every act of the artist and every brushstroke is symbolic.

It's an exacting process, but if you make a mistake, it's the egg tempera that allows you to confess to your teacher and erase the mistake rather than as with acrylic simply covering it over. You can repair any mistake you make by going clear down through the layers of previous weeks' work, down through the lighter paint to the darker, down through the gold leaf, down through the layers of hide and chalk to the beech tree, down as far as it takes until you can begin again. The farther you go with your erasing brush the darker the image gets until you get down to the pure solid light of glaze. The teacher won't let you live with a mistake because the image is both matter and at the same time a god—a metaphor, the incarnation.

As an apprentice, you will learn to be patient. You will learn to trust the process. You will learn to see.

The process of learning to paint an icon involves learning how to see double. The process of learning to write, Flannery O'Connor said, is the

same. The basis of all the arts, she wrote, with the possible exception of music, is learning how to see.

The irony is that the end result—in the case of O'Connor's fiction and in the case of the icon—won't look like realism to anyone who thinks he knows what things look like. The icon's eyes are large and round and the hands sticklike, and because the light source is supposed to be evenly emanating from within the image the only shadows are in the folds of cloth which makes the image seem initially cartoon-like, like O'Connor's glaring images.

O'Connor's images:

A steward places a man at a table in a dining car with "three youngish women dressed like parrots." A woman in slacks "whose face was as broad and innocent as a cabbage and was tied around with a green-head kerchief that had two points on the top like a rabbit's car," a "fat woman with pink collars and cuffs and pear-shaped legs that slant off a train seat" and "don't touch the floor, and eyes the color of pecan shells set in deep sockets," stares at a man wearing a "glare blue" suit with the price tag still stapled on the sleeve and eyes with settings so deep that they seem almost like "passages leading somewhere." Or "The fountain counter was pink and green marble linoleum and behind it there was a red-headed waitress in a lime-colored uniform and a pink apron. She had green eyes set in pink and they resembled a picture behind her of a Lime-Cherry Surprise."

O'Connor's characters have the large eyes of icons or Egyptian mummies, or of the dead. They drive rat colored cars through landscapes where hogs nose in the furrows along the road looking like "large spotted stones." O'Connor's imagery is sharp and spare, rendered with an acute eye to color and line but almost no attention to shading and detail. The blood red suns shine on a highly stylized world of bright imagery. Human figures are absorbed into animals and things into humans: trees look as if they had on ankle socks, a cow is dressed up as a housewife. In O'Connor, similes are literalized, which gives them that edge of surrealism that you find in Kafka or Marquez or Denis Johnson. It's not like the Holy Ghost seeps into your consciousness like a water stain; it *is* a water stain. If you literalize a Bible verse—"shall they not rise up suddenly that shall bite thee"—for instance, into a backhoe, or you pluck out your eyes literally when they offend you, you're in the world of O'Connor.

Yet the symbols have their beginnings in perception guided by a particular set of internal lenses that see the world as both matter and spirit. " 'If you've been redeemed,' " Hazel Motes says to Mrs. Hitchcock on the train in the first chapter of *Wise Blood*, " 'I wouldn't want to be.' Then he turned his head to the window. He saw his pale reflection with the dark

empty space outside coming through it. A boxcar roared past, chopping the empty space in two, and one of the women laughed." That reflection with the dark empty space is both carefully observed and symbolic and bare. While faith might guide perception, for O'Connor it doesn't negate the hard work of trying to perceive.

I read Flannery O'Connor as the work of an iconographer.[1] Fiction, she said, in *Mystery and Manners,* is an incarnational art. The artist seeks revelation, she explained, through sense perception. Because she didn't see spirit and matter as separate, she was always looking for those specific images that revealed both themselves and something else.

Iconography. Revelation. Mystery. It's almost impossible to talk about O'Connor's work without speaking in religious terms, and she wouldn't want you to. "That belief in Christ is to some a matter of life and death has been a stumbling block for readers who would prefer to think it a matter of no great consequence," she wrote. For them, Hazel Motes's integrity lies in his trying with such vigor to get rid of the ragged figure that moves from tree to tree in the back of his mind. For the author, Hazel's integrity lies in his not being able to.

O'Connor was a Catholic artist, but hers was a Catholicism influenced by twentieth-century existentialists, by Sartre, by Maritain and Kierkegaard, whose Christian existentialism comes closest to O'Connor's vision in her stories of characters who learn that a human being needs "to live" constantly in the face of death, in the awareness that here and now may be the last moment. According to critic Marjorie Greene, for Kierkegaard, "the quintessence of terror is not man's fear of death, it is the dread ensuing from a confrontation with the possibility of his own immortality."[2] Jesus, in O'Connor's fiction, is the "ragged figure motioning [Hazel Motes] to turn around and come off into the dark where he was not sure of his footing, where he might be walking on the water and not know it and then suddenly know it and drown."

Even though O'Connor's fiction is intricately tied to her vision, it didn't come automatically with the vision and was in fact continually

1. O'Connor was a cartoonist in addition to being a writer, and I would argue that she saw herself in these terms. In the famous self-portrait that hangs in her study, she painted herself with the wide eyes of an icon, and where the halo would be, in exactly the same proportion to her face, she painted a straw hat.

2. Marjorie Greene, "Kierkegaard: The Philosophy" and "L'Homme est une passion inutile: Sartre and Heidegger," *Kenyon Review* 9 (1947): 53, 57, 66–67, 168. Cited in *Flannery O'Connor, The Imagination of Extremity,* Frederick Asals (Athens: University of Georgia Press, 1982), 30.

learned as a craft. She was of course probably the first major American writer to earn an M.F.A. And, like an iconographer, she learned the craft through an apprenticeship. To her teachers, and to writers she read: good influences, such as John Hawkes and Kafka, as well as influences she had to shake off, such as Faulkner and Joyce.

Or rather, maybe it was graduate school combined with Joyce that she had to shake off, as in the early story "The Train" where she wrote, "Now the train was greyflying past instants of trees and quick spaces of field and a motionless sky that sped darkening away in the opposite direction." Note the portmanteau words and the voice that screams "I'm a good writer."

Nathaniel West's *Miss Lonelyhearts* was a big influence, with its ironic voice, grotesque perception, theme of the religious quest, relationship between a nonrealistic approach to fiction and explicit treatment of religious motifs, the episodic action, and the novel structure through image and motif rather than through conventional plot, as was Edgar Allen Poe's mix of horror and comedy.[3]

But part of O'Connor's apprenticeship as an iconographic writer was through an amazing and generous lifelong correspondence with the writer Caroline Gordon. O'Connor sent Gordon drafts every time she finished a story, and every time, Gordon replied with a letter. It was an amazing and generous friendship made even more so by the fact that Gordon was a writer herself, but a writer who also had a husband and usually a house full of visitors for whom she cooked elaborate meals.

When you look at the earlier drafts of stories and drafts revised after Gordon's letters, you can see that O'Connor accepted a fairly large percentage of the suggested changes and went on to take those changes as templates for later stories. She didn't accept all of them.

You have to understand that O'Connor didn't accept any criticism easily.[4]

Contrast letters to her editors with the relationship she had with Gordon. After fourteen years of correspondence, it was still important for her to say that "Caroline was crazy about my story 'Revelation.' She read it to her class and they laughed until they cried. This did not keep her from writing me six pages on the principles of grammar and on how to spell such words as 'horde' which I spelled 'hoard' but which means something else."

Many of the letters Gordon wrote are lost or not collected, but a particularly amazing one in response to O'Connor's first novel, *Wise*

3. Flannery O'Connor, *The Imagination of Extremity.*
4. See "On Being Fierce."

Blood, survives. The letter is postmarked the 13th of November, 1952, and it begins:

> Your manuscript has come. I spent yesterday reading it. I think it is terrific! I know a good many young writers who think they are like Kafka. You are the only one I know who succeeds in doing a certain thing that he does. When I say that I am merely reaching out for some phrase that will partly convey my notion of your work. I do not mean that it is in any way derivative of Kafka. In fact, this book seems to me the most original book I have read in a long time. But you are like Kafka in providing a firm Naturalistic ground-work for your symbolism. In consequence, symbolic passages—and one of the things I admire about the book is the fact that all the passages are symbolic, like life itself—passages echo in the memory long after one has put the book down, go on exploding, as it were, depth on depth. . . .

> . . . I think that you have done a good job on the revision. I don't really see how you managed it. The Fitzgeralds told us that you have had a severe illness and are only recently out of the hospital. There comes a time for any manuscript when one must let it go with no more revisions. I think that having done the job you've done you could let this manuscript go with a good conscience. But I am going to make a few suggestions and comments. They are really suggestions for your future work, but I have to have something to pin them to, so I am going to take passages from W.B. as illustrations of the points I am trying to make. If I seem overly pedantic it is doubtless the result of teaching. When you are reading a manuscript for a fellow writer you can say I like this or I don't like that and he figures it out for himself, but if you are dealing with students you have to try to relate your reactions to some fundamental principle of the craft. I admire tremendously the hard core of dramatic action in this book. I certainly wouldn't want it softened up in any way. I am convinced that one reason the book is so powerful is that it is so unflaggingly dramatic. But I think that there are two principles involved which you might consider. . . .

> It is the fact that in this world nothing exists except in relation to something else. . . . You have to imitate the Almighty and create a whole world—or an illusion of a whole world, if the simplest tale is to have any verisimilitude.[5]

Gordon goes on to give advice for O'Connor's revision of the book that would become *Wise Blood*.

5. Cited in an article in *The Georgia Review* by Sally Fitzgerald, from an unpublished letter. The O'Connor Collection.

Novel-writing was difficult for O'Connor. Her training at Iowa was in the short story, as is true of most writing programs today, and the short form seemed to come more naturally. So O'Connor did what novelists who feel more comfortable with short fiction often do. First, because plot is not an essential element in the story but is in many novels, she *found* her major plot point in a rereading of *Oedipus*. Her protagonist, Hazel Motes, would blind himself. Once she knew that, the novel moved in that direction. But most importantly, she let the novel grow from earlier stories. Anyone who is interested in seeing the evolution of her fiction, and in particular the effect of Gordon's suggestions, can look at the stories from her M.F.A. thesis (the first stories in *Flannery O'Connor: The Complete Stories*) and compare them with chapters in *Wise Blood*. In her initial draft of the novel she left the stories virtually unchanged.

Gordon's letter to O'Connor is helpful not only to O'Connor but to any young writer of fiction. Every year I share it with my own fiction writing students, and every year it continues to teach.

In her letter, Gordon writes that although she admires "the core of dramatic action in this book very much," she has some technical suggestions, suggestions primarily about dialogue, characterization, and scene. About scene, she writes:

> I think that the whole book would gain by not being so stripped, so bare, by surrounding the core of action with some contrasting material. Suppose we think of a scene in your novel as a scene in a play. Any scene in any play takes place on some sort of set. I feel that the sets in your play are quite wonderful but you never let us see them. A spotlight follows every move the characters make and throws an almost blinding radiance on them, but it is a little like the spotlight a burglar uses when he is cracking a safe; it illuminates a small circle and the rest of the stage is in darkness most of the time. Focusing the reader's attention completely on the action is one way to make things seem very dramatic, but I do not think that you can keep that up all of the time. It demands too much of the reader. He is just not capable of such rigorous attention. It would be better, I think, if you occasionally used a spotlight large enough to illuminate the corners of the room, for the corners of the room have gone on existing all through the most dramatic moments. . . .
>
> What I am trying to say is that there are one or two devices used by many novelists which I think you would find helpful. . . .

She explains to O'Connor that a writer can make a scene "more vivid by deliberately going outside of it." She uses as her example a scene from *Madame Bovary* when Emma and Charles meet and in the distance hear

the sound of a chicken, a sound that adds another dimension to the scene in the room.

Gordon is particularly helpful in her suggestions about landscape and mood. "Occasionally," she writes, "you get a powerful effect by having the landscape reflect the mood of the character, as in the scene where the sky is like a thin piece of polished silver and the son is sour-looking. But it seems to me monotonous to have the landscape continually reflecting their moods. In one place I think you could get a much more dramatic effect by having it contrast with them. For instance, in the scene where Haze, Sabbath and Enoch meet, I think that the landscape ought to actually play a part in the action, as it does sometimes in Chekhov's stories. If the night sky were beautiful, if the night were lyrical, the sordid roles the characters have to play would seem even more sordid. After all, here are three young people trying to do as best they can what they feel that they ought to do. Sabbath wants to get married. Enoch wants to live a normal human life. Haze, who is a poet and prophet, wants to live his life out on a higher level. You convey that admirably, I think, by emphasizing his fierce dedication to his ideals. But the scene itself is too meager for my taste. Your spotlight is focused too relentlessly on the three characters. . . ."

Notice that in this section of the letter Gordon is also reinforcing the way that each character's desires drive the plot. Sabbath wants, Enoch wants, Haze wants. Gordon has scanned the text for those motivations, and she reminds O'Connor of them.

O'Connor, whose tendency in her early stories was to have landscape reflect mood, uses the technique suggested by Gordon most famously in her story "A Good Man is Hard to Find" when she writes that "the trees were full of silver-white sunlight and the meanest of them sparkled" while the Misfit's criminal friend begins shooting the family, one person at a time.

For my own students, one of the most helpful suggestions Gordon makes has to do with what Gordon calls "strokes," what some writers call "gesture," and what I like to call "beats" because of the way they work rhythmically. In screenwriting, those strokes are often referred to in this way. In fiction writing they serve to help us visualize the characters, and they also serve rhythmically, as they do in the dialogue of a screenplay. You can see the strokes slowing down the action in "A Good Man is Hard to Find" when the story opens up during the conversation between the grandmother and the Misfit.

Here's the dialogue without what Gordon calls strokes and I'll call beats:

"You're the Misfit! I recognized you at once."

"Yes'm but it would have been better for all of you, lady, if you hadn't of reckernized me. Lady, don't you get upset. Sometimes a man says things he don't mean. I don't reckon he meant to talk to you thataway."

"You wouldn't shoot a lady would you?"

"Listen. I know you're a good man. You don't look a bit like you have common blood. I know you must come from nice people."

Here it is with the beats:

"You're the Misfit! [Beat] I recognized you at once."

"Yes'm [Beat] but it would have been better for all of you if you hadn't of reckernized me."

[Beat beat]

"Lady, don't get upset. . . .

Here's the way it reads in the final version of the story. In this case I've italicized the added beats:

"You're the Misfit," *she said.* "I recognized you at once."

"Yes'm," *the man said, smiling slightly as if he were pleased in spite of himself to be known,* "but it would have been better for all of you, lady, if you hadn't of reckernized me."

Bailey turned his head sharply and said something to his mother that shocked even the children. The old lady began to cry and the Misfit reddened.

"Lady," *he said,* "don't you get upset. Sometimes a man says things he don't mean. I don't reckon he meant to talk to you thataway."

"You wouldn't shoot a lady, would you?" *the grandmother said and removed a clean handkerchief from her cuff and began to slap at her eyes with it.*

The Misfit pointed the toe of his shoe into the ground and made a little hole and then covered it up again. "I would hate to have to," *he said.*

About the scene in *Wise Blood* where the patrolman has just pushed the car over the embankment and says, "Them that don't need a car, don't need a license," Gordon writes O'Connor that it needs

another stroke or two. I don't see Haze plainly enough. The chief thing I have learned from Flaubert is that it takes at least three strokes, three activated sensuous details to convince us of the existence of any object. I want to know how Haze's face looked then. His knees bending and his

sitting down on the edge of the embankment is fine, but it is not enough for me. Also I want to know how the patrolman looked when he said 'Could I give you a lift to where you were going?' If we are to believe that anything happened we must be able to visualize the action. The minute we are unable to visualize it we quit believing in it. Very often a scene in which two people figure will be unconvincing because it is lopsided. The writer furnishes us the data which will enable us to visualize the main character but he doesn't give us the data that we must have in order to visualize the subordinate character. But he is there, taking up just as much space as the main character and I think that he must be presented with just as much care. If, for instance, the main character is doing all the talking the reader's attention must be directed to the subordinate character at regular intervals. The fact that he isn't talking must be dramatized almost as much as the fact that the other man is talking—or you will get a one-sided affair. The whole passage is too hurried for me. It needs more sensuous detail and more numb lines. I want again to see how Haze's face looked when he said he wasn't going anywhere and again I want to know how the patrolman looked or at least what position his body assumed when he said 'You hadn't planned to go anywheres.' A few, a very few more strokes would do wonders for that passage.

And so in her revision of that scene O'Connor adds details that allow us to see the secondary character, and she adds the specific beats that Gordon suggests—the way Haze's face looked and the position of the patrolman when he says "You hadn't planned to go anywheres." She adds details of scene that slow the action down and allow us to visualize it, details that give the piece its final rhythm. She also adds details—ground, middle, and far distance—that give the scene the three-dimensionality that Gordon was always looking for.

I'm going to go through the scene, putting the added revisions in italics:

> The patrolman got behind the Essex and pushed it over the embankment *and the cow stumbled up and galloped across the field and into the woods; the buzzard flapped off to a tree at the edge of the clearing. The car landed on its top, with the three wheels that stayed on, spinning. The motor bounced out and rolled some distance away and various odd pieces scattered this way and that.*
>
> "Them that don't have a car, don't need a license," the patrolman said, *dusting his hands on his pants.*
>
> Haze stood for a few minutes, looking over at the scene. His face seemed to reflect the entire distance across the clearing and on beyond, the entire distance that extended from his eyes to the blank gray sky that

went on, depth after depth, into space. *His knees bent under him and he sat down on the edge of the embankment with his feet hanging over.*

The patrolman stood staring at him. "Could I give you a lift to where you was going?" he asked.

After a minute he came a little closer and said, "Where was you going?"

He leaned on down with his hands on his knees and said in an anxious voice, "Was you going anywheres?"

"No," Haze said.

The patrolman squatted down and put his hand on Haze's shoulder. "You hadn't planned to go anywheres?" he asked anxiously.

Haze shook his head. His face didn't change and he didn't turn it toward the patrolman. It seemed to be concentrated on space.

The patrolman got up and went back to his car and stood at the door of it, staring at the back of Haze's hat and shoulder. Then he said, "Well, I'll be seeing you," and got in and drove off.

Gordon's suggestions often focus on dialogue. She suggests places where O'Connor could benefit from alternating direct and indirect dialogue.

Here a device is that I think you had better get on to," she writes. "It is dangerous, I think, to have a character emit more than three sentences in one speech. If he does you get an unlifelike effect. If he has to say more than that you ought to dramatize the fact that he is making quite a long speech. Ordinarily, one can improve dialogue tremendously by making three speeches out of every speech. Thus:

Haze: Listen, I'm not a preacher.

Then the driver either says something or doesn't say anything. In either case, the reader must learn how he received what Haze said.

Then we ought to know how Haze looked when he makes his next speech: I don't believe in anything.

Again, we ought to know how the driver received that or what he said.

Then Haze says I don't have to say it but once to nobody.

When speeches are run together in one paragraph the way you have Haze's remarks here they muffle each other. Speeches need air around them—a liberal use of white space improves almost any dialogue. White space at the end of a paragraph gives a speech room to reverberate in and if you will clear the space for it, it will reverberate every time.

Look at any O'Connor story, and you'll see that this is one of Gordon's rules she hardly ever broke. Characters never say more than a sentence or two without that speech being broken up by description or summary.

And again and again O'Connor comes back to the necessity of moving between description and dialogue so that the reader never forgets the scene. And she comes back to the issue of three strokes, three concrete details, to describe any character. Gordon writes:

> You attempt to create Haze's eyes by two strokes. I don't think that it can be done. I have thought about this business of three strokes being necessary to create the illusion of life and I've come to the conclusion that it's related to our having five senses. A person can get along without one or more of his senses but once he's deprived of all of them he's dead. Two strokes is like a person who is deaf and dumb and blind and has, perhaps, lost his sense of touch to boot. He's hardly there.

You can see this use of three strokes in almost every story O'Connor ever wrote. For instance: "Enoch had on a yellowish white suit and a pinkish white shirt and his tie was the color of green peas. . . . Then he looked up and saw the blind man's child not three feet away. Her mouth was open and her eyes glittered on him like two chips of green bottle glass. She had a white gunny sack hung over her shoulder." Three details. Three strokes.

Gordon goes on in this letter with a whole list of numbered specifics such as, "The knobs framing her face were like dark toadstools." In fiction, she says, "did" is always better than "was," unless you are handling some state or condition so that mere being becomes a form of action. "It seems to me," she writes, "that the knobs ought to frame her face instead of just being. Same thing goes for the sentence, 'In his half sleep he thought where he was lying was like a coffin.' 'Was' makes it less dramatic there. If I were doing it I'd say, 'He thought that he was lying in a coffin.' I'm not sure though that I'm right here. Maybe not."

O'Connor ignores this second change but makes the first:

Here's the original version from her story "The Train." "Going around the corner, he ran into something heavily pink; it gasped and muttered 'Clumsy!' It was Mrs. Hosen in a pink wrapper with her hair in knots around her head. He had forgotten about her. She was terrifying with her hair slicked back and the knobs like dark toadstools framing her face."

And here's the revision from *Wise Blood*: "Going around the corner he ran into something heavy and pink; it gasped and muttered Clumsy! It was Mrs. Hitchcock in a pink wrapper, with her hair in knots around her head. She looked at him with her eyes squinted nearly shut. The knobs framed her face like dark toadstools."

The change is in part stylistic in response to Gordon's suggestions that have to do with style. But style is of course a reflection of thought and vision, which Gordon understood. Critics have often seen the changes as

thematic. One particularly brilliant O'Connor scholar, Frederick Asals, writes of this particular passage that:

> . . . in "The Train" the narrative eye is primarily on the perceiving character. Mrs. Hosen is presented as she appears to Haze and his explicit reaction absorbs and cushions our own. In *Wise Blood* all suggestion of Haze's response to this encounter is stripped away; even the impressionistic "heavily pink" becomes the more precise and objective "heavy and pink." The simple sentence which replaces the excisions is no less revealing: a single stark image that heightens the incongruity of the woman's appearance. And compared with its counterpart in the story, the final sentence from the novel is piercing, the soft falling effect of the three participles replaced by the abruptness of the decisive verb, and the neutral image of the slicked back hair abandoned to throw into sharp relief the repellent knobs. In the flatness and simplicity of style which seems baldly to thrust the images at us, Mrs. Hitchcock is made to materialize through a power of language which renders her more terrifyingly present than in "The Train."

All of which is of course true, but it begins with a stylistic suggestion from Gordon's letter.

At times Gordon suggests that O'Connor slow down so that we don't forget the scene. At other times she suggests that O'Connor slow down to emphasize a point. She writes, " 'He had all the time he could want to be converted to nothing in' is another place where I think you hurry the reader too much. After all, his conversion to nothing is the crux of the book. You must give us time to take that in."

At all times Gordon reminds O'Connor of what she knows—that thing that it's so easy to forget. That a writer has to see, that seeing is difficult, that there's something inside us that doesn't want to do that hard work of seeing. And so Gordon prods her: *I wish I could see the house from the outside. I need to see the inside of that toilet. The fact that you haven't set your stage properly takes away from the drama of this scene. You have not taken the trouble to create the driver of the car. I think that if a man sells somebody a newspaper in a story that man must be rendered. That is the reader must be given just enough details to enable him to visualize the man. Otherwise you will have what Ford Madox Ford used to maintain was the most dreadful ghost story he knew; the guest in the country house who decides he will smoke in the night and is pretty upset when an unseen hand hands him a match. Anybody would be and anybody is when this happens. One gives a character like this a different kind of attention from the kind one gives important characters. Nevertheless, one must give him his due or he will take his revenge.*

And O'Connor writes. She adds the details. She moves away from abstraction.

She improves the rhythm of the scenes. Say this, then show that. Say this, then show that.

The result: the combination of O'Connor's vision and Gordon's technical suggestions are a master class in fiction writing. It's worth the time to get the *Complete Stories* and compare the first version of *Wise Blood* evidenced in "The Train" with the first chapter of the finished novel. It's evidence that vision is something that cannot be taught but that craft can. It's also evidence that any improvement in craft deepens vision. When a writer of vision is reminded where to look, something will always be found.

At the end of the letter, Gordon writes, as any good teacher would, "Well enough of that! I would like to see you make some preparation for the title and I'd like to see a little landscape, a little enlarging of the scene that night they all meet, and I'd also like to see a little slowing up at certain crucial places I've indicated, but aside from those few changes I don't think that it matters much whether you make any of the revisions I've suggested. I am really thinking more of the work you'll do in the future than of this present novel which seems to me a lot better than any of the novels we've been getting. But of course in writing fiction one can never stand still. Once you learn how to do one thing you have to start learning how to do something else and the devil of it is that you always have to be doing three or four things at a time."

And this is of course what a student in any workshop or an artist in any studio class learns: that everything has to be re-learned, that all criticism is contingent, that everyone is always an apprentice, and that the criticism you receive on one piece may not help you until you begin work on the next thing. "You won't, of course," Gordon says, "pay too much attention to anything I've said in this long letter. After all, it's just one novelist talking about the way she thinks things ought to be done. I may be quite wrong. But my heartiest congratulations to you, at any rate. It's a wonderful book. I've written to Robert Giroux, expressing my admiration. My best wishes to you. I do hope that you continue to feel better.

Yours, Caroline."[6]

6. Gordon goes on to write, "Next morning: I realize that in all this long letter I've said little about what I admire in the book. It is, first of all, I think, your ability to present action continually on more than one plane. Only writers of the first order can do that. Everything in your book exists as we all exist in life, mysteriously, in more than one dimension. . . . I admire, too, very much, the selection of detail. You unerringly pick the one that will do the trick. And the dialogue is superb. But you will have gathered, by this time, that I am tremendously enthusiastic about the book. My heartiest congratulations on the achievement. It is considerable."

And O'Connor writes back:

Thank you so much for your letter and for wanting to help. I am afraid it will need all the help it can get. I never have, fortunately, expected to make any money out of it, but one thing that has concerned me is that it might be recognized by Catholics as an effort proper to a Catholic. Not that I expect any sizable number of them who aren't kin to me to read it—reading is not necessary to salvation which may be why they don't do it—but I have enough trouble with the ones who are kin to me to know what could be expected. You can't shut them up before a thing comes out but you can look forward to a long mortified silence afterwards. I used to be concerned with writing a "catholic" novel and all that but I think now I was only occupying myself with fancy problems. If you are a Catholic you know so well what you believe that you can forget about it and get on with the business of making the novel work. . . . When I first started my book I was right young and very ignorant and I thought what I was doing was mighty powerful (it wasn't even intelligible at that point) and liable to corrupt anybody that read it and me too so I visited a priest in Iowa City and very carefully explained the problem to him. He gave me one of those ten cent pamphlets that they are never without and said I didn't have to write for 15 year old girls. . . .

All these comments on writing and my writing have helped along my education considerably and I am certainly obliged to you. There is no one around here who knows anything at all about fiction (every story is "your article" or "your cute piece"). . . . So it means a great deal to me to get these comments.

I had felt that the title wasn't anchored in the story but I hadn't known how to anchor it. I am about that now. . . . I had also felt that there were places that went too fast. The cause of this is laziness. I don't really like to write but I don't like to do anything else better; however it is easier to rewrite than do it for the first time and I mean to enlarge those places you've mentioned. I've been reading a lot of Conrad lately because he goes so slow and I had thought reading him might help that fault.

The business about making the scenery more lyrical to contrast with their moods will be harder for me to do. I have always been afraid to try my hand at being lyrical for fear I would only be funny and not know it. I suppose this would be a healthy fear if I had any tendency to overdo in that direction. By this time working so long on the book I may have cultivated the ugly so that it has become a habit. I was much concerned after your letter to Robt. To get everything out of that book that might sound like Truman Capote. I don't admire his writing. It reminds me of Yaddo.

Caroline Gordon commented on every story and novel that Flannery wrote after this, including her final story, "Parker's Back." It was, from the beginning, a very one-sided relationship, remaining teacher and student until the end. O'Connor comments in a couple of letters that she hasn't "gotten around yet" to reading Gordon's newest work, and she doesn't actually meet Gordon until four years after the correspondence begins. In a letter to "A"[7] she writes, "Last summer I spent a weekend with Caroline [Gordon]. . . You are right about her not being timid. She lays about her right and left and has considerable erudition to back herself up with. . . . She takes great pains and is very generous with her criticism. Is highly energetic and violently enthusiastic. When I am around her, I feel like her illiterate grandmother."

O'Connor wasn't unappreciative, usually. As is true of the relationship between a parent and a child, the relationship between a teacher and a student is almost always aimed toward the next generation. You don't expect to get back from your children the same amount of energy you gave to them. You give to your children what your own parents gave to you.

In the same way a teacher forgets what her teacher taught her, the words finally becoming her own. O'Connor's letters to others have echoes of her teacher's voice, and often she passes Gordon's advice on to someone else. Sometimes she gives Gordon credit, and sometimes she refers to her as "a lady I know, who also writes," and sometimes she passes on the advice as though it suddenly occurred to her out of the blue. And so in O'Connor's letters to younger writers there are letters that sound like the ones she received from Gordon: "There are one or two places where I think a false note is struck. On p. 11, on p. 14, on p. 15, on p. 19 you as omniscient narrator say 'then there was a fight beat any . . . 'This is using colloquial language when you leave out that that belongs in there. The omniscient narrator never speaks colloquially," she writes. "This is something it has taken me a long time to learn myself. Every time you do it you lower the tone. It took Caroline about five years to get this through my head. You get it through yours quicker." In fact many of the things she learned from Gordon she passes on to Cecil and to "A." In 1961 she writes:

> We have just had a weekend of Caroline. She read a story that I have been
> working on and pointed out to me how it was completely undramatic
> and a million other things that I could have seen myself if I had the
> energy. It all goes to show that you can know something in your head
> and still not carry it out. . . . I have written so many stories without
> thinking that when I have to think about one, it is painful. Caroline says

7. See O'Connor's collected letters, *The Habit of Being*.

that I have been writing too many essays and it is affecting my style. . . .
Caroline was strenuous as usual. I had a story that I had written a first
draft sort of on and Caroline thought as usual that it wasn't dramatic
enough (she was right) and told me all the things that I tell you when I
read one of yours.

If you contrast an early story, "The Geranium," with the later story, a ver-
sion of "The Geranium" titled "Judgment Day," or you contrast "The Train"
with the first chapter of *Wise Blood*, you'll see the debt she owes to Gordon.

"The Geranium" is particularly sceneless, relying on "would" and
flashbacks, not because O'Connor couldn't do it on her own but because
she needed to be coaxed.

Who doesn't? Why take the risk when you can stay on dry land? If the
risk of being redeemed for O'Connor's characters lies in the terrible pos-
sibility that the saving miracle of grace may at any moment collapse,
perverted by self-consciousness, that same risk exists when writing fiction,
that risk that you might start walking on water and halfway across you'll
realize what you've done and drown. It's tempting to not attempt the walk.
Relying on abstractions, flinching from detail, all these things are the
marks of a writer who is afraid of the imagination.

Gordon reminded O'Connor to head on across with faith and not
look down. She was a coach, a midwife. Step by step across the water, to
trust the process—the slow unfolding of sensory perception, even when it
leads in the story to that terrifying violence that seemed to be the only
thing capable of returning O'Connor's characters to reality. "Their heads
are so hard," she wrote, "that almost nothing else will do the work."

The God she followed in the walk across the water was the one Martin
Buber calls "the unwished for God who demands that His human crea-
tures become real, they become human."

After her apprenticeship O'Connor begins her own walk across the
water into that strange O'Connor universe where the sun is "a huge red
ball like an elevated Host drenched in blood," where the human faces you
thought were real are nothing more than the projection of a social self
onto a screen. She walks through into that shadow-less world of hard lines,
of cartoon, of vermillions and ochres, where characters discard comfort-
ing illusions and have sudden intimations of "what time would be like
without seasons and what heat would be like without light and what man
would be like without salvation." It's that terrifying world she perceives as
the real one, where the mysterious suffering icon eye peers through the
eyehole of every human face.

THE GIFT OF FIRE

A Meditation on Art and Madness

Understand O Reader.
Forgive me for not stating your name.
I tremble in fear that you will forget
 me.
Let us come to an understanding.
I respect that fact that you exist and
that means something if not very much.
 For
you to even glance into the direction of
my meaning warms my blood. My skeleton
is relaxed to the fact that you are
 glancing
into the direction of my meaning.
Maybe we should call a meeting of
some sort in order to settle our
 differences.
We share the moon and stars on various
nights. If ever you journey by my way
maybe we could share a cup of coffee.

 —Frank Dattilo, patient at Madison State Hospital,
 student of Brian O'Neill

Art Class, Central State Hospital

I sit on the floor in the art studio, a legal pad on my lap, recording details. The studio is quiet, as lovely as glass. There's a plastic glove pinned to the wall, covered with paint like those swirl balloons that children carry.

Jon pours yellow into a cup and hands it to Phil. Phil's working on a painting with a brilliant sun in dark space. He dabs at the yellow and then at the black with intense concentration. He never paints a single thing but suns, he says, like the one he saw on a record album cover in middle school.

Jon's the teacher—an artist with a Ph.D. in psychology. I call him Jon here and the patient Phil because the art studio is one of the only places in the hospital where it feels as though there's no hierarchy of patient and physician, no sense of reason with its power, no matter how kindly, exercised over the realm of unreason.

For years Jon's been obsessed with triangles, and he divides canvas after canvas into three pie-shaped slices while the patients paint beside him—Phil with his suns, Ira with his line drawings of women, Jim with his layering of words and symbols.

Years ago I rode on an elevator, in another hospital, with a friend who was quite convinced she was the bride of Christ. I remember closing my eyes to feel the Braille dots on the wall by the floor numbers. I was working on a piece of fiction at the time about a blind woman. I still haven't finished it—ten years later and I'm still walking around, closing my eyes, wondering how it feels to be without sight.

You're pretending that you're blind, my friend said to me. I said I was. She knew me well. And I wanted to say, "And you're telling yourself that you're the bride of Christ," but I didn't say it. She was working on a delusional system, and I was working on a story. I'd watched both narratives grow in a process so similar that ever since then I've wondered what the difference is between them. That question's burned inside me now for years. I've written about it before. And it's brought me here now, to Central State Hospital in the month before it closes down for good, to observe this class of schizophrenic artists. It's a question that kept me mired for months—through books and lectures and interviews—in the museum of medical history.

Lost in the Medical History Museum

For months I wandered through it, until I was afraid I'd be quite stuck there.

[183]

I walked into a fellow teacher's office, and he was reading a medieval Islamic mystic—a book full of rules about how to arrange your body when you want to pray. Where to put your thumbs, your feet, how to lay your head against your hand. From my place in the museum of medical history I thought to myself about that mystic—Personality Disorder, Cluster C, Obsessive-Compulsive.

Roethke lecturing nonstop from his classroom window, Dickens wandering the streets of London for nights without sleep, Twain's depressions and periods of mania, Virginia Woolf's suicide attempt. Byron, Shelley, Coleridge, Melville, Schumann. In the Museum we keep the lists of famous artists and the diagnosis: bipolar disorder, also known as manic-depressive disorder. The ones who aren't on the official scholarly lists of famous bipolars we consider to be at least cyclothymic (alternating periods of euphoria and depression but without a major episode requiring hospitalization). Strindberg, Artaud, Nijinsky, Pound, Van Gogh; all of them spent time in mental hospitals. Official diagnosis: schizophrenic. We click them off.

I begin to diagnose my friends, many of them artists and most of them, I find, personality disorders: clusters A, B, or C. I diagnose myself—cluster C, perhaps a little cyclothymic. A few are maybe schizoaffective, but I wouldn't tell them I think so. It doesn't sound like something you could say to a friend. I diagnose my children, my husband, my colleagues, my boss, my goldfish, and my gerbils. It's exhilarating, all this classifying. It's a complete grand unified system with its own Bible—the DSM IIIR, the official manual of psychiatric symptoms—and it explains anything you ever wanted to know. If you can't find yourself in there, you probably don't exist.

I spend a week or two of my time in the museum reading theories of consciousness. There's a neurologist who says we perceive things and go through imperceptible neural drafts, like a computer binary system. That explains consciousness. You see something up near the house where your rose bushes were last summer, say, and your brain goes: It's tall like a . . . it's triangular like a . . . it's white like a . . . Before you decide it's a Styrofoam rose cone, one of your drafts says it's an old man, or an angel.

Of course! I think. That explains the connection. Most people ignore the drafts. Artists and the mentally ill are, for some probably chemical reason, programmed to be aware of them. Schizophrenics believe the early versions. I feel like a machine so I *am* a machine. They literalize the simile. Artists simply keep all the drafts but know which one we would probably all agree with. I can live my life out here in the world where everyone

believes it's a Styrofoam cone, but doesn't it have a nice metaphoric resonance to think it's an angel? Mental illness is a malfunction of similes.

I have my own theory! What a wonderful theory! No, no, no, I say to myself. You're becoming grandiose. It's a symptom of something. Look it up.

It's great fun here in the museum of medical history.

Madness and art.

I heard Robert Bly tell a story about the Ohio poet James Wright coming to his house so manic that his wife Carol stole his false teeth and put them in ice so they could take a break from his talking. I love that story. Graham Greene gave credit to his bipolar illness for the emotional range of his novels. Robert Lowell, in one of his many devastating manic phases, stopped cars in the middle of a highway in Bloomington, Indiana. During the most florid phases of the illness most of these artists were so debilitated that they created very little. They were most productive when hypomanic—on the way up but not there yet—or in the reflective stage of a mild depression. You can, in fact, chart Schumann's output according to where he was in the swing of his moods.

There are several books that give credit to manic-depressive disorder in particular for creativity in all the arts because of the insight that comes with the attempt to fight your way out of depression and the energy and obsessive abilities that come with mania. It's like Prometheus' gift of fire; too much of it and it destroys the psyche. Just enough and it warms the blood. (Though psychologist D. Jablow Hershman in his book *The Key to Genius* explains that Sir Isaac Newton wrote some of his books in a hypomanic state and was unable to even understand his own writing when he was in a depression; creativity in the arts seems to vary from that in the sciences in that science relies more on, I'm told, a slow accumulation of theory—like building with bricks and mortar—and less on finding connections between things that have no obvious logical connections. Usually. Harvard evolutionary biologist Stephen Jay Gould is a writer as well, and one of the hallmarks of his style is tying together topics as diverse as the Liberty Bell and the eggs of kiwi birds. I asked him, when he visited Butler last year, if he thought that scientists usually thought in that way, and he said no. That that kind of thinking is what separates him from his colleagues. There does, however—if you're a medical materialist—seem to be a connection between madness and religious creativity. George Fox, founder of the Quakers, saw rivers of blood in the streets. Mother Ann Lee, founder of the Shakers, hallucinated and was as obsessive-compulsive as the medieval Islamic mystic I referred to earlier. Catholic theologian Simone Weil died of what was probably anorexia. The mystic tradition is, in

fact, filled with hallucinations and voices and altered states of consciousness, though in some traditions—Buddhism, for example—if you think you actually *see* God, you're to spit in his face because it isn't real.)

The most well known contemporary psychologists doing research in artistic creativity and mental illness are Nancy Andreasen and Kay Jamison. Andreasen's famous study involving University of Iowa writing students found that the percentage of those with a mood disorder was significantly higher than the general population. Of fifteen writing students she studied, ten were afflicted to some extent with the disease. The percentage of writers, she estimates, who are treated at least once for the disease reaches as high as 80 percent.

Kay Jamison surveyed forty-seven of the top British writers and artists and found that 38 percent had sought treatment for unipolar or bipolar illness. Poets topped the list. One-half of the poets reported either drug therapy or hospitalization. Playwrights were the most likely to seek the talking cure; two-thirds of them had gone in for counseling.

While those who study writers seem to be more interested in manic-depressive disorder, those in the visual arts are interested in the connections between art and schizophrenia, perhaps because of the visual hallucinations that are more common with that form of psychosis.

John MacGregor, a psychologist and art critic who spoke in Indianapolis a few months ago about the schizophrenic artist Adolph Wolfli, said he thought that neurosis was "absolutely essential for creativity." He spoke, a bit wistfully, about the disappearance of what he considers purely psychotic art—art which is a geometrically elaborate world system, frenetic with imagery—due to the advent of antipsychotic drugs. I've been told that there are buried corridors on the grounds of Central State, hallways that used to connect buildings that have since been destroyed. You should see the artwork on those walls, I've been told. Like Escher.

According to some studies, the connection between art and madness is genetic. The percentage of artists with first-degree relatives who are mentally ill is very high. When James Joyce went to Carl Jung for advice about his mentally ill daughter Lucia, he was told that they both descended to the bottom of a river. The difference, Jung said, is that the daughter fell and the father swam. And that Joyce was able to swim back up, bringing a treasure with him that those outside himself were happy to receive because it made a connection with their world.

That connection, that ability to communicate, is important. The reason that Wolfli was hospitalized and that William Blake—whose complete world system and illuminated manuscripts are remarkably similar to Wolfli's—was not is that Blake was able to maintain his life outside the

world he created. Wolfli was often violent, and his system shut the rest of the world out. Now and then, in a cross made entirely of birds for instance, there was a metaphoric truth that rippled outward. But primarily he seemed to be speaking to himself, with ripples that traveled inward, no matter how beautifully. The doctor explains that one of his artist patients has a delusional system so inclusive that every object in the world outside of him, every placement of a piece of paper or coffee cup on the doctor's desk for instance, refers, the patient believes, to him. The difference between Wolfli and Blake, to me, is the difference between a black hole and an explosion of new stars. The same intense energy, and even beauty. But one lights up the world outside itself.

While major mental illness is without a doubt one of the world's most devastating illnesses, and while I'm not saying that artists are the least bit insane or that the insane are all artists, there are certainly traits that mental illness and creativity hold in common: an excessive energy that can give rise to a flurry of ideas, an ongoing receptivity to new information, the ability to make huge leaps between seemingly incongruous images and to synthesize them—what psychologists call loose associations and Coleridge called the "esemplastic gift"—and the ability to become obsessed and to stay obsessed and to pull all perceptions into a whole through the lens of that obsession.

I wonder what the connection is between mental illness and twentieth-century art in particular. One obvious answer is that, little by little, we've turned human traits into symptoms, and so we see a pathology where once we saw the gods or gifts or hard work. But there are other answers as well.

One afternoon I leave the metaphorical museum of medical history and travel to a real one. It's on the grounds of Central State Hospital, the state mental hospital that was due to close that summer. A hundred years ago it was a pathology lab where they did research on biology and mental illness.

I walk through the building. It's a wonderful place. Let me describe it.

The lecture hall: torn black flaps covering the ceiling glass to keep out the light. Black electrical outlets. Paintings of nineteenth-century male doctors. Cantilevered rows of desks circling like a shell around the one podium.

There's a room where a black microscope and clicking lenses turn green with reflected light from a tree outside the window. Thick cobalt blue glass protecting chemicals. Oak cabinet after oak cabinet filled with slides of human tissue. A stereoscope where you can view Victorian gray glass pictures of Indiana farm couples with matrimonial syphilis. The

terrified expressions on the innocent faces. A hundred years ago they experimented with giving syphilitic patients of Central State malaria to slow down the course of the disease. In the nineteenth century syphilis was the major cause of institutionalization. Pathologists are brave, I think, to see the things the rest of us don't want to see, to do the things the rest of us don't want to do.

Let me make explicit what I'm doing as I'm writing this:

1. I'm so aware of sound that it almost drives the meaning—all the spitting sounds of t's and g's. (I can't remember, actually, whether the stereoscope photos are glass or not. I just like the sound of gray glass. And I had to get in the assonance of "black flaps," and it had to be near gray glass. You need to watch out for that, I tell myself for the millionth time, knowing it won't do any good.)

2. I'm continually amazed that anything in the world exists at all and sense that things mean something even if I'm not sure what that meaning is—like the black electrical outlets.

3. Somehow I learned to believe that it's the purpose of the artist to force a visual perception dulled by habit to see the strangeness in the ordinary. It's the Russian Formalist aesthetic. The schizophrenic surrealist artist Giorgio de Chirico said that an artist must "picture everything in the world as an enigma . . . , to live in the world as if in an immense museum of strangeness."

 That's why the microscope reflects green light from the tree, sort of like a moon. I could have done a lot more with that, maybe gone off onto something about the moon, the sun, some sort of implied metaphor about nature and technology. I could have let the microscope actually become the moon—all those round glass lenses all somehow moon-like, and I could have remembered trying once to *see* the moon through a telescope and the fact that I kept seeing nothing but the blinding reflection of my own eye. As I'm writing this I see that that memory would have meant something as well. It is, like most images, that golden thread that Blake said, if followed, would lead to the New Jerusalem. Here in the museum of medical history, as I've already hinted, we'd say that Blake was schizophrenic.)

4. I carry around a little voice, like a chattering mouse that is conscious of why I'm doing something even as I'm doing it. (The attempt to keep out the light sets off a riff on reason, maybe on Jung's description of insanity as an eclipse or darkening of consciousness, the nineteenth-century male doctors sets off a feminist riff, all the frightening images—malaria,

syphilis, black microscopes, human tissue—set off their own riffs. I don't even need to *follow* them; you know what they are, they're in the air, and I know that you know them. The thing about the bravery of pathologists is a setup about hiding the mentally ill away and refusing to see them. I had planned to come back to it.)

I'm watching myself watch myself write and almost every sentence has an implied parenthetical comment like the actual parenthetical comments in John Barth's famous postmodern short story "Lost in the Funhouse" where he describes the purpose of every detail and the theory of fiction writing that lies behind it even as he writes it.

Not only am I aware of what I'm doing, I'm aware that I'm aware of what I'm doing. I'm aware that I'm aware that I'm aware of what I'm doing. This is postmodern angst. Nietzsche called it (it's okay if he wasn't alive to experience it—this is postmodern angst) a growing consciousness that is "a danger and a disease."

And it's not just artists that suffer from this disease. It's all of us. If you're a parent, think of how many times you've said something to your child at the same time you're thinking that you're saying this in this way because the psychologist on Oprah said that it's best to say, "I understand that you're feeling angry . . . "; or how many times you've said something to your lover and thought about why you're saying it the way you're saying it, or the complicated set of funhouse mirrors known as the presidential elections, where the post-speech critiques become the speech itself, and spin doctors try to influence the critiques, and on and on. Until you yourself have lost track of what you're really feeling. And, as Nietzsche predicted, you feel yourself absolutely unable to make a decision, or to act. You get so lost in reflection that you can only suffer, until you get sick of it sick of it sick of it and want to stop thinking altogether; that feeling was rampant at the turn of the century, right before World War I, and as we've seen, there might be a little potential for violence in that feeling.

Everyone's written about this. Ours is a time, Susan Sontag says, "in which every intellectual or artistic or moral event is absorbed . . . by a predatory . . . embrace of consciousness." The mind possesses, she says, "almost as second nature, a perspective on its own achievements that fatally undermines their value and their claim to truth." Kafka talked about the "wild tempo of an introspection that will suffer no idea to sink tranquilly into rest but must pursue each one into consciousness, only itself to become an idea, in turn to be pursued by renewed introspection." Wittgenstein looked at self-consciousness as a disease that you should study in the same way you study malaria, so you can cure yourself of it.

We think we really know ourselves by looking at ourselves, and if we can't, then maybe by looking at the looking at ourselves, and we go on and on and on in what Foucault calls a "sleep so deep that thought itself experiences it paradoxically as vigilance." Nietzsche, again, called self-consciousness a screw with no end; at each moment it is applied "an infinity begins, so it can never be brought into action."

All of the things that were underlying the description of the museum, and every paragraph that follows, as a person trying to create some sort of art in the West at the end of the twentieth century also underlies, according to psychologist Louis Sass, the thought of schizophrenics.

In part, the similarities were willed by modern artists, who took their inspiration from the insane, from children, from the "primitive." The veering into alienation, the unanchoring. The irony is that in willing wildness, what's resulted is more reason, an unanchored self-consciousness. Which leads, as we've seen, to hesitation and paralysis in, for instance, the poetry of Eliot. We sense that isolation is inevitable, that in fact it's closer to the truth, closer to the real. The postmodern turns the screw of self-consciousness even one step further, adding a sense of irony.

The attention to the material qualities of the words, of the surface (a schizophrenic listening to the sound of his own speech to the exclusion of a communicable meaning is called glossolalia; there are obvious parallels in painting—in Rothko and Pollock, that attention to the surface, to the paint). The amazement that things outside yourself exist at all, and the subsequent sense that they must mean something, are characteristic not only of artistic perception but of the pre-schizophrenic "Stimmung" or stare. "Like the schizophrenic in the Stimmung," Sass says, "all modernist writers and painters describe objects that seem alien and incomprehensible—stripped of familiarity and reality, and of any sense of coherence or connectedness, yet bursting with some profound inner significance that always lies just beyond the reach of one's comprehension."

In the modern and postmodern eras, this is the way we all view the world. According to Sass, the artist expresses it, and the schizophrenic lives it out.

The delusions and habits of mind of mental illness may have chemical causes, but they don't exist in a cultural vacuum any more than art does. And the particular form that major mental illness takes in the West is an increased self-consciousness, a hyper-awareness. While manic-depressive disorder exists in equal percentages in all cultures, the form of schizophrenia we're most familiar with seems to have risen with the rise of the industrial era and with what Foucault calls the "modern episteme" that he

traces back to Kant and characterizes as that tendency to think about ourselves thinking about ourselves thinking about ourselves. We can look at our whole culture, including our art, through the lens of schizophrenia or say that we're all responding to the same pressures.

Or maybe artists have consciously chosen the strangeness, the sense of unreality of the schizophrenic vision, as the surrealists did, to bring some sense of mystery back into a century that has, in so many ways, abandoned mystery.

At any rate, for one more month these artists at Central State will continue to create what Indiana arts critic Steve Mannheimer calls "not just good in the relative sense, but good," period. And there are some poets writing strong poetry at Madison State Hospital under the direction of Brian O'Neill.

Because they're crazy? No. The interesting thing about the art of institutionalized patients is not that they're mentally ill; it's that there seems to be the same level of talent both inside and outside the institution. The schizophrenic, while self-reflective within his own delusional system, is able to cut through the thick miasmic soup of theoretical self consciousness that artists in the academy are particularly prone to. That's our disease, and the lack of it feels eminently sane.

> Did you say that you have education?
> *No. I have only attended many schools.*
> Are you cultured?
> *Of course not. "Aida" needs elephants.*
> *And they are in short supply here.*
> Are you ill?
> *Oh, I must be: I'm terminal.*
> *What an answer to a prayer I was.*
> —from "Oxymoron," by Hazel Baker, Madison State

Christmas Party at Central State

I went to a Christmas party for the patients. The tables in the basement were filled with castoff sweaters and pair after pair of shoes, with posters of sweet sayings donated for the occasion. *Laugh It Up, Snap Out of It, The Goal of Life Is Living in Agreement with Nature.*

Each patient was given a sack to fill up with things to take as gifts. The walkman radios went quickly—they drown out the sounds of the voices. There were toys to give to baby sisters and cosmetics to give to mothers and aunts and grandmothers on the Christmas home visit. It was festive and sweet.

A young man in hand-me-down pants and a hand-me-down jacket looked through the table of old tennis shoes and told me about his new job at Kmart stocking shelves in the off-hours after the store closes. He loved the job, loved the opportunity it gave him to be out in the community.

I talked to the psychologist while the patients filled their sacks. Christmas music in the background. "I'll be honest with you, when I started painting with the patients," he said, "I was hoping I'd get some really nutty-looking stuff. But most of it's very mundane, pedestrian really. It is because of the medicine finally.

"But this whole business of drawing inferences from artwork is risky. This whole process of getting an image on paper is confounded by your hands, by this thing called talent. There's no guarantee that what the painter sees in his head is what's getting down on paper."

"I paint with the patients," he continued. "And the reason I paint with them is I think they do good work. I want them to be known as artists, not as people who are crazy who also paint.

"It's good enough just to do the work; I don't see the need to analyze it any further than what's on the face of it. Isn't it obvious what the good of it is? When you start analyzing something, you put distance between yourself and the thing, and the thing I enjoy is being in the here and now, with the patient, painting."

A lovely girl with long brown hair, wearing overalls, was looking through a pile of sweaters for a pink one. "I went home at Christmas," she said. "My brother said go out and look up your friends, and I couldn't find any."

She found two sweaters littered with balls of fuzz and held them up to her face. "Which one looks best on me?" she asked and a friend told her the one in her left hand. She put it in her paper sack.

"My boyfriend and I are getting married when I get out," she said. "He left here last week for a group home. We want to wait three years and then have babies. I want to breast-feed my babies, I heard that's the way to go, to make them happy."

"You know," she said, "my mother's a bullet stop."

A what?

She began drifting off to look at hair ribbons. "A bullet stop," she said. "And my father is an engineer."

On the way out there was an old man standing by the door, all his earthly possessions in a black plastic trash bag. He smiled really big; there were dark lines on the gums around his teeth. He wore a green thermal coat. "I'm leaving," he said, "I'm moving out."

"I'm proud of you," the doctor said.

"You knew I'd make it didn't you, Doctor?"

"I knew you would," the doctor said. "He's been here for thirty years," he said to me. "This has been his home for thirty years."

> Hitchhiking goes slow
> from Indiana. Mexico
> for no other reason. 100
> miles from the Arkansas
> border. It's been Hell and
> two nights to get this
> far. The sign said Chekata
> so it must have been a
> town. The sun near spent
> I laid by the road both
> for rest and sometimes
> cars stop to investigate
>
>
>
> I wore out my welcome
> and remaining small change
> sipping coffee and asking
> questions at the gas station.
> No travel tonight. I can
> feel in my bones there's
> no hope of a ride.
> Oklahoma.
> I found a restroom
> unlocked, and laid down,
> pulling my arms inside my
> shirt and sweater, buttoning
> my coat from the inside.
>
> —excerpt from "400 miles out and not half way there,"
> a poem by Thomas F. Hale, patient at Madison State

Art Class at Central State—Reprise

Ira sits in front of a canvas. He tries once, turns the paper over, tries again. "It's not turning out right," he says. "It's just a bad drawing." He says the "medication interrupts things," that it doesn't allow him "to do anything better."

At other times, he admits, it allows him to come back close enough to himself to do anything at all. Ira believes he's a mathematician. His paintings, he explains, are differential equations.

Red-haired freckled Hugh puts his feet up on the old oak desk. Do you get a lot of ideas for paintings, Hugh?

"Yes," he says. He grins.

What are they?

"Something like the Milky Way," he says, "or kites in the sky."

Across the room there are reds dripping down across a blue heart. Someone's interviewing William Shatner on the radio, then the poet James Merrill. "Many of us have wanted to go far away," Merrill says, "to be transformed by the experience, and come back a different person."

Music again and it's quiet, quiet. No one talks for a while. Two cats walk across the floor. Hugh sips his pop. The sound of brushes. In the window a plastic cup stained on the inside with a cobalt blue. "Isn't it unbearably lovely?" Jon asks, holding it out to Phil. "Like Delft china."

Phil nods and keeps on painting.

"I can't paint today. I'm just sick of trying to do it. It just gets worse and worse," Ira says. A cat brushes against his leg. I'm reminded of Kafka's diaries, the constant litany—I can't write I can't writeIcan'twriteIcan'twrite. Kafka, it's said, hid out in his bedroom and watched his wife through the crack underneath the door.

Mike splashes colors across a canvas. It's beautiful, like an early Rothko. "He needs time to paint every day," Jon tells me later, "the space to do it, some regular instruction. He has real talent." This art class will end when the hospital closes down. Mike will leave, trailing his Medicaid funds with him like a rainbow. If he gets a job in a sheltered workshop, he'll have some discretionary income to buy art supplies. If he doesn't, and if the privately run group home he goes to (if he goes to one and doesn't end up simply being shipped to another state hospital) won't buy paint for him, he won't have the materials he needs, and the art may stop.

Whether he has real talent or not is, in some ways, not the issue. He obviously has the need, the drive, to do it. And that's where the connection between madness and art is most poignant to me. There's the suffering that comes with the illness itself, and the need to shape that into art. Brian O'Neill puts it this way: "People who are in the hospital, anyone who suffers a traumatic dislocation, they're refugees. Their country's been wiped out, their family relationships are ruined, their families think they're being unreasonable or evil.

"They've lost their jobs, been put into a place where they're scared. They've lost their freedom.

"The desperation and dislocation inspire us to be honest, puts us closer to the bone. It takes a tremendous amount of imagination for them to just survive."

National Public Radio tells us that Fellini has died. For the wake, workmen are busy reconstructing one of his movie sets. It will be peopled with all those strange wonderful people he worked with.

After Fellini's last movie was released, says a woman's voice, Fellini said to reporters that "all meetings, relationships, friendships, experiences, trips, begin and end for me in the studios of Cinecittà. All that exists outside the gates of Cinecittà is an enormous storehouse to visit, to plunder, to transport avidly and tirelessly inside Cinecittà. Maybe it is a privilege, maybe a servitude—but it is my way of being."

I close my eyes and think of the blind woman I've been carrying around inside me for several years. Phil paints his suns, Ira works on his line drawings, Jon paints his triangles over and over again. I think about my dear friend who thought she was the bride of Christ. She died last spring about this time, still believing. What did we have in common? Maybe nothing, more or less, than human suffering. And the attempt to understand it—by forging everything we see in the fires of our own obsessions.

ON COMMON GROUND

Indiana Literature and the Land

Landscape foams up round about me like a painted picture where every brush stroke's got meaning. Meaning bursting out of weeds and fence rails. Full of meaning I can't read. What's the message? What're they saying?

—Jessamyn West, *The Friendly Persuasion*

A year ago, on a July day, my family and I went tubing on the Little Pigeon River in Tennessee. My son and I in separate tubes, my husband and daughter sharing one and fighting the whole way about whether they should go to the left or the right of that rock or stick and whether they were too close or too far away from the shore. We were with a whole group of tubed people, bobbing around on the Little Pigeon in our orange lifesavers, a lot of chatting between tubes, a lot of falling and splashing in

the water. For a while I talked and then for a while listened and then finally, after an hour or so, I just sat back in the tube and relaxed absolutely, letting the river take the tube and my thoughts without any direction from me— no paddling, no pushing against the shore, nothing—and after a half an hour there was this one moment when suddenly everything dissolved— the sky became the river, the river bled into the trees; I felt my body start to disintegrate into glittering particles, what the Eskimos call kayak sickness, and I felt like I was falling into the sky. And suddenly there was this physical start, like the yank of a bridle. I felt the bit of reason in the corner of my mouth. Okay: that's up, that's down, this is upstream, that's down-stream, these are the hard edges that separate one thing from another. This is the way you locate yourself on your own internal map, the way you keep from drowning in the river of the universe.

After reading books by Indiana writers and driving around the state looking, with landscape photographer Tori Kensington, for the connec-tions between our literary heritage and the land itself, I keep coming back to two ideas. The first is that that moment on the Little Pigeon when everything dissolved, when I felt I was drowning in a sea of light and the sudden sharp need to add hard edges, that conflict between the fluid universe on the one hand and the straight lines of human reason and control on the other, is at the heart of much of Indiana's literature. (And let me say at the start that although I'm going to be talking about Indiana literature as though it's something separate from American literature, it isn't in the least; it's just a convenient way of classifying, and like all classification of things that are themselves like a river, it's a bit of a fiction, but a useful one as they say.)

So, even though this is a landlocked state, this essay is about water and about those things that are fixed and those that are fluid. When I talk about the fluid, think of the large inland sea that once covered this ground. When I talk about the fixed, think of township lines, straight rows of corn and soybeans and fences and canals and interstates and railroad tracks. The straight lines of gravestones. A grid. I'm going to, as Ross Lockridge said, "muse upon this mingling of man's linear dream with the curved earth, couched in mystery like a sphinx."

I'm writing this in a city, where nature has to flow and ooze through a mesh of sidewalks and tubing and buildings. We experience nature in patches of mud or snow, in the sight of rivers as we cross over them on bridges, but primarily in sunlight and wind, in rain or the lack of it, in temperature, in the closeness of the sky. Nature that's primarily air, un-grounded, those parts of nature that represent flight to us and not decay. It's the fluid that's bothersome, that covers our shoes with mud, that we

protect ourselves from, barely, and that oozes through in literary works. I'm talking about freedom and restraint, about decay and preservation, about restlessness and settling *in*. Like Sonny in Dan Wakefield's novel *Going All the Way*, at some point we have to consciously face the basic existential problem of everyone who is born or finds himself living in Indiana: we have to decide if we're one of those who leave or one of those who stay.

The other idea I keep coming back to is how Indiana's physical landscape is in fact as much a fiction as the fiction. As Lockridge says of Raintree County, this is "an ancient, man-created ground." We winter in a cultural landscape as surely as bees winter in their geometric waxy hives.

Indiana is malleable ground. Even the limestone, relatively. Very few places remain in the least as they once were, and even as we speak they're changing to what they'll become. There's hardly anything we haven't changed and that we don't continue to change. You live near a mountain or an ocean, and there's the mountain or the ocean. You have to work around it in any plans you make. It's a constant. You may burrow under it, but you're not about to completely bulldoze or divert it. The Indiana landscape is open to constant revision. Ask a developer what he sees in the farmland just north or south of this city. What he sees is the homes or apartments or office complexes and man-made drainage lakes in his imagination. Ask the pioneer who stood in the dense woodland or prairie what he saw. The farms of Germany or Scotland. Because of that malleability, one of the recurring themes of Indiana literature is a sadness over what's been lost, a hard-edged or not so hard-edged nostalgia. Writers mourn the passing of familiar landscapes, of community and family and idealism and the dream of the Republic; contemporary writers express a later grief over the loss of cultural icons and the subsequent loss of identity—railroads, diners, or the kind of sadness or anger or disorientation or need to praise —that you feel when the Haags Drugs you bought baseball cards in as a child is taken over by Hooks and then by Revco. Historian George Geib says that he can locate any Hoosier on a continuum between boosterism and nostalgia. Our writers are elegiac and tend to be obsessed with loss.

So Tori and I went looking within the Indiana landscape for the landscape of imagination, tracking down clues in, say, Vonnegut's *God Bless You, Mr. Rosewater*. The town, we read, is thirty miles away from New Ambrosia—New Harmony. Vonnegut mentions a Parthenon with a roof of green copper, a canal, the tracks of the Nickel Plate, the New York Central, and the Monon. I would find the clues, and Tori would follow the tracks, the mention of towns, the paths of rivers, and in Vonnegut's case it led us

to the capital of Posey County, Mt. Vernon—Rosewater County, in Vonnegut's book—and an old store front with the word Rose, the only *tangible* evidence in the observable landscape of the landscape of imagination.

Yes, people said, there was something like a Parthenon here at one time and probably something like an Eliot Rosewater, Vonnegut's character who comes here to this landscape that his wife thought was "so deathly flat," peopled by "the rickety sons and grandsons of the pioneers," and "so deathly dull" that it is difficult to love them—us. But the Parthenon is gone now, the townspeople said, just like the railroad tracks and the canal and the two utopias of New Harmony. Nothing stays the same.

Sometimes a specific place was impossible to find. Writers will have moved the imagined landscape, based on a real landscape, into another state entirely—an easy task in a state that's home to all the major van lines. Usually the move is to Illinois or Ohio. But Janet Flanner's Excelsior, Ohio is easily recognizable as Indianapolis in *The Cubical City*. Sometimes, as in Flanner's case, the move serves as camouflage, an attempt to divert attention away from the original place, to make criticism easier, and the name serves as a mask or disguise, the way you give a character who's based on someone you know a completely different hair color so no one will recognize him. Sometimes it's because the three syllables of Ohio or Illinois work rhythmically in your sentence much better than the four syllables of Indiana, a word that's all strangely accented and a challenge to work into a line of poetry or lyrical prose—Indiana—two trochaic feet. The line almost has to be heroic, as it is in Hart Crane's poem "Indiana." I know that I've located whole stories, myself, in either Ohio or Illinois and chosen one over the other simply because I needed a three syllable word with the accent on the second syllable—O HI O, not Illinois—even though the place I'm writing about is Indiana. I mention this to say that sometimes the landscape of Indiana is there, but hidden, and although at times Indiana names are scattered, consciously, throughout a text by writers who, often, have moved away from the state, where the literary imagination twists and circles around the names of Broad Ripple or Fort Wayne or the Blind School or the Redkey Tavern or the Perfection Bread factory until the story lifts off the ground into myth like a tornado; and although at times the place is named, as Indianapolis is in Anthony Burgess's novel *Enderby's Dark Lady* but isn't at all recognizable as *this* place, the one we think we know; at other times place names are erased at the level of language, the place itself still hugging the ground as solidly as ever.

Other than Indianapolis, Raintree County is the place in Indiana that I know best. My husband and I lived there for six years at the beginning of

our marriage, and I taught Ross Lockridge's book at the high school that replaced the schoolhouses of Straughn and Lewisville, known in the book as Waycross and Roiville. So I saved rereading the book, and revisiting Henry County until last. I also figured that, at 1,200 some pages, any issues that had come up in other books had to be contained within the pages of *Raintree County* as well.

Because it had been several years since I'd read the book, I was sucked back into its vision of Raintree County as this "green mesh" and the Shawmucky River halving the county with "loops of shimmering green," the shining railroad cars, the deep grass, the "bladed corn swaying softly in the fields," and Waycross, the town of Straughn, Indiana, "dense with human faces," a "time-enchanted world." When John Shaughnessy looks at Waycross, he sees a place "bathed in light and longing." Somehow I expected, going back, to see a sentimentally lovely place, even though I'd lived in Raintree County and knew better.

In 1995 Waycross and the house Lockridge lived in, summers, with his grandmother Elsie Shockley, had become what Lockridge predicted it would. "Some day," he wrote, "suddenly and surely, this little piece of paper called Raintree Co. would be rolled up and put in a bottom drawer of the cosmos along with the loose sheets of an unfinished poem, and it would be forgotten. Forgotten. Lost. . . . Hard roads and wide will run through Raintree Co. and its ancient boundaries will dissolve. People will hunt it on the map, and it won't be there."

Waycross today has one store, the Trails End gun shop. Even seven or eight years ago there was a general store, but it's closed down, boarded over, with graffiti painted on the doors: *I love Karen, Dean, Dan, Randy, Jennifer, Kevin, Angie, Devon, Amy, Mary. Kurt Cobain Lives,* it says in green ink, Kurt having joined Elvis in the pantheon of living dead rock star gods. *Kurt Lives.* There are ghost signs on the sides of buildings all through Raintree County. Odd signs: *Curios. Mexican Baskets.* The glass in the broken windows is pond green and glossy in the sun.

And everywhere there are castoff un-cared-for things: an electric blue easy chair on someone's front yard, a bright lavender porch swing and lavender planters on a gray asphalt shingled house, a red plastic rose on the ground beside a Plymouth Gran Fury, black plastic covering several old cars. You walk through town and hear the suck of trash bags against metal like the sound of a flock of bird wings. A little boy pushes a push mower through a yard of straw-covered mud and intense trash (hubcaps, tires, washing machine parts, rusted pipes, a broken kerosene heater, a lean-to built onto the side of a trailer). It's all the detritus of the industrialization

that came roaring into Indiana after the Civil War, that reached its height, in Raintree County, during and right after World War II, sucking men and women off the farms of Kentucky, flinging them up to New Castle and Richmond and Muncie, and sometimes as far as Detroit. When the industry began to leave, it left this trash like the aftermath of a rock concert or company picnic, or the morning after a party when you feel sort of headachy and slow and wonder who was that wild man with the lampshade on his head who left all this stuff behind for you to clean up.

The only real evidence of Raintree County as it appears in Lockridge's book is in the names of businesses, the Atlas in the historical society in New Castle—which is really there; the fictional Atlas is real, and you can touch it—the Henry County Courthouse, and, as Tori pointed out to me, in the pristine white of the flag in front of the post office in Straughn. There are signs of vandalism everywhere, but the symbol of The Republic, that grand collective fiction that Lockridge wrote about, the dream that "being but a dream must be upheld by dreams . . . , the gigantic labor by which the earth is rescued again and again from chaos and old night," has been left untouched.

Lockridge writes about a separation between the "fiction" of human culture—Raintree County—and the land itself. All of Raintree County— the post office, the feed store, the schools, and the trains, everything down to the tiniest button on John Shawnessy's coat—is a mask covering the mists of what Lockridge calls The Great Swamp. He locates the swamp just north of Paradise Lake. For Lockridge, The Swamp is the place of dissolution and decay, the place of the hidden wounds of genocide and slavery, as well as the place of sexuality and freedom. It's both beautiful and dangerous, and this split is the central conflict in the novel. (This is also true in the Yusef Komunyakaa poem "The Millpond" in which he writes about a place where "April oozed sap like a boy beside a girl squeezing honeycomb in his fists," a place that has nothing to do with "hammer and saw and what my father taught me," a place he "clutched something dangerous and couldn't let go." But this poem takes place in Alabama so I can't talk about it here and am doing it, as you see, only parenthetically.)

Lockridge's swamp is "moist and heavy with the rank scent of the widening river and its flowers" where "the solid substance of the earth dissolved with life. The creatures of the river swarmed, shrilled, swam, coupled, seeded, bloomed, died . . ." and it's impossible to "find firm ground." At one point it almost kills John Shawnessy: "[H]e dropped neckdeep into a pool. A thick net of roots and lily stems laced his body. A

bottomless ooze drank his feet. . . . He was going down surely. . . . The Great Swamp . . . Why, a man went in there once and never came out again. . . . With a brutal indifference, his own earth had nearly killed him."

The land is the source of life, but also of death, so maybe if we build a cultural landscape hovering above the physical one, we can outwit death. Of course it doesn't work.

Lockridge connects sexuality, death, and the river most beautifully in his description of the town of Danwebster and the Danwebster cemetery. "All the people who ever lived here were lovers and the seed of lovers. Where are all those who ever beheld beauty in bright waters? They lie beside the river. They lie beside the river."

The swamp has a similar function in Porter's *A Girl of the Limberlost*. Before the novel begins, the Girl's father drowns in mud in the swamp while taking the shortcut home to his wife after spending time with his lover in the city. By the time his wife discovers him, all that's left is "that oozy green hole, with the thick scum broke, and two or three big bubbles slowly rising that were the breath of his body." But Porter's swamp is also bubbling over with mystery and wisdom. In Porter, the Limberlost has simple moral force—it's the place where the wages of sin are collected, but it's also the source of virtue and wisdom, of a direct knowledge of God that's denied to those who live in cities. For Porter, it's only our living in cities, in control, that causes us to see the swamp as The Swamp rather than a source of shelter. "You should know without being told," the Harvester's Chicago-bred Dream Girl says, "that when a woman born and reared in a city, and all her life confined there, steps into the woods for the first time, she's bound to be afraid. The past few weeks constitute my entire experience with the country, and I'm in mortal fear that snakes will drop from trees and bushes or spring from the ground. Some places I think I'm sinking, and whenever a bush catches my skirts it seems as if something dreadful is reaching up for me; there is a possibility of horror lurking behind every tree and—" And the Harvester says to her, "Will you try to cultivate the idea that there is nothing in all this world that would hurt you purposely?" Porter herself, in her life as a photographer, often had to tie scarves around her face and crawl out on limbs in the muck of the Limberlost to photograph rare birds that fed on carrion. That type of knowledge makes its way rarely into her fiction, and only when she feels someone needs to learn a lesson, inducing at times the type of blindness you get when you look too long at the sun.

In Etheridge Knight's poetry, water is internal but still associated with freedom and movement. He writes behind the straight bars of prison where "there is a gray stone wall damming my stream," and he dreams of

the "old land and the woods" where he "sipped cornwhiskey from fruit jars with the men" and "flirted with the women." In his poem "Belly Song" he talks of a sea that can drown you but also carry you—like catching the wave just right or swallowing water, and it's "this Singing Sea" that has fallen /in love:

> with the sea in you
> because the sea
> that now sings/in you
> is the same sea
> that nearly swallowed you—
> and me too.

(There's an interesting tradition of political writing in Indiana. In Knight's poetry, Mari Evans's and others. When there's justice, Knight explains in his poem "Apology for Apostasy," then he can write about sunsets. And in German-American writers like Vonnegut and Eugene Debs. "It does not matter that nature spreads forth all her scenes of beauty and gladness . . . ," Debs wrote. "[I]f liberty is ostracized and exiled, man is a slave, and the world rolls in space and whirls around the sun a gilded prison." Some of the Germans in Indiana were political fugitives, leaving Germany at the time of the great revolutions in thought that produced Marx and Engels—meeting the very southern Scotch-Irish strain. All these cultures continue to clash and blend, to join with new ones, to keep Indiana alive. Another way of looking at the threads in Indiana literature, besides my metaphor of the fixed and the fluid, is to keep in mind that Debs, the father of American Socialism, and Larry Bird, the favored son of Indiana basketball, both lived in Terre Haute, Indiana.)

Over and over in Dan Wakefield's novel *Going All the Way* there are elemental rains that confront the protagonist both with the overwhelming nature of passion and with spiritual yearning. So you get these hilarious scenes in Topper's Tavern or The Redkey when the "sharp green smell of the wet grass" makes its way through "the stale, beery air of the bar" like "some deep, poignant perfume mixed of elemental things," and both Sonny and Gunner stop talking for a moment in a kind of blessing, and one of them will come up with some non sequitur like "Donna Mae Urlich. What a pair of knockers" or "I sure would like to try that surfing."

In *The Cubical City* Janet Flanner describes the ripe decadence of the catalpa trees around her parents in terms of water—the branches drift "like seaweed," and "beneath her soles the earth felt fevered." In her book the protagonist leaves Indianapolis specifically because of what she feels as

Puritan restraints, the "modest passions that flow through a wedding ring," that "nuptial trial" where even a woman who had seven children "retained too much respect for herself . . . to know what had caused them. She had merely had, so she said, occasional periods of unconsciousness." In the Midwest even the land itself, she says, is "dull and useful." This is the same vision in Wakefield's book, as though the writers are hearing the call of the great swamp and the restraining clamp with equal force and are unable to reconcile that conflict and remain.

I could go on and on here. In the Walam Olum, the creation myth of the Lenni Lenape tribe, the earliest piece of Indiana literature arguably, you get this line—*The water ran off, the earth dried, the lakes were at rest, all was silent, and the mighty snake departed.* In Jared Carter's poem on a line from the Walam Olum, water is associated with a woman and freedom and darkness, "as though all the land were water, without edge or ends, and all I hoped to find or know was gathering there."

In Walter Wangerin's *The Book of the Dun Cow,* which takes place in a mythical landscape but was written by the banks of the Ohio in Evansville and takes on the tone of that landscape, the river swells and floods the farmland when evil escapes from the earth's center, and the battles between good and evil take place in the air over water, and when good triumphs, the waters subside.

In Indiana, the Great Swamp is more than symbolic. Early writers describe the undrained uncut Indiana forests as boggy and dense with mud. This is the landscape we've built our farms and houses and strip malls over. Try to see it underneath the Capital or the Circle Centre Mall when you leave here today. "It's hard to picture this part of the country as I first remember it," Oliver Johnson tells of the early days in Marion County. "Here and there was a cabin home with a little spot of clearin close by. The rest of the country was just one great big woods and miles and miles in most every direction. From your cabin you could see no farther than the wall of trees surroundin the clearin. . . .

"The trees and bushes made such a dense shade in the summer that grass couldn't grow. In the winter time the snow would sometimes lodge on the branches, leavin the ground bare, except for leaves. The mass of leaves fallin every year covered the ground. Then the rains and shade kept the leaves a wet slimy mess most of the year. That's the reason we didn't have any forest fires. There was swampy places all through the woods on account of the leaves holdin in the water like a big sponge."

For Johnson, the forest was sheltering. For many Indiana writers, it also meant terror. Charles Major's protagonist is lost at one point in *The*

Bears of Blue River, and we feel his fear as he's cut off from the man-made landscape: "I could not tell from which direction I had come, nor where I was going. Everything looked alike all about me—a deep black bank of nothing. . . . Now and then I heard wolves howling, and it seemed that their voices came from every direction." Even into the twentieth century, as journalist Ernie Pyle describes the lines of cars in Brown County State Park in the fall, he says "they were all gone by eight in the evening because they were afraid of the darkness and they wanted to flee before the night engulfed them."

Eventually the forest was clear-cut for settlements and farming, but the mud remained. Catherine Merrill, in her letters, writes, "Ma says some day this town [Indianapolis] may grow very large Pa says, too that Indpls. may be that big; but I heard some men tell him he was mistaken. They said it was situated in a vast mud-hole which never could be dried up so as to be depended upon. There's White River, they said, overflows its banks. Fall Creek overflows its banks, and Pogue's Run, though the least of the 3, is the very worst to spread out over everything, yet it isn't so bad as the bayou which William calls River Styx, and I think ought to be called River Logs. That bayou is awful. It's mostly made up of mud and mud drowns worse than water, as Mr. Norwood's cow could prove if it were alive."

Eunice White Beecher writes in her novel *From Dawn to Daylight,* "It [Marion County] was a broad, level stretch of land as far as the eye can reach, looking as if one good thorough rain would transform itself into an impassable morass. . . . The city itself has been reclaimed from this slough. . . . [But] [y]ou will have to shut your eyes before you can well imagine anything like our home hills in this flat, boggy region." And Edward Eggleston in his novel *Roxy* describes an Indianapolis where "the mud was only navigable to a man on a tall horse. . . ." So the early settlers cut the trees and drained the land and began to create the landscape we see now. Industrialism changes it even more, and Indiana writers mourned the changes.

Of course the great Indiana novel of the new industrial order is Tarkington's *The Magnificent Ambersons.* Tarkington talks about a city that says "[t]he more dirt, the more prosperity," and people who "took the foul and heavy smoke with gusto into the profundities of their lungs . . . , [who] were happiest when the tearing down and building up were most riotous, and when new factory districts were thundering into life." The city, he writes, "heaved and spread . . . , befouled itself and darkened its sky. . . . Its

boundary was mere shapelessness on the run; a raw, new house would appear on a country road; four or five others would presently be built at intervals between it and the outskirts of the town; the country road would turn into an asphalt street with a brick-faced drug store and a frame grocery at a corner; then bungalows and six-room cottages would swiftly speckle the open green spaces—and a farm had become a suburb, which would immediately shoot out other suburbs into the country, on one side, and, on the other, join itself solidly to the city."

It's Lockridge who connects late nineteenth-century industrialization back to The Swamp. This is the professor talking to Johnny Shaughnessy: "[T]he creators of the Machine, believing it the fairest flower of human progress, have really made it the noxious weed that chokes out everything else and finally begins to choke itself out of room and means of sustenance. Thus with the Machine, his last brilliant contrivance, the Heir of all the Ages succeeds in hurling himself back into the Swamp and destroys all the beautiful insubstantial dreams that made him think he had a home forever on this earth."

Several writers describe this postindustrial swamp in great detail, often with great humor. These writers describe a swamp that drowns every bit as much as the original watery one but without the possibility for wisdom or spiritual transcendence, without the spirits and gods of the original swamp, because it's entirely man-made. There's still a separation between what humans make and what God makes, but now it's flipped— what man makes is not a heroic answer to the questions of nature— human creations are nothing more than meaningless chatter. These are the writers that give you the swamp as giddy lists of trash.

"From the day they moved in," Jean Shepherd writes in *Wanda Hickey's Night of Golden Memories*, "the house was surrounded by a thick swamp of junk: old truck tires, barrels full of bottles and tin cans, black oil drums, rusty pitchforks, busted chicken crates, an old bathtub, at least 57 ancient bedsprings, an old tractor hood, a half-dozen rotting bushel baskets overflowing with inner tubes and galoshes, a wheelbarrow with one handle, eight or nine horse collars and a lot of things that nobody could figure out—things that looked like big tall water boilers with pipes sticking out." In his novel *In God We Trust: All Others Pay Cash* he describes the postindustrial water in the lakes in da-region: "The water in these lakes is not the water you know about. It is composed of roughly 10% waste glop spewed out by Shell, Sinclair, Phillips and the Grasselli Chemical Corp; 12% used detergent; 35% thick gruel composed of decayed garter snakes, deceased toads, fermenting crappies and a strange unidentifiable liquid that holds it all together."

"So naturally," he goes on, "fishing is different in Indiana. The muddy lakes, about May, when the sun starts beating down on them, would begin to simmer and bubble quietly around the edges. These lakes are not fed by springs or streams. I don't know what feeds them. Maybe seepage. Nothing but weeds and truck axles on the bottom; flat, low, muddy banks, surrounded by cottonwood trees, cattails smelly marshes and old dumps. Archetypal dumps. Dumps gravitate to Indiana lakes like flies to a hog killing."

James Alexander Thom, in his historical novel *Long Knife*, describes in an afterward looking for George Rogers Clark's monument and the wilderness he'd written about in the novel. There used to be a Falls on the Ohio, and an island named Corn Island, a kind of watery paradise tinctured, always, with the light of the setting sun. Those places were destroyed by locks and erosion. Driving there in the twentieth century to look for the place of his imagination, he "drove among shopping centers, roller rinks, mobile home parks, chain restaurants, filling stations, discount stores and ice cream shops where men and women with listless eyes and overstuffed shorts waited in line to be served." He finds someone in an auto parts store who had gone to George Rogers Clark High School and knows the direction to the monument. When he finds it, "the evening was full of the snarling racket from a chain saw somewhere nearby. . . . [and] the words on the monument's bronze plaque were dwarfed by the spray painted declaration 'I hate Debbie.' The air was dirty. Smokestacks jutted into the horizon. . . . High tension wires spanned the river like a string of Eiffel Towers. . . . The roadside was strewn with empty beer six packs."

Scott Russell Sanders, in his essay "In Limestone Country," describes this conflict between the river of the earth and the power of technology as a war: "Waste rock litters the floor and brim like rubble in a bombed city. . . . Wrecked machinery hulks in the weeds, grimly rusting, the cogs and wheels, twisted rails, battered engine housings, trackless bulldozers and burst boilers like junk from an armored regiment."

My favorite Indiana story is William Gass's "In the Heart of the Heart of the Country." It's probably the one that expresses the time we're living in most clearly. This is the only story representing Indiana as a place in *The Norton Anthology of Contemporary Fiction*, the one story many contemporary writers from Indiana (and other midwestern writers such as Ron Hansen and Charlie Baxter) will consistently mention as an influence.

Gass describes the town of "B," an imaginary combination of Brookston and Battleground, Indiana, near West Lafayette. The nameless protagonist has gone there "in retirement from love." The story begins, "So I have sailed the seas and come . . . to B . . . , a small town fastened to a field in Indiana." And that's the story, in that first sentence, the passionate seas

of the body he sailed on to arrive in this place. Gass describes the fluid world of the erotic: "I dreamed my lips would drift down your back like a skiff on a river," he says. His lover rose to greet him like the fog and sometimes, now "on the road along the Wabash in the morning, though the trees are sometimes obscured by fog, their reflection floats serenely on the river, reasoning the banks, the Sycamores in French rows." The sun through the mist is like "a plum on the tree of heaven, or a bruise on the slope of your belly." He's sailing on that world still, but it's left him "scattered, like seed," and he feels himself swimming on the mist covered glass that separates him from an authentic life. He's attempting to dock in the fixed fastened world of this Indiana town—like my moment on the Little Pigeon River—to become grounded in a place where, in the winter, "it's a rare day, a day to remark on, when the sky lifts and allows the heart up.

"I am keeping count," he writes, "and as I write this page it is eleven days since I have seen the sun." This is a place that is, he says, "nothing more than a rural slum," with "piles of useful junk" in back yards and everything measured by commerce—"two restaurants here and a tearoom, two bars, one bank, three barbers, two grocers, a dealer in Fords, a factory for making paper sacks and pasteboard boxes. This place. A place it's difficult for the narrator love.

"There's a row of headless maples behind my house, cut to free the passage of electric wires. High stumps, ten feet tall, remain, and I climb these like a boy to watch the country sail away from me.

"These wires offend me. Three trees were maimed on their account, and now these wires deface the sky. They cross like a fence in front of me, enclosing the crows with the clouds. I can't reach in, but like a stick, I throw my feelings over. What is it that offends me? I am on my stump, I've built a platform there and the wires prevent my going out. The cut trees, the black wires, all the beyond birds therefore anger me." These are wires that, if they led back to the woman, he would "know what they were." But they don't, and he doesn't know, and instead, these are straight lines, he says, that "fasten me."

The story is filled with sleepwalkers, images of blunted lives maimed like the trees in order to fix the town to the field. The landscape is filled with grayness. Tell me that you don't recognize this as a day in February: "The sides of the buildings, the roofs, the limbs of the trees are gray. Streets, sidewalks, faces, feelings—they are gray. Speech is gray, and the grass where it shows. Every flank and front, each top is gray. Everything is gray: hair, eyes, window glass, the hawkers' bills and touters' posters, lips, teeth, poles and metal signs—they're gray, quite gray. Cars are gray. Boots, shoes, suits, hats, gloves are gray. Horses, sheep and cows, cats killed in the

road, squirrels in the same way, sparrows, doves, and pigeons, all are gray, everything is gray, and everyone is out of luck who lives here."

"This Midwest," he writes. "Like a man grown fat in everything but heart. . . ." Where "everywhere the past speaks, and it mostly speaks of failure. The empty stories, the old signs and dusty fixtures, the debris in alleys, the flaking paint and rusty gutters, the heavy locks and sagging boards. . . ."

The fallen buildings are, he says, "endless walls" that "keep back the tides of earth." This is a world he knows he should love, that it's "better to live in the country, to live on a prairie by a drawing of rivers, in Iowa or Illinois or Indiana, say, than in any city . . . in any blooming orchard of machines." Shouldn't he be "strong enough, diligent enough, perceptive, patient, kind enough, whatever it takes" to love this place; isn't he a fool to want to live anywhere else?

Like Lockridge, Gass writes about the connection between the fear of death, the land, and the erotic. "Flies braided themselves on the flypaper in my grandmother's house. . . . I knew it as I dreamed I'd know your body, as I've known nothing, before or since; knew as the flies knew, in the honest, unchaste sense . . . , flies and more flies in clusters around the rotting fruit. They loved the pears. Inside, they fed. They were everywhere the fruit was: in the tree still . . . , or where the fruit littered the ground, squashing itself as you stepped . . . ; there was no help for it. Deep in the strong rich smell of the fruit, I began to hum myself. The fruit caved in at the touch. Glistening red apples, my lifting disclosed, had families of beetles, flies, and bugs, devouring their rotten undersides. There were streams of flies; they were lakes and cataracts and rivers of flies, seas, and oceans."

William Gass is a philosopher, and part of what he's doing in this story is arguing with the narrator in William Butler Yeats's poem "Sailing to Byzantium." That narrator has sailed the seas and come as well, but he landed in brittle golden Byzantium, not in Brookston, Indiana, and his solution to the decay of the body is to fly away from it, to create a pure life of mind and art—shopping malls. Gass's solution, finally, is that you can't fly away from this body, this place, this house because they are all of who you are. If the body or the landscape is diminished, the soul is diminished as well, because, Gass says, "my body is all of who I am."

I'm strongly attracted to fiction. Which means stories constructed by human beings into a net of sense. Sense in both its meanings—understanding and feeling. Which means, as well, this landscape. And so I accept the story that we've been telling ourselves about the separation between mind and land. But there are other possible stories, other possible metaphors.

Those other metaphors occur in writers who often aren't thought of as Indiana writers at all. I'm thinking of novelists like Marguerite Young and Mary Ward and Jessamyn West, and poets like Jean Garrigue and Ruth Stone. Young has a different take on the watery nature of reality—not mud, not swamp. In *Angel in the Forest* she writes about a man who "was not depressed to discover no fundamental law. The realization of the flowing of sensations like water had given to him a vast freedom." I picture her as an especially strong swimmer, watching the shifting phantasmagoric landscape with a wry smile, and without cynicism. Everything is fluid in Young's Midwest, constantly being and becoming everything else because everything is imagination "even to the last tenth," she says. In the novel she write of a character who "was the divan, the mirror, the lamp, the rug, all of which might suddenly move away in the evening light, leaving a bare room. . . . She was everybody and the rose petal, too, the cause of this dissolution which was this creation, and she was the street lamp beaming through the fog like one great pearl, a sarcophagus enclosing the moon's flame . . . , for what was her personal identity among so many transshifting objects and flickering shadows, and how should she walk where the landscape moved like waves?"

To allow yourself to be transformed, to settle back into the tube and not pull back, "is an experience engendered by emotion, elation, enthusiasm, intuition—but rarely by reason. . . . Only he who feels deeply can tell how the woodpecker becomes the unadulterated angel, how the sewer cleaner becomes a god—though such transitions, like that from all to nothingness, are always going on."

The wonderful poet Jean Garrigue sees a "binding element" that rises from the land, something like a web, and she asks, "Is it this that forged the angel's smile, the gay stone lips, the strong wings folded back, and is it this of which the poplars speak glittering and shouting in the full, strong morning light?" This is a world where "[a]ll is a golden burst . . . , [a] changeless changing, transforming into an ethereal storming, freshening, continuous. . . ." Jessamyn West writes of something that "came down, or perhaps it came up, out of the earth itself, something very thin and fine, like a spun web, and held them all together. Josh could feel it. Anybody could break away from it, if he liked, but while they headed the same way, waited the same time, it held them. You could lean against it like steel."

"What would thee change?" Eliza asks herself in *The Friendly Persuasion*. "Have the warm wind which was lifting the curtains lie down? Have the peaches which were ripening, ripe? Have Lafe and Jess, who were on the back porch talking, silent? Have it another hour, another house, an-

other season? No, no! This hour, this house, this season. All was as it should be."

When confronted with the entropically fluid nature of matter and the fixed nature of human reason, sometimes writers approach that as a joyful marriage rather than as conflict. Or rather, another possible story that explains the connection between human beings and this land—aside from the story of a separation that leads to the either/or of rigidity or drowning —are the domestic metaphors of marriage or farming, or the marine metaphors of swimming or sailing. These are metaphors that say that the chief end of man is to work with the tide of entropy—in discipline, rather than repression—or to joyfully sail on top of it in the heady rush of the wave.

Garrigue and Young are writers of the second metaphor. Scott Russell Sanders pursues the first metaphor in his collection *Staying Put* when he connects wildness and domesticity. And Porter with her warm light-filled dwellings to house the Dream Girl or the moths. Jessamyn West does in *The Friendly Persuasion* with her images of the home: "Behind her were the dark woods, shadows and bosky places and whatever might slide through them when the sun was set. Here, the kitchen, the stove still burning, sending a wash of light across the scrubbed floor boards, the known dishes in their rightful stacks and ma's ring sounding its quick song of love." "Taste eternity," Jess says later in the novel, "on a May morning in a white clapboard house on the banks of the Muscatatuck." In Darryl Pinckney's novel *High Cotton* there's the yellow school bus that's always on time, mud free, "on mornings that got darker and darker, mornings of rain, frost, untrammeled snow . . . , on mornings when the sun's running yolk caught the moon in the ether," or the sheltering bars in Wakefield's Indianapolis.

And then there are writers like Michael Martone, who choose to *celebrate* the icons of industrial culture. His perfection bread sign is *perfection*. His "Return to Powers" restaurant is a return to *powers*. "The ancient shape of the coke glass . . . , the archetypes of mustard jars and ketchup bottles, the high contrast of salt and pepper. . . ."

It's nature's job to dissolve and change and human nature's to learn to live in response to that. "What's the main idea behind this world?" a trash-saving Indiana character says in West's novel. "A wasting away—a wasting away. Trees rotting. Ground carried off by the rivers. The sun getting less hot. Iron rusting.

"I run counter to that," he continues. "I put a stop to it. God don't care. Wreckage is His nature. It aint mine. I save. Piles of everything.

Boxes, papers, I get old papers from as far as Kokomo. Nails, money too. I save all. Me alone. Against the drift. The rest of you letting it run down the spout."

On the way home from Raintree County, still musing on the intense trash of Waycross, we drove through Pendleton, the setting for West's novel *The Massacre at Fall Creek*. Tori said the best antique store in the world was right there, and so we parked and went inside. And the most amazing thing! Glassware arranged along the wall by color, baskets overhead, tangled nests of rusted pulleys, tin trains and pressed tin clocks. An entire doctor's office, chemicals still in their paper containers, canning jars blue and clear and amber, velvet hats, and there, along one wall, in straight clean lines, were plastic Best Ever cottage cheese containers at five dollars each, Marsh cottage cheese for two. This is landfill, I said to the antique store owner—wavy gray hair down to his shoulders, Santa Claus glasses on his nose—and he smiled the purest smile and said, They aren't making these any more; eventually people pull everything out of landfills. A landfill's just a stage, a waiting station in the process of change. *Don't Throw Anything Away!* the sign says by the cash register. This store's the place where junk is resurrected. And all cleaned up, spiffy, in a row on the antique store shelf; those Best Ever containers were beautiful in that little boat of an antique shop with its glistening lamps and blue glass canes, all of it floating so peacefully on the river of this earth, right there, in Pendleton on Fall Creek, Indiana. *Indiana.* Like waves.

THE ECONOMY OF PEACE

The world there was the flat world of the ancients; to the east, a cornfield that stretched to daybreak; to the west, a corral that reached to sunset; between, the conquests of peace, dearer-bought than those of war.
—Willa Cather, "A Wagner Matinee"

Kurt Vonnegut is fond of saying that Indianapolis is the largest city in the world that's not on a navigable body of water. And I've also heard it said that Indianapolis has more bridges than Venice. Regardless of whether either statement is accurate, I know that, like certain math equations, they're close enough estimates to start with, and so I'll start with them because, factual or not, they're true.

At one time the American Midwest was the site of a large inland sea, and even two hundred years ago the state of Indiana was swampland and forest, the canopy so thick that the wet decaying leaves never caught fire. So it makes sense to me that Indianapolis would have more bridges than Venice. To change that natural landscape into the urban landscape we have now, the ocean was squeezed into streams, then rivers, the sodden sponge controlled with underground tiles and stone. We replaced the sea with an abstract geometry that stretches clear to the imaginary lines that separate us from Ohio, Illinois, Michigan, and Kentucky. Everything we see is domesticated by human beings. A web, a net of intersecting lines, that's what we live so comfortably within. And so now, when we set sail, it's with automobiles, trucks, and combines; with bicycle or plane; with the click of the cursor on a screen.

There is one sure note in midwestern literature, as writers in generation after generation discover the economy of this ordered landscape, its benefits and costs. When writers turn their eye toward the Midwest as a place, they document the struggle between freedom and restraint, passion and control, between wildness and the sacrifices and joys of domesticity.

And so, the costs of peace. Here, our writers say to us, is the bargain we've struck, and here are its limitations. If you're a young artist, the cost of this eternal vigilance can feel like resignation. It can feel like repression. You feel like Gulliver caught in the Lilliputian strings, fastened to the land or family with rows of stifling corn and church pews. Sometimes the cost feels like the destruction of the self. This is why many of our artists and writers leave. The price of peace can seem too dear, too much like war.

The work of the great midwestern novelist Willa Cather is a case in point. "Don't love it so well," the aunt in Cather's early story "A Wagner Matinee" says to her nephew when she sees him at the piano, "or it may be taken from you." As music was taken from her, or rather, as it had been renounced. There wasn't room for it. The aunt lives in a world where human lives are spent ploughing "forever and forever between green aisles of corn, where, as in a treadmill, one might walk from daybreak to dusk without perceiving a shadow of change."

Change isn't possible because the aunt's world is one that demands the kind of sacrifice where the soul seems to evaporate from the body, leaving something hardened, like stone. When the nephew escapes this life and moves to Boston, he brings his aunt out east for a visit and they attend the symphony. Here the stone softens and the aunt comes back to her true self "like that strange moss which can lie on a dusty shelf half a century and yet, if placed in water, grows green again."

All our souls are filled with that strange moss, dried up yet thick, as William Gass writes, "in everything but heart." But how could a heart survive, Cather asked later in her novel *My Antonia,* as other midwestern artists before and since have asked, in this vast heartland where lives seemed to "to be made up of evasions and negations . . . "where every individual taste, every natural appetite, was bridled by caution" and people "tried to live like the mice in their own kitchens; to make no noise, to leave no trace, to slip over the surface of things in the dark." And so Cather's narrator, like Cather in both her life and in her fiction, will escape the Middle West.

But only for a time.

Because, slowly, the wages of peace and the cost of restlessness make themselves known. The wages seem so slight at first, and they don't seem to appear until that initial conflict between passion and control has either run its course or resulted in catastrophe.

And because this is a tragic world where every living thing must die, we receive the wages of peace with a note of sadness. It's not what we expected, and the work has been so hard. Is this all? The wages are as subtle as the rise in a flat Midwestern road, but finally greater than we think.

When a person becomes aware of them, there's a change. The imagination pours back into the landscape. In novels such as *My Antonia* or *Lucy Gayheart* or *O Pioneers!* Cather's rural landscape changes from the imagery of chains and monotonous prairies as her characters learn to within the light the landscape of the infinite.

Kindling! The very blue of the air, which was at first an emptiness, is clearly, when you pay enough attention to it, the blue at the center of a flame, the deep burning of a log. Pay attention, the great French mystic Simone Weil wrote, and that paying attention in itself is prayer. That which is always there is always on fire with holiness.

And so in *My Antonia,* when Cather's narrator begins to pays attention even to "the narrow brown leaves (that) hung curled like cocoons about the swollen joints of the stem," he begins to see, in the agrarian landscape, the infinite in the particular: "As far as we could see, the miles of copper-red grass were drenched in sunlight that was stronger and fiercer than at any other time of the day. The blond cornfields were red gold, the haystacks turned rosy and threw long shadows. The whole prairie was like the bush that burned with fire and was not consumed. . . .It was a sudden transfiguration, a lifting-up of day."

The bush that burns with the voice of spirit is not *someplace else.* It's not even in the unbroken wildness of the land that was, before the pi-

oneers, "not a country at all, but the material out of which countries are made." It's located, Cather discovers, in what she had already dismissed— in her earlier stories—as the monotony of fields. It's in a human being turning his or her face with love and work toward what *is*.

Cather's metaphor for this is farming. While the currency of peace is a fire that warms instead of burns, its smoldering never ends. Anything less than commitment and the recognition of limitations means, according to Cather and many other midwestern writers, that you will never be fully connected to life. But when you embrace the sadness, you're also, they conclude, released into joy. "I was something that lay under the sun and felt it, like the pumpkins, and I did not want to be anything more. I was entirely happy. Perhaps we feel like that when we die and become a part of something entire, whether it is sun and air, or goodness and knowledge. At any rate," Cather wrote, "that is happiness; to be dissolved into something complete and great."

"When it comes to one," she wrote, "it comes as naturally as sleep."

And so I myself have sailed these seas as both a reader and a writer and offer these essays in gratitude for those who built and have maintained the boats I use to sail. When John Updike wrote his book of interviews and essays about books and art, he called it *Hugging the Shore* and opposed this kind of writing to the heroic sailing out into the rough seas of the imagination required of a novelist or poet. While the inland sea of the landlocked imagination may be circumscribed, it's not stagnant, and when the artist leaves the shore, he sails within.

The American Venice where I live is beautiful today. The air is dry and cool, the rivers contained within their banks. It's the season of purple; the Russian sage, verbena, and lavender are all in bloom. The synapses between the white pine branches outside my window are marine blue. It's dusk. I turn the lamp off and the blue pops to a whiter glacial blue before it fades to black.

I went to my childhood church this morning. Transfiguration Sunday. There was a new white satin cloth on the communion table made by the banner committee, one member of which has been quietly sewing, without applause, for years. She has never stood at the front of the church transfigured, but the new white cloth she stitched is free now from the decades of spilled juice and wine in this season of purple, and that's enough. The gold embroidery on the cloth is in the same watery cursive as the one that someone stitched before her. The cloth is cut from a different bolt of satin, but the knowledge and the lettering flow through time.

Near the end of the service someone dropped a silver plate of bread and

the stitching woman in her sky-blue summer skirt waited until the right moment in the final hymn to bend down quietly from her pew and pick the cubes of white bread up from the floor so the minister in her robes and candled silver hair would have a space to stand for the benediction.

One bends, one lifts her arms in praise. Sailing away or sailing back: each motion is the same.

SELECTED BIBLIOGRAPHY

Asals, Frederick. *Flannery O'Connor: The Imagination of Extremity.* Athens: University of Georgia Press, 1982.

Bachelard, Gaston. *The Poetics of Space.* Trans. Maria Jolas. Boston: Beacon Press, 1994.

——. *Water and Dreams: An Essay on the Imagination of Matter.* Trans. Edith R. Farrell. Dallas, Tex.: Pegasus Foundation, 1983.

Barbour, Julian. *The End of Time: The Next Revolution in Physics.* New York: Oxford University Press, 2000.

Baxter, Charles, and Peter Turchi, eds. *Bring the Devil to His Knees: The Craft of Fiction and the Writing Life.* Ann Arbor: University of Michigan Press, 2001.

Beecher, Eunice Ward. *From Dawn to Daylight; Or, the Simple Story of a Western Home by a Minister's Wife.* New York: Derby and Jackson, 1859.

Buber, Martin. *Good and Evil.* New York: Prentice Hall, 1980.

Cather, Willa. *Death Comes for the Archbishop.* 1927. Reprint, New York: Vintage Classics, 1990.

Chekhov, Anton. *Longer Stories from the Last Decade.* Trans. Constance Garnett. New York: Modern Library, 1999.

Crane, Stephen. *The Portable Stephen Crane.* 1969. Reprint, New York: Penguin, 1977.

De Montaigne Poncins, Gotran. *Kabloona.* 1941. Reprint, New York: Time-Life Books, 1980.

Flanner, Janet. *The Cubical City.* 1926. Reprint, Carbondale: Southern Illinois University Press, 1974.

Gass, William H. *In the Heart of the Heart of the Country.* New York: Pocket Books, 1976.

Johnson, Oliver. *A Home in the Woods.* 1951. Reprint, Bloomington: Indiana University Press, 1978.

Kawabata, Yasunari. *Snow Country.* Trans. Edward G. Seidensticker. New York: Vintage International, 1996.

Kimmel, Haven. *A Girl Named Zippy: Growing up Small in Mooreland, Indiana.* New York: Broadway Books, 2002.

Knight, Etheridge. *The Essential Etheridge Knight.* Pittsburgh, Pa.: University of Pittsburgh Press, 1986.

Lockridge, Ross, Jr. "Raintree County." Boston: Riverside, 1947.

Makowsky, Veronica. *Caroline Gordon: A Biography.* Oxford: Oxford University Press, 1989.

Mann, Thomas. *The Magic Mountain.* Trans. John E. Woods. New York: Vintage Books, 1996.

Martone, Michael. *Ft. Wayne is Seventh on Hitler's List.* Bloomington: Indiana University Press, 1993.

McPhee, John. "The Search for Marvin Gardens." *Pieces of the Frame.* New York: Farrar, Straus, and Giroux, 1969.

Nin, Anaïs. *The Novel of the Future.* 1979. Reprint, Athens: Swallow. Press/Ohio University Press, 1986.

Oates, Joyce Carol, ed. *Best American Essays of the Century.* New York: Houghton Mifflin, 2001.

O'Connor, Flannery. *A Good Man is Hard to Find and Other Stories.* New York: Harvest Books, 1977.

——. *Mystery and Manners: Occasional Prose.* New York: Farrar, Straus and Giroux, 1969.

——. *Wise Blood.* New York: Farrar, Straus and Giroux, 1949.

Salih, Tayeb. *A Season of Migration to the North.* Portsmouth, N.H.: Heinemann, 1970.

Sanders, Scott Russell. *Fetching the Dead.* Urbana: University of Illinois Press, 1984.

——. *Secrets of the Universe: Scenes from the Journey Home.* Boston: Beacon Press, 1992.

——. *Staying Put: Making a Home in a Restless World.* Boston: Beacon Press, 1994.

Stratton-Porter, Gene. *Girl of the Limberlost.* Bloomington: Indiana University Press, 1984.

——. *Harvester.* Bloomington: Indiana University Press, 1987.

Tillich, Paul. *The Interpretation of History.* New York: Scribners, 1936.

Vonnegut, Kurt. *Breakfast of Champions.* New York: Delacorte, 1973.

——. *Cat's Cradle.* New York: Holt, Rinehart, and Winston, 1963.

——. *Deadeye Dick.* New York: Delacorte, 1982.

——. *Galapagos.* New York: Delacorte, 1985.

——. *Hocus Pocus.* New York: Putnam, 1990.

——. *Mother Night.* New York: Fawcett, 1962.

——. *Slaughterhouse Five.* New York: Delacorte, 1971.

Wakefield, Dan. *Going All the Way.* Bloomington: Indiana University Press, 1997.

——. *How Do We Know When It's God?* New York: Little, Brown, 1999.

——. *New York in the 50s.* New York: St. Martin's Press, 1999.

West, Jessamyn. *The Friendly Persuasion.* New York: Harcourt, Brace and Co., 1945.

Williams, Daniel Day. *The Demonic and the Divine.* Minneapolis, Minn.: Fortress Press, 1990.

Young, Marguerite. *Angel in the Forest: A Fairy Tale of Two Utopias.* Normal, Ill.: Dalkey Archive, 1994.

——. *Miss MacIntosh, My Darling.* Normal, Ill.: Dalkey Archive, 1993.

SUSAN NEVILLE is a native Hoosier and professor of English and creative writing at Butler University, and is also on the faculty of the Warren Wilson Program for Writers in North Carolina. Her books include *Indiana Winter* (1994), *Falling Toward Grace: Images of Religion and Culture from the Heartland* (co-edited with J. Kent Calder, 1998), and *Iconography: A Writer's Meditation* (2003), all with Indiana University Press. She is also author of *The Invention of Flight: Stories* (1984), *In the House of Blue Lights* (1998), and *Fabrication: Essays on Making Things and Making Meaning* (2001).